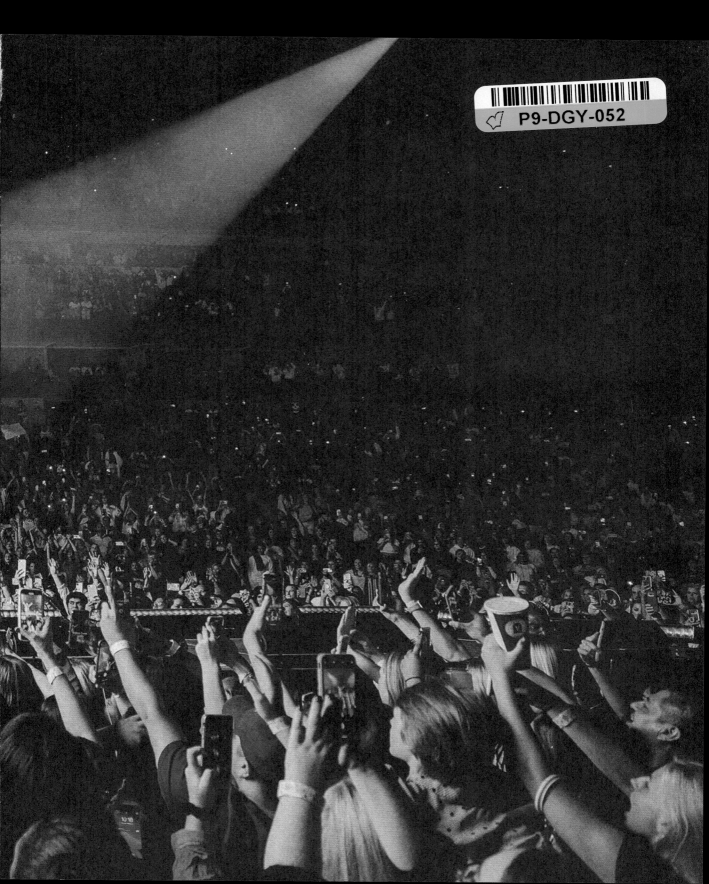

Billie Eilish

Billie Eilish

by Billie Eilish

GRAND CENTRAL
PUBLISHING
NEW YORK AND BOSTON

Cover design by Hans Hettich at **SOMNIC**INC
Cover copyright © 2021 by Hachette Book Group, Inc.

Grand Central Publishing
Hachette Book Group
1290 Avenue of the Americas, New York, NY 10104
grandcentralpublishing.com
twitter.com/grandcentralpub

First edition: May 2021

Grand Central Publishing is a division of Hachette Book Group, Inc. The Grand Central
Publishing name and logo is a trademark of Hachette Book Group, Inc.

The publisher is not responsible for websites (or their content) that are
not owned by the publisher.

The Hachette Speakers Bureau provides a wide range of authors for speaking events. To find
out more, go to www.hachettespeakersbureau.com or call (866) 376-6591.

Print book interior designed by Hans Hettich at S OMNIOINC

Library of Congress Cataloging-in-Publication Data has been applied for.

ISBNs: 978-1-5387-2047-9 (hardcover), 978-1-5387-2049-3 (ebook)

Printed in the United States of America

WORZ

10 9 8 7 6 5 4 3 2 1

I've always had such a passion for pictures. I grew up wanting to become a photographer when I was older. Not because I was good at photography, just because I loved it. In this book you'll find the chronological story of my life in photos taken by many different people throughout my life.

When I was little, any time my parents would start to film me, I would always say, "I wanna see." If you watch any home movie we have, there's always a certain part where I'll look at the camera and say, "I wanna see." I couldn't stand not being behind the camera. Ironically, my entire life now is the other way around. There always seems to be a camera on me.

I think it's so important to take photos throughout your life because otherwise you might forget. I don't want to forget, I want to keep my memories close and vivid.

I don't know if it's just because I'm really sentimental, or maybe I just love to look at old pictures. My mom always kept big albums of our childhood photos; we have books and books of pictures taken throughout my life. I've gone and opened them up every couple of months to look back. Even if I've seen them a million times, I like to see them still.

I think it's really interesting to look back on myself when I was a little kid, and see the similarities between me as a toddler and me now. My mom has always said that a three-year-old's interests and personality traits will show up in that kid later in life. That was definitely true for me.

I don't want this book to feel like a chore, I want it to feel like a photo book you might have of yourself. I don't want to spell out everything for you. I want to give you a big pile of pictures that speak for themselves.

Picking all the photos was kind of a torturous task. Not because it was a lot of work (it was, but I enjoyed the work), but because it meant going through every single photo library of ours. And it was seeing all the different phases in my life, some of which were amazing and some of which were terrible. Every week during this process, I was feeling a different emotion because I was remembering everything that happened in whatever period of time I was looking back on, and kind of being thrown back into that year.

These pictures have been taken by all different types of people. A lot of them were taken by my parents, by me, by my brother. Some were taken by friends or by people on my team, some by photographers from all over the world. They all vary in levels of intimacy, because that is life. I didn't want to show you the same emotion the whole time.

If there's anything I want you to take away from this book, I think it's that we're all just our three-year-old selves. No one isn't annoying, nobody isn't cringey at a certain age. No one doesn't go through different phases, including...puberty. I just want you to see me and see my life, with your own eyes.

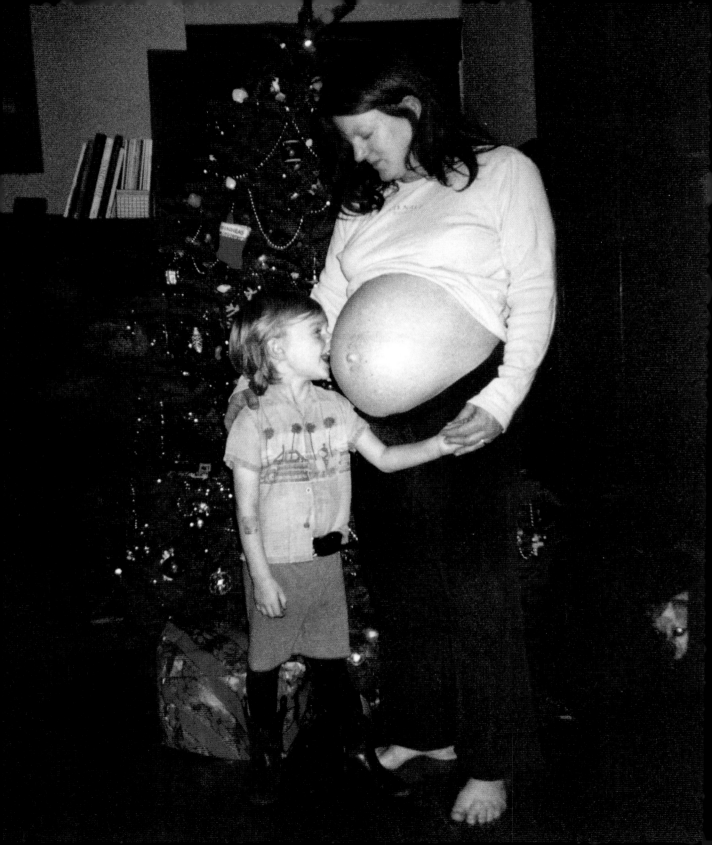

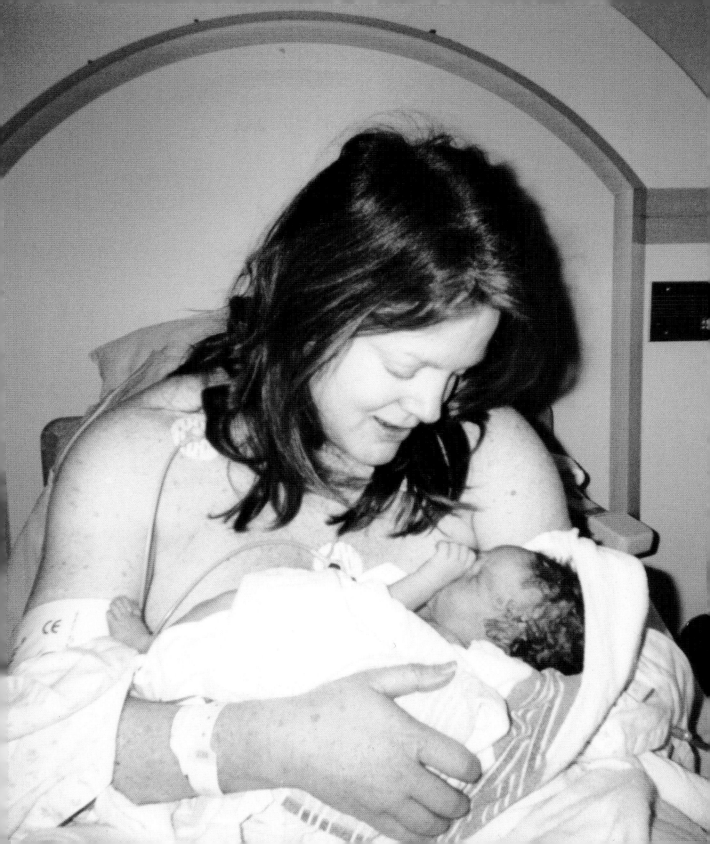

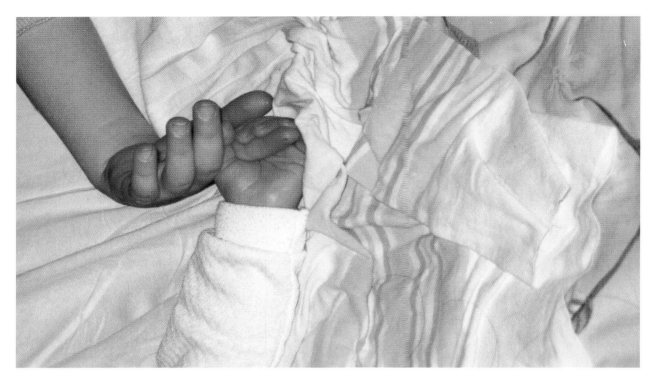

My big brother, Finneas. Been best friends from the beginning.

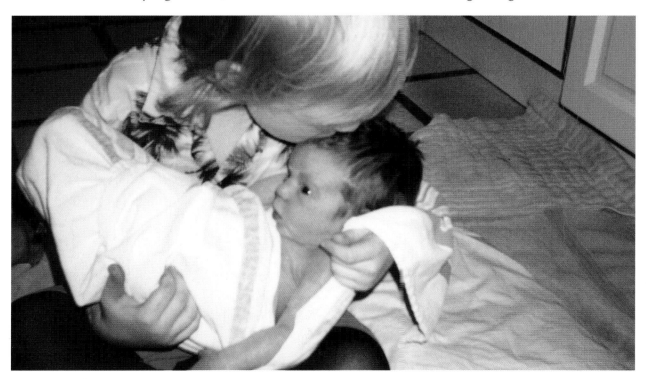

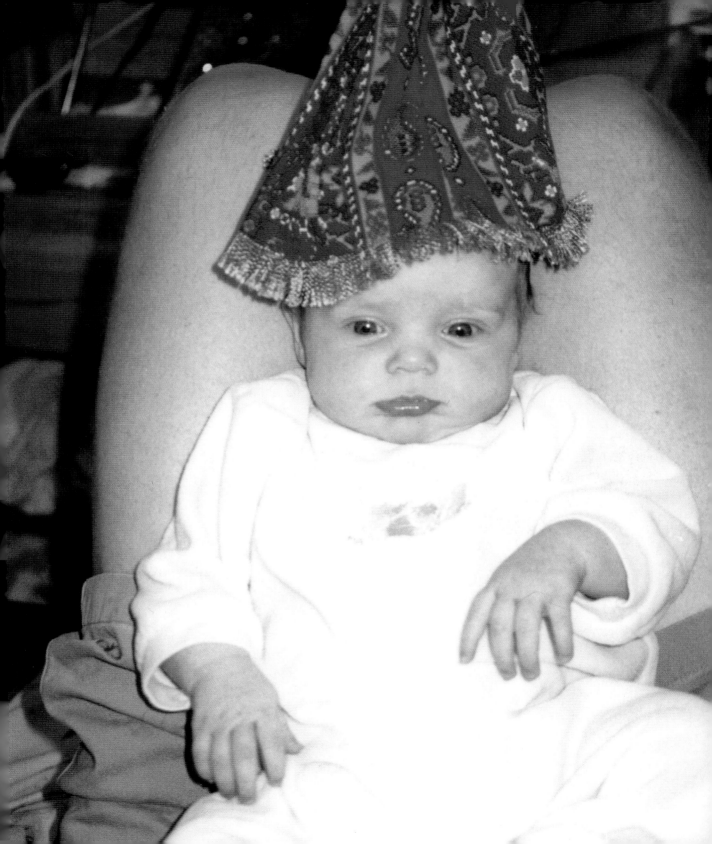

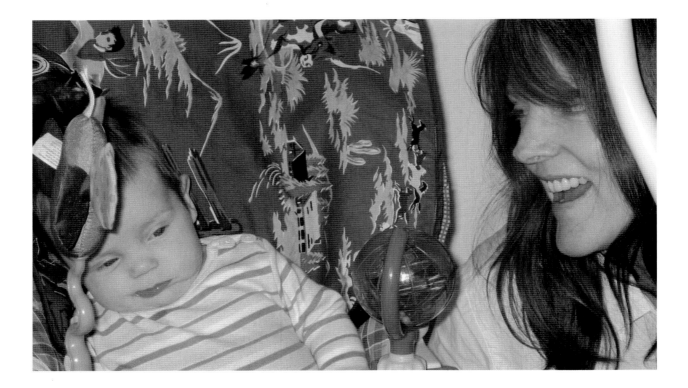

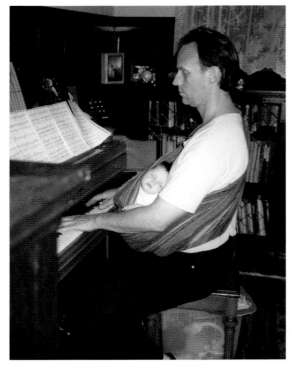

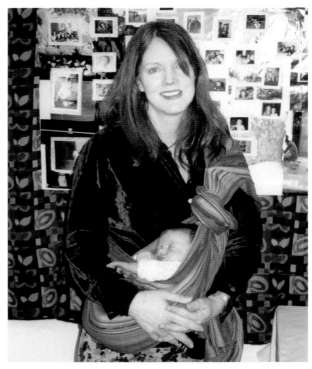

Always in this sling

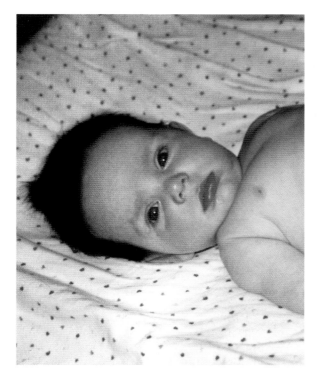

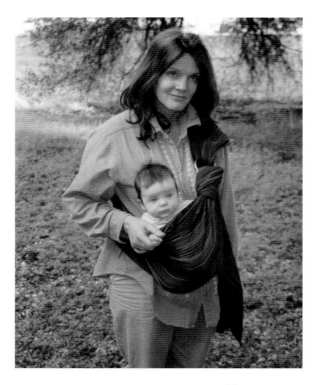

My mamaaa

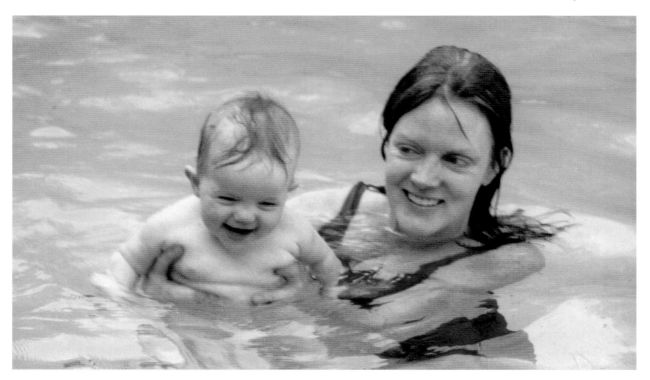

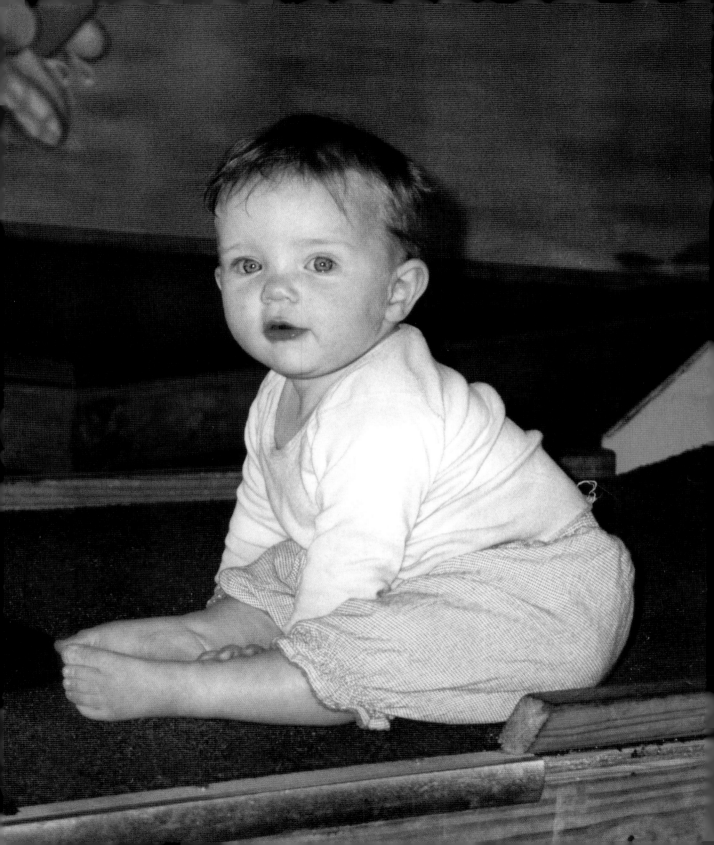

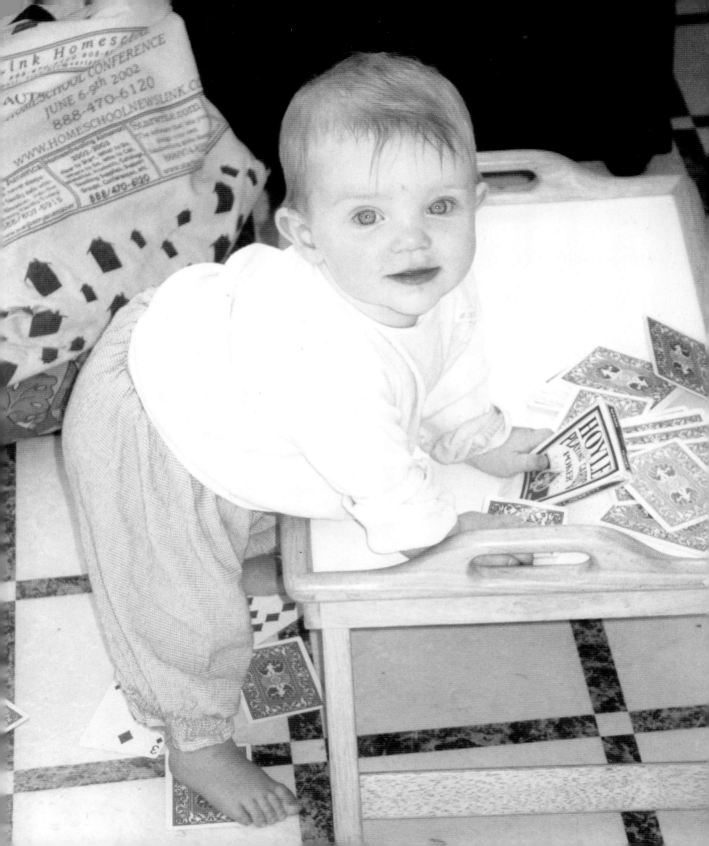

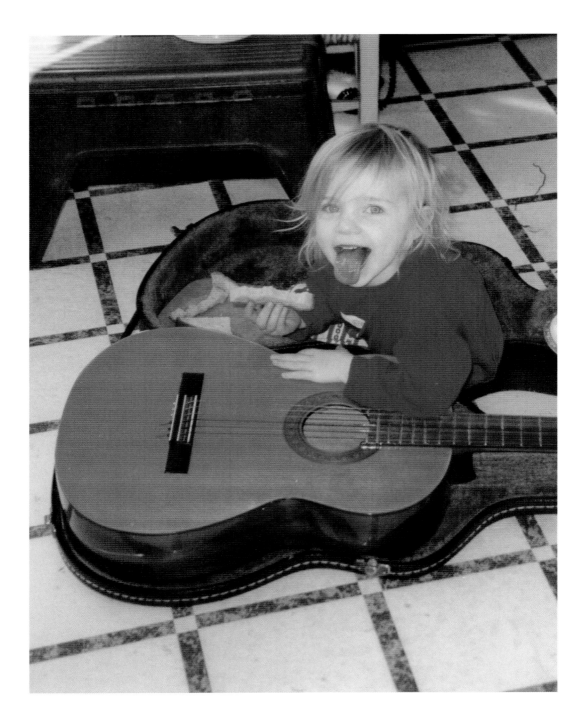

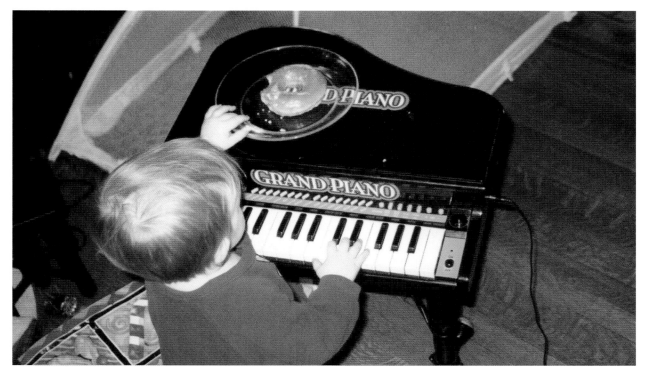

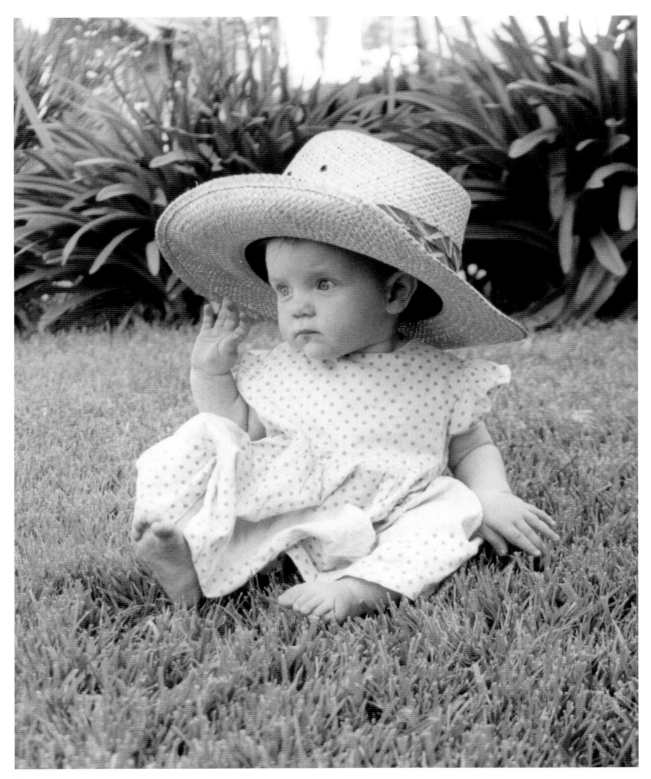

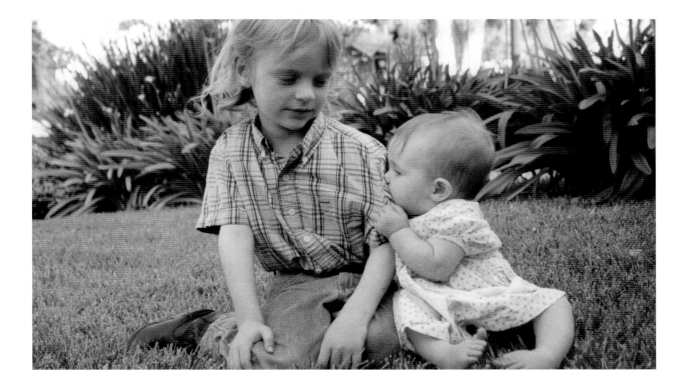

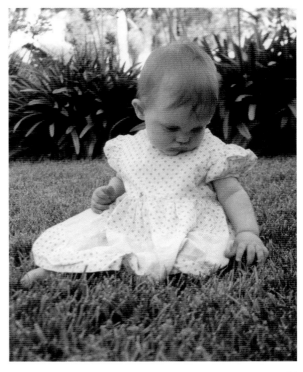

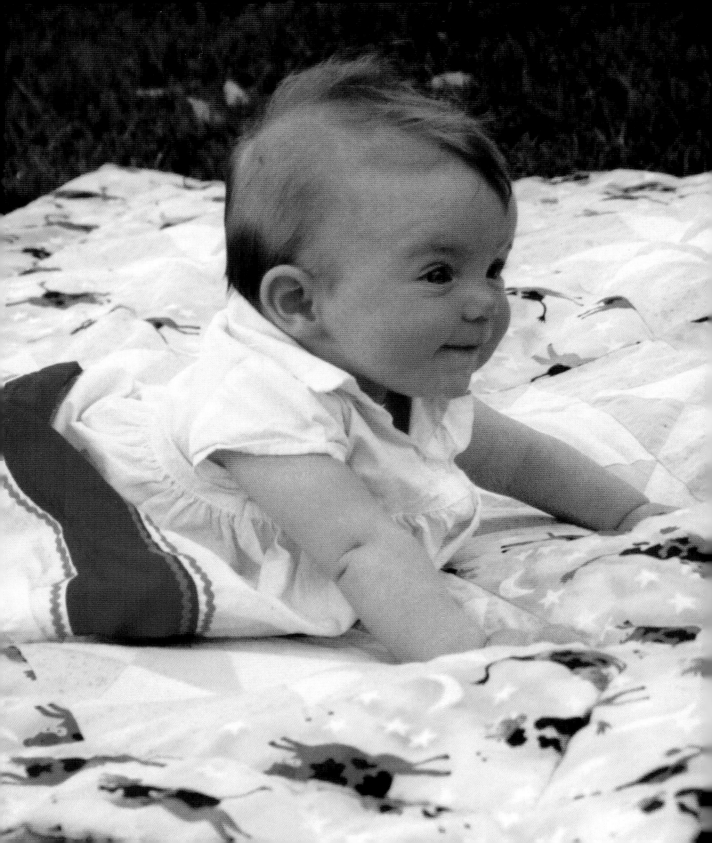

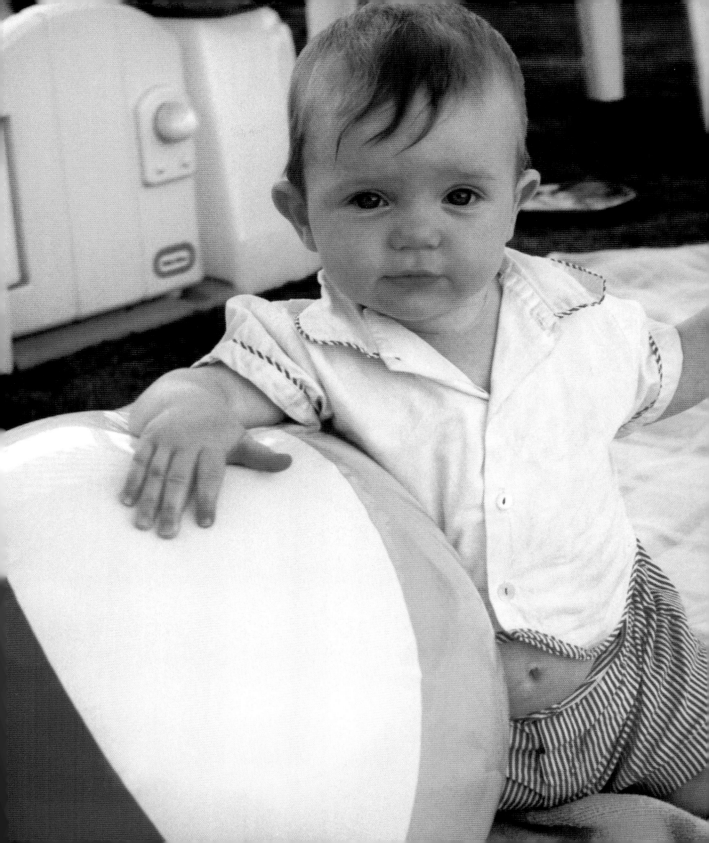

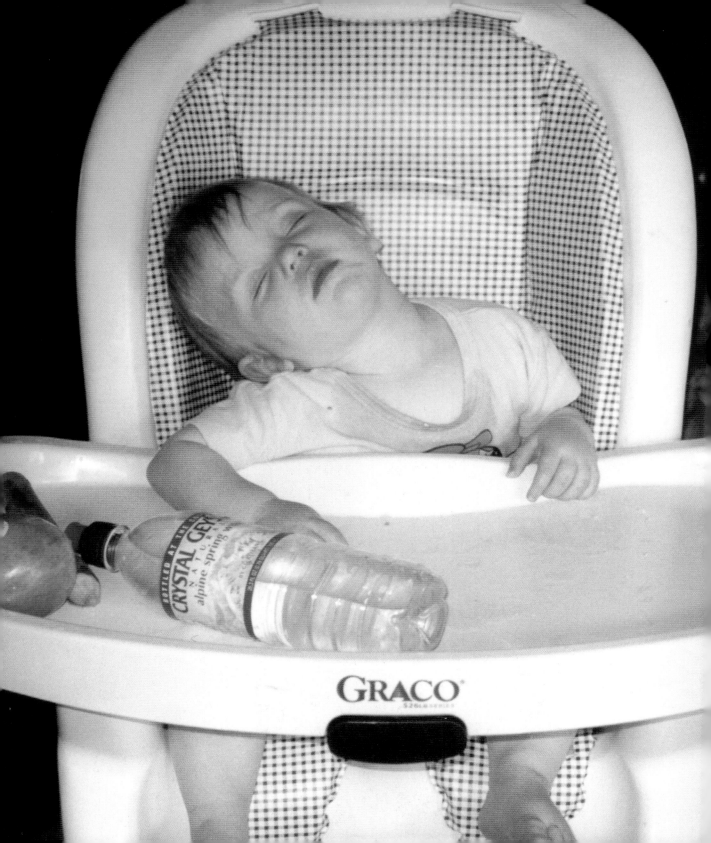

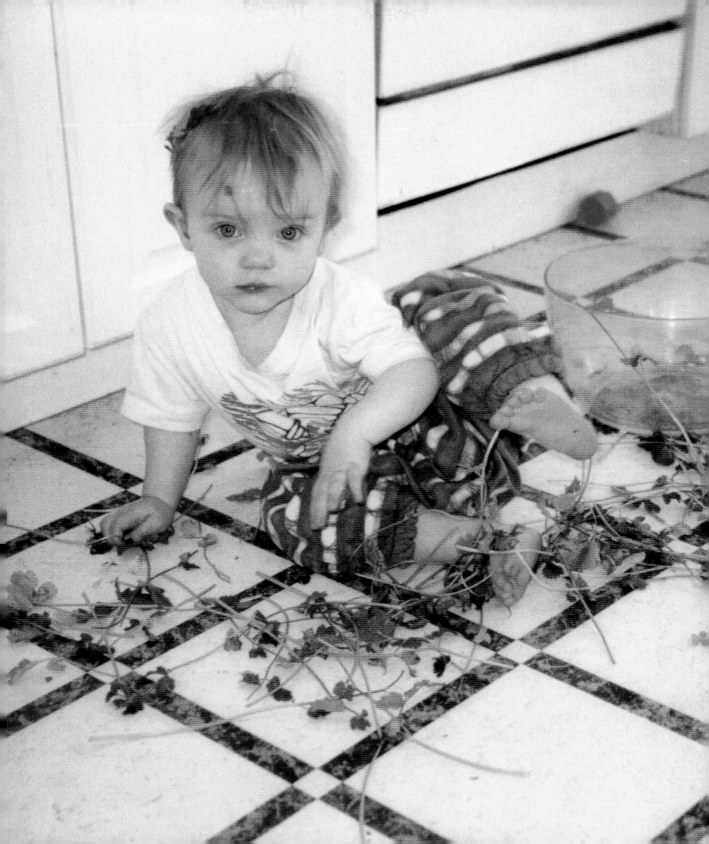

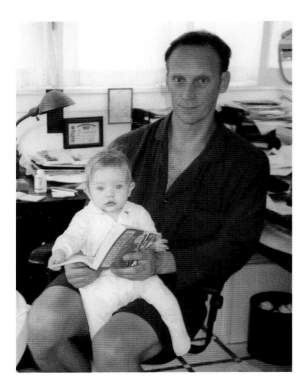

My sweet dad

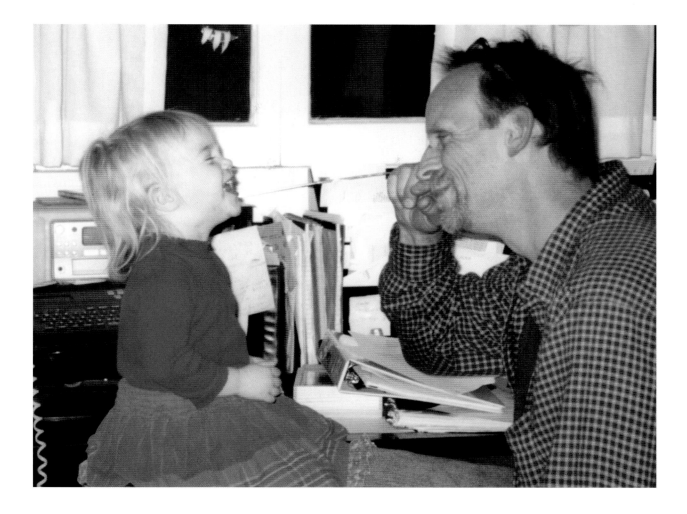

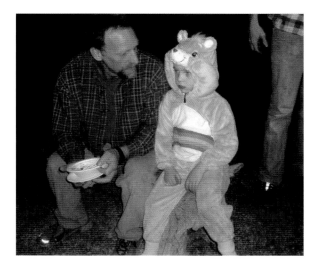

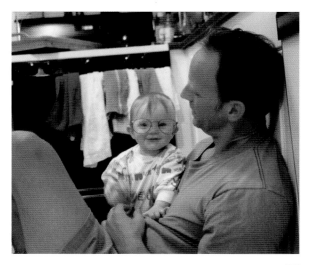

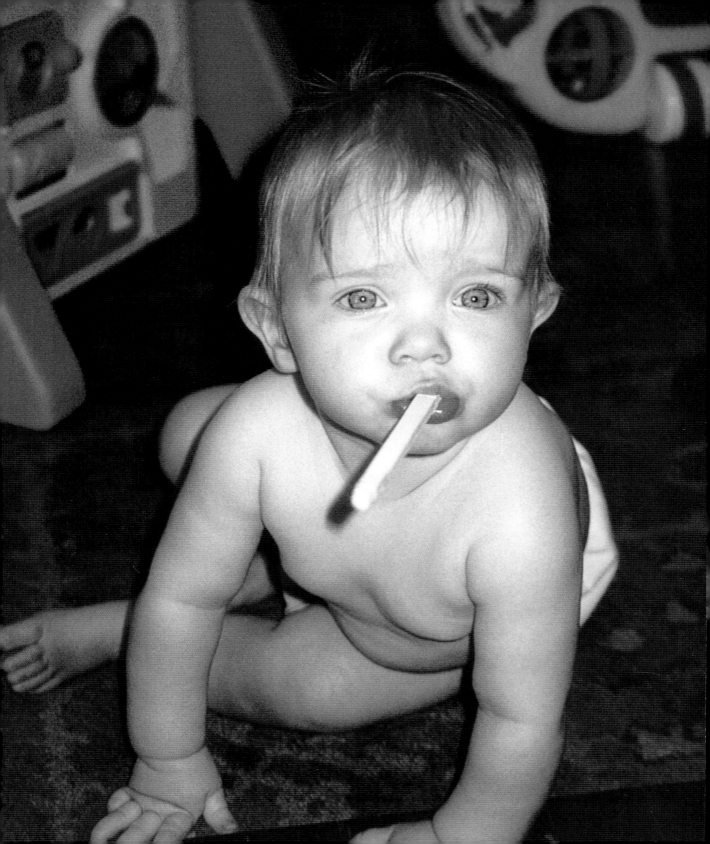

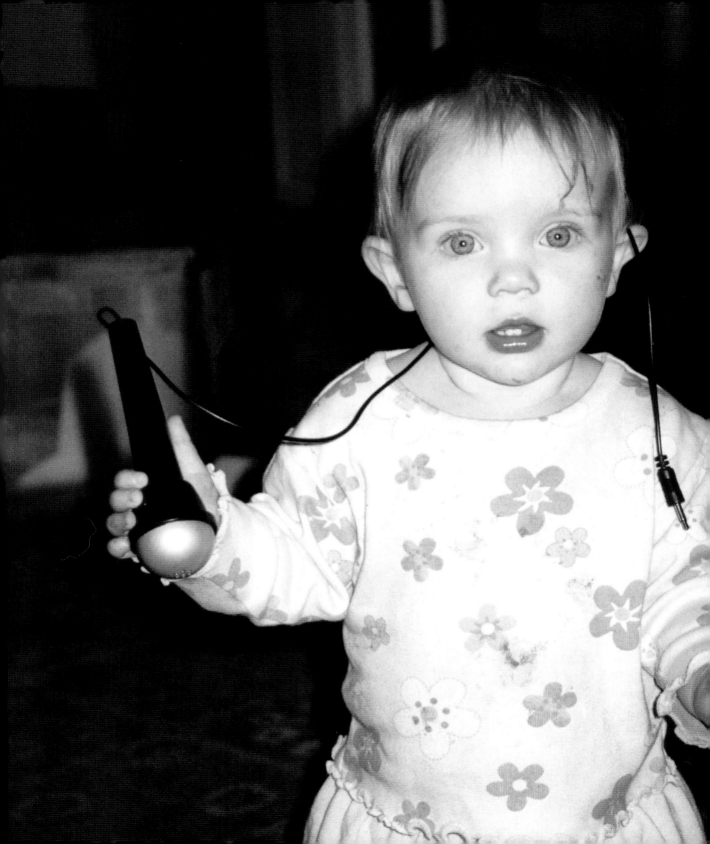

Same shit

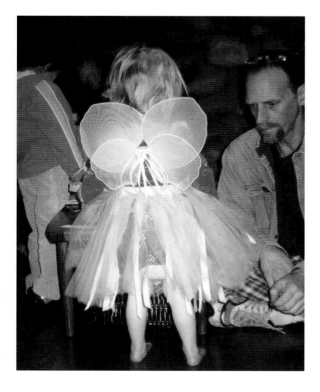

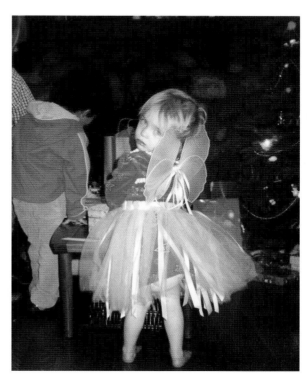

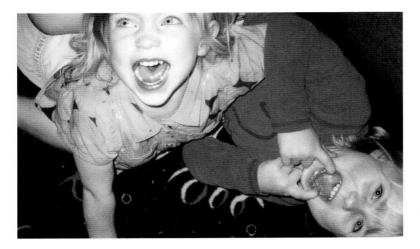

My lifelong friend Zoe (you'll see more of her later). We met when we were both two. I was playing in the sand with a friend and Zoe came and asked if she could play with us. We stepped aside to discuss whether we felt she could or not, lol. Then came back and said she could play with us—some real KID shit. I remember we were playing a game where we were pretending to eat pasta and Zoe didn't know what pasta was because she had only ever heard it called noodles. We then fought about whether it's called pasta or noodles. Hehe. She said later she called her grandma to tell her she learned a new word for noodles.

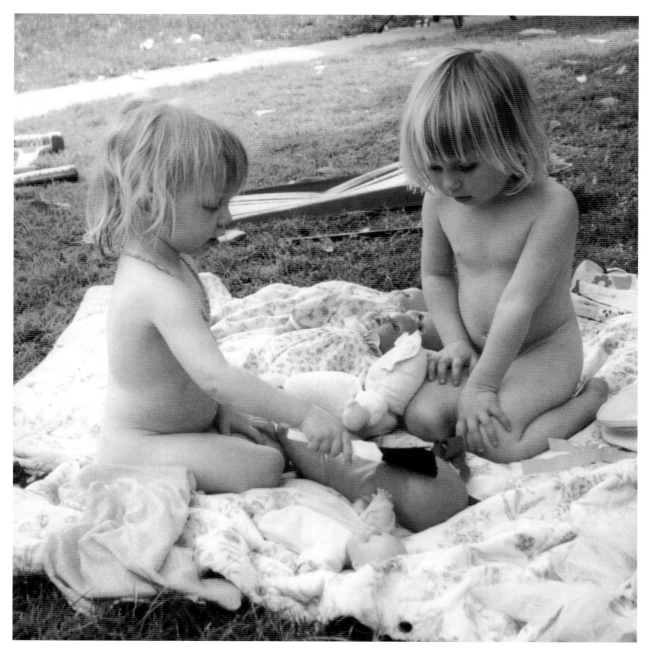

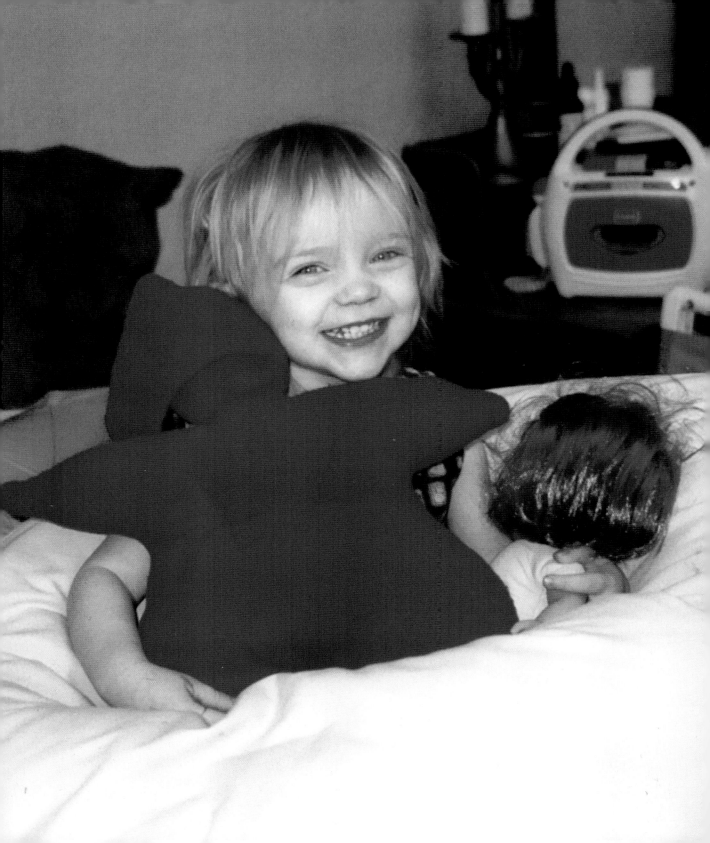

Always eating or pooping

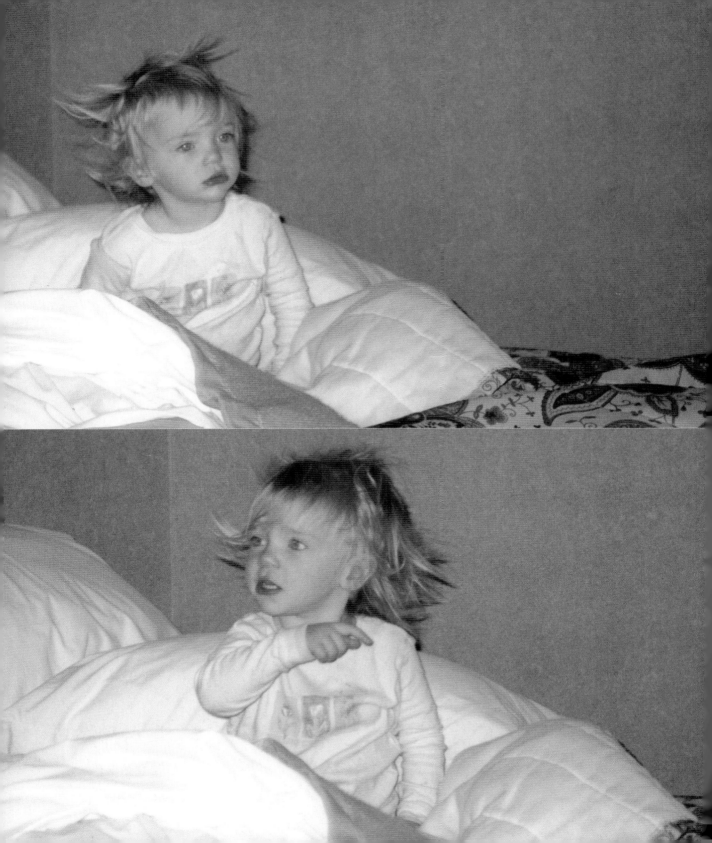

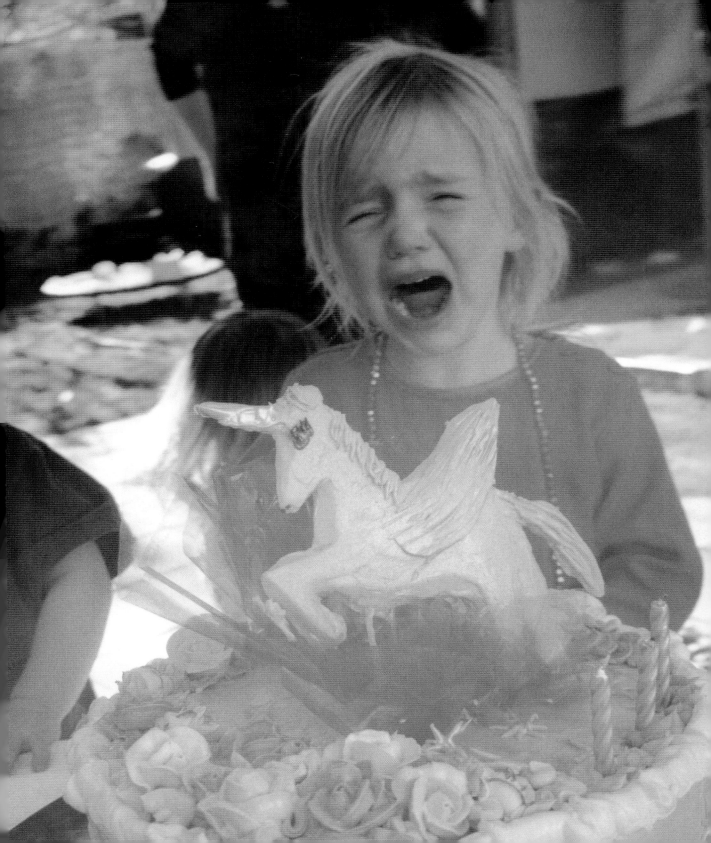

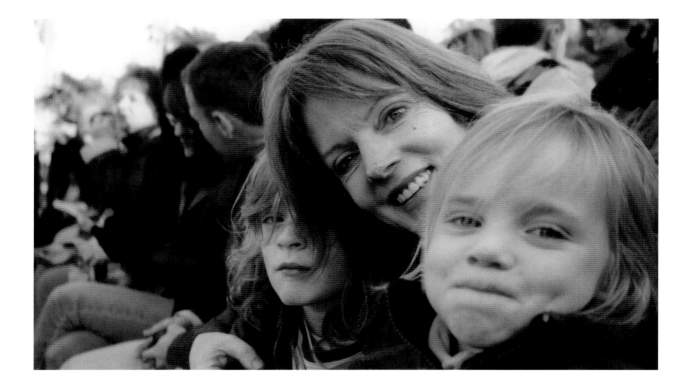

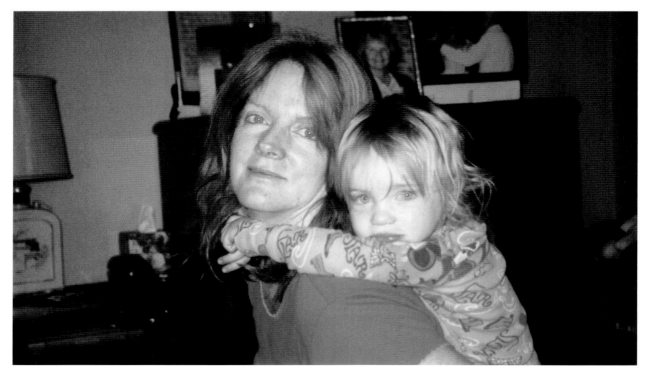

Never had any fear with animals. Maybe it's a blessing and a curse. Always way too bold. This was my first dog, Smidgen.

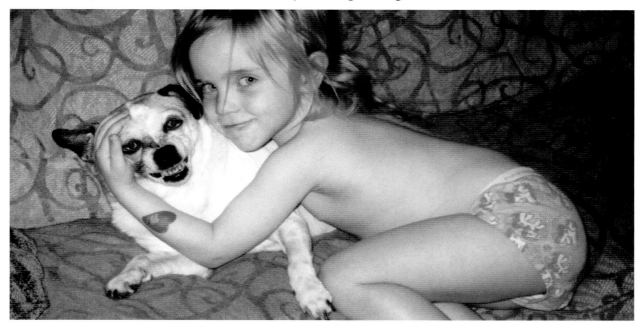

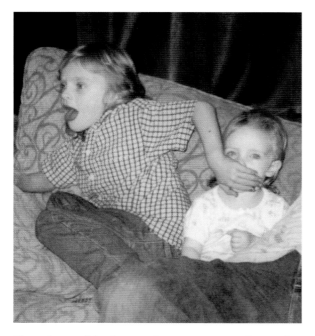

I've always felt the need to comment through every movie and Finneas had enough.

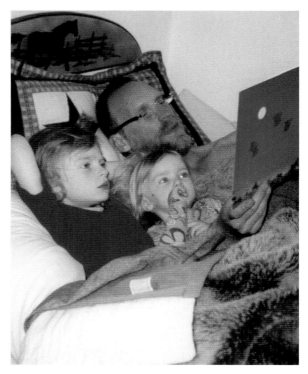

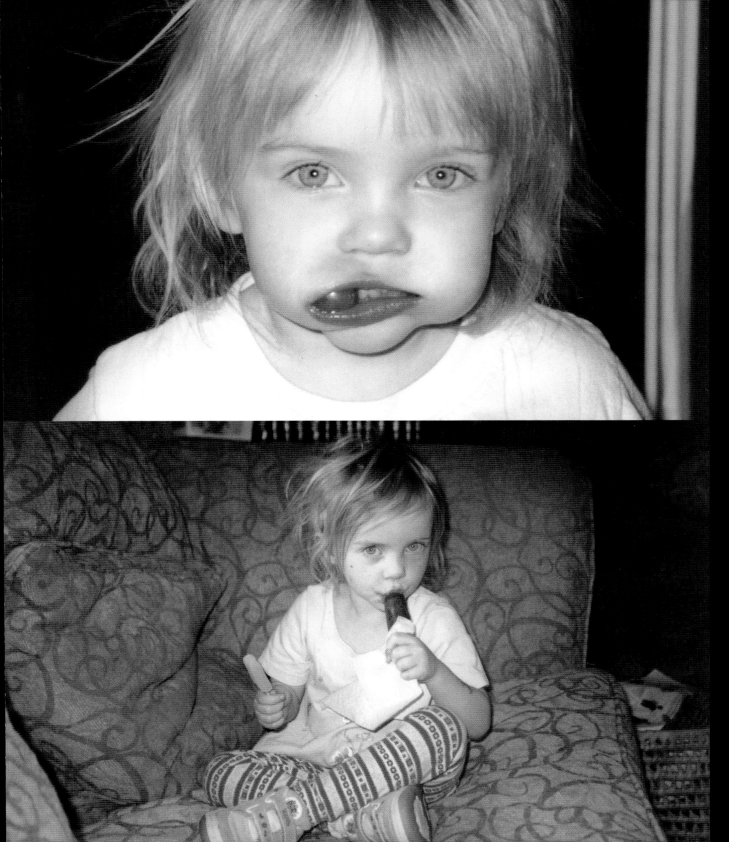

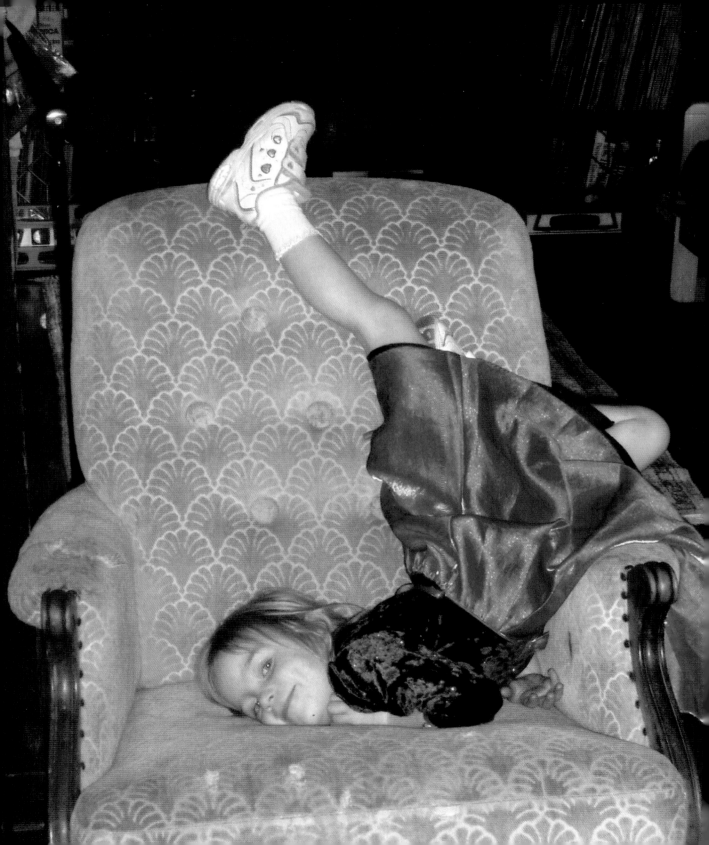

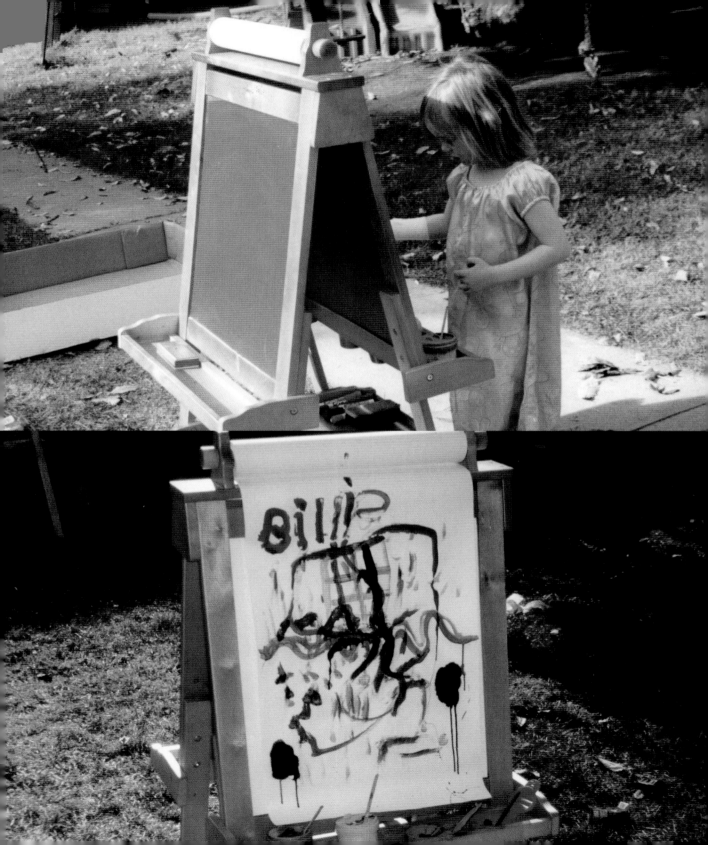

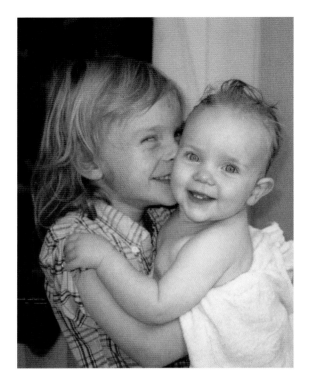

FINNEAS

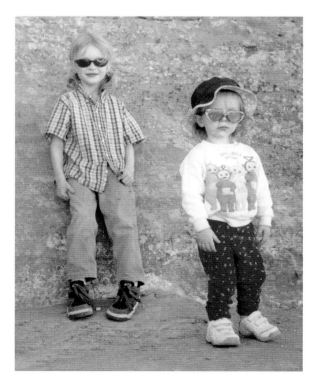

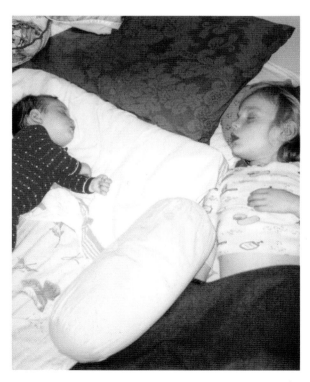

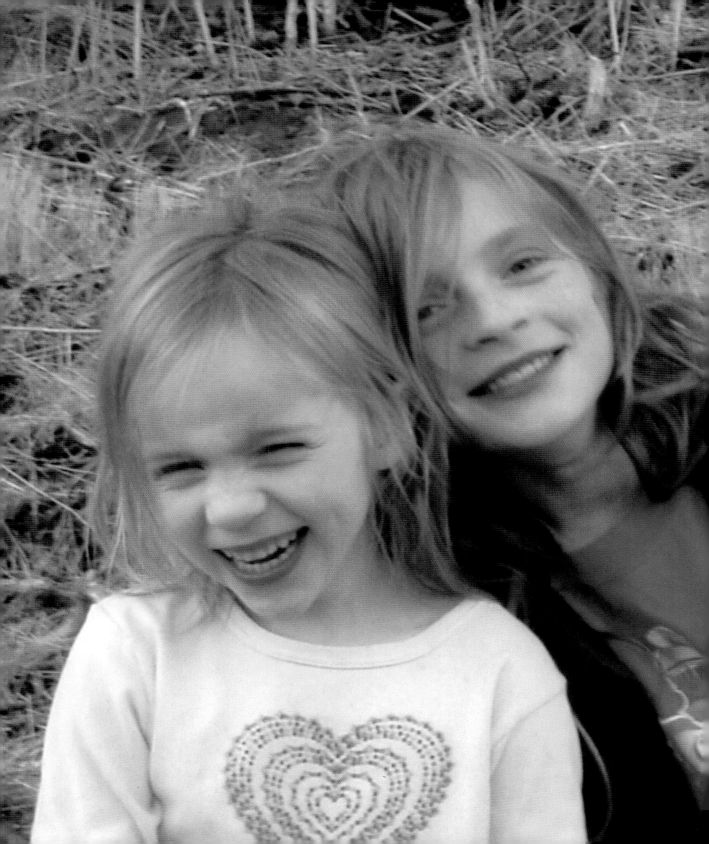

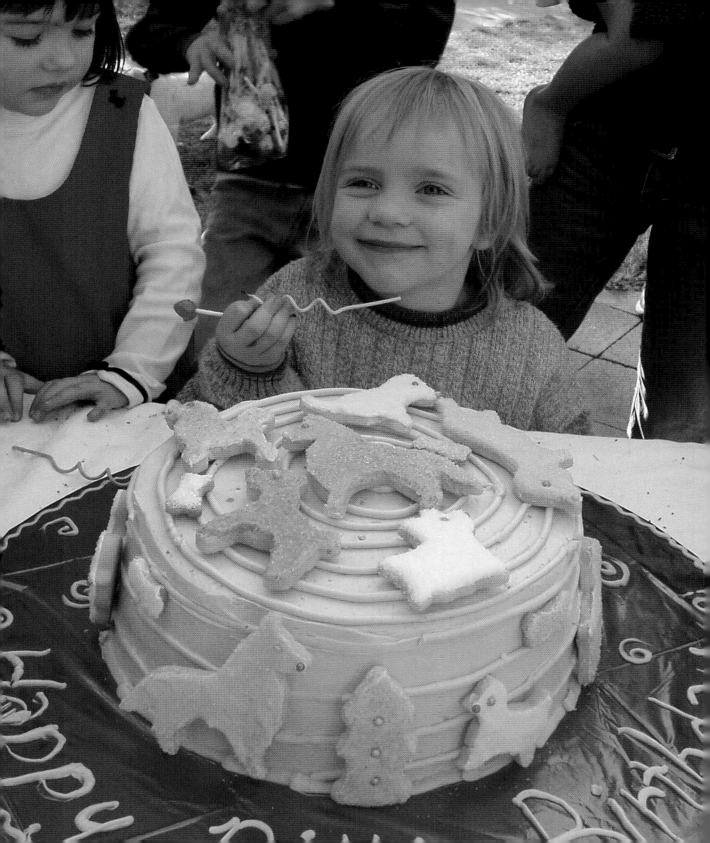

Always reaching for any mic

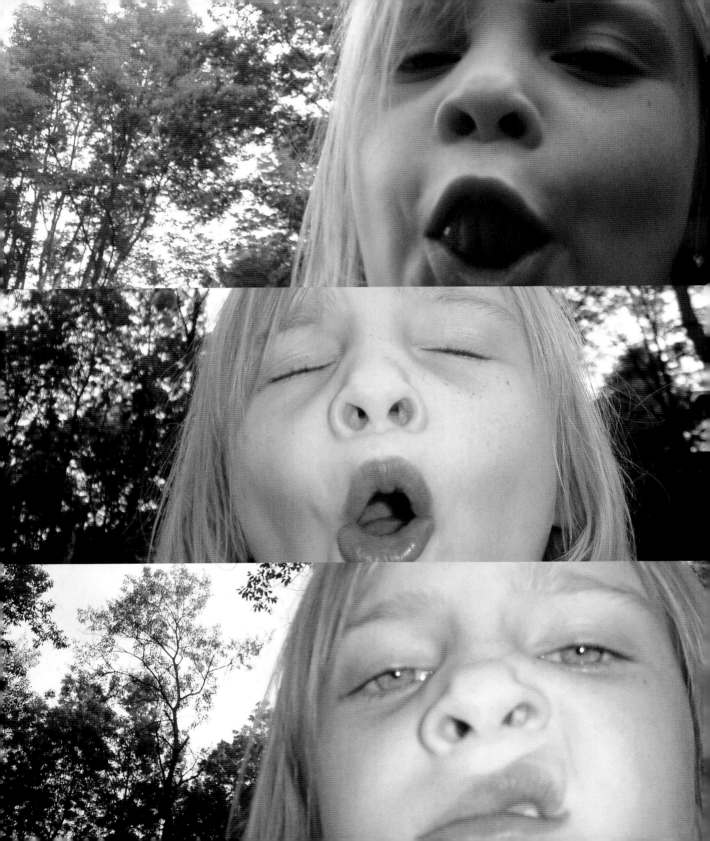

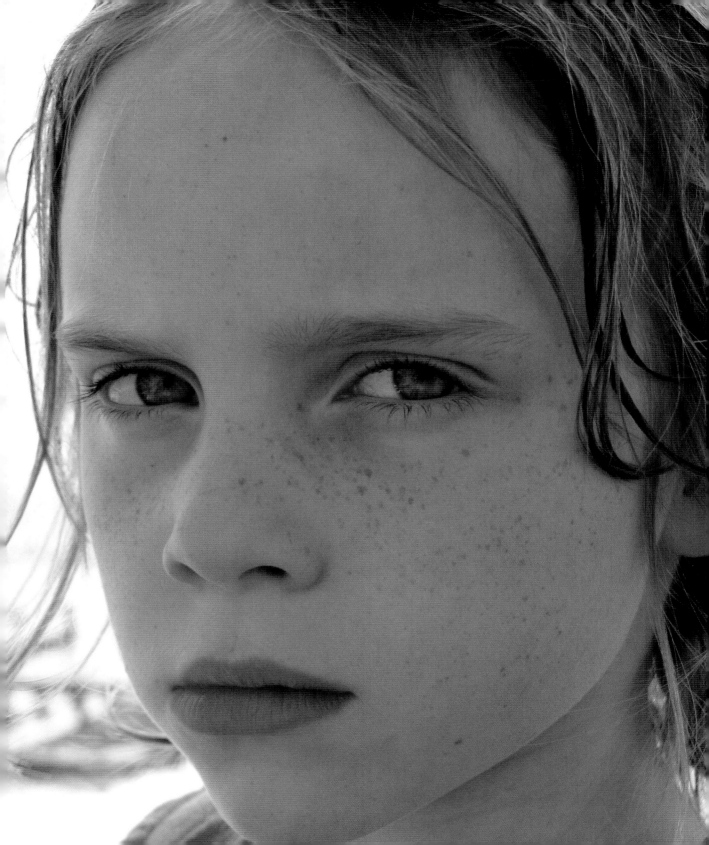

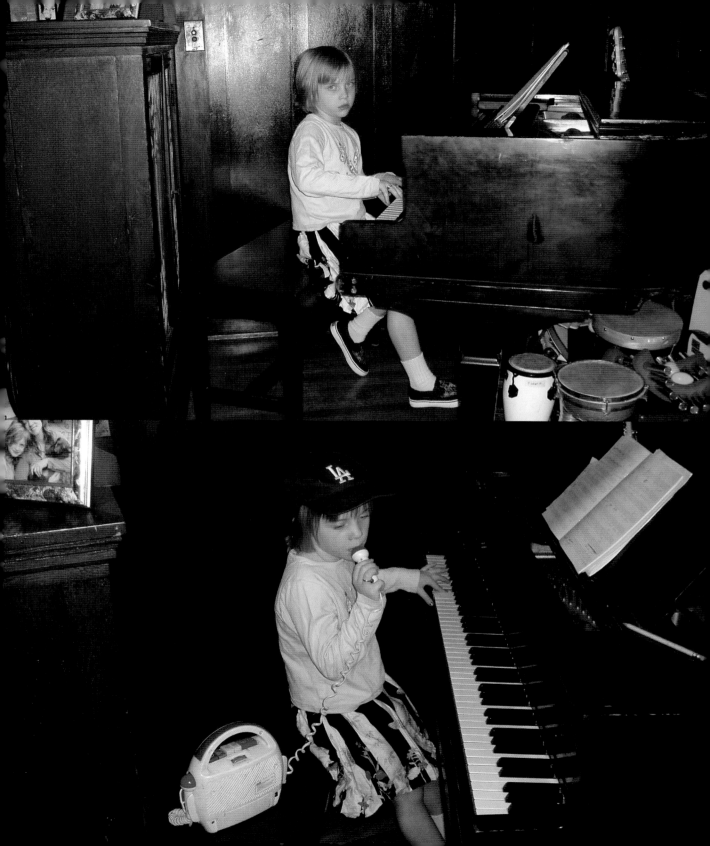

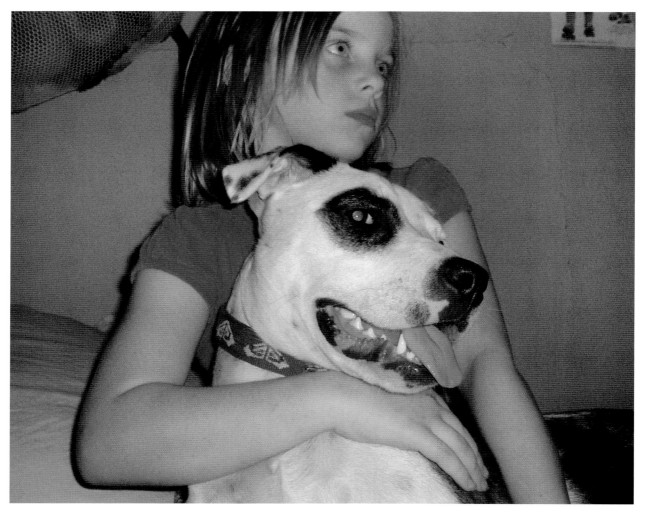

My childhood dog, Pepper. We adopted her when I was six.
She's still going strong, very old and chunky now, lol.

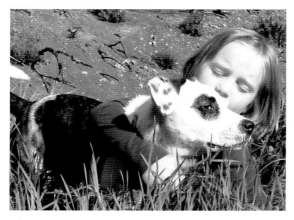

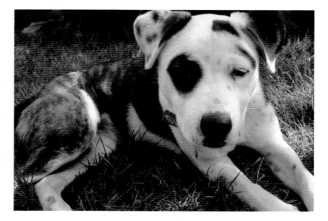

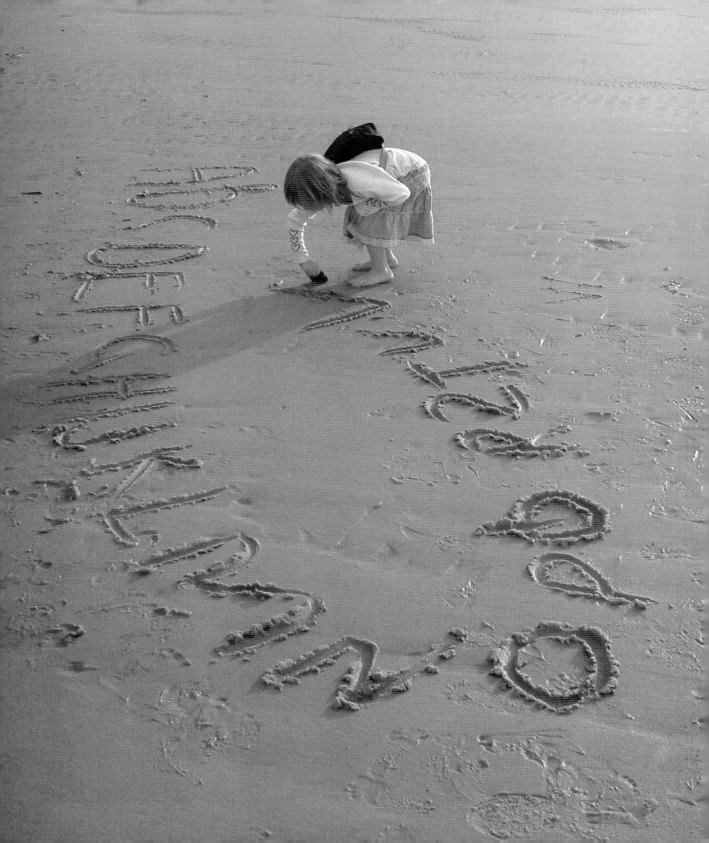

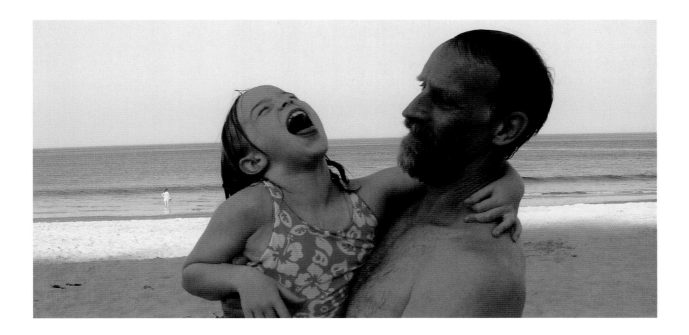

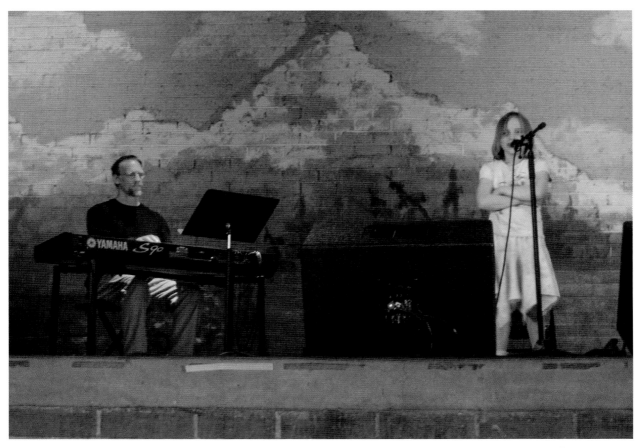

My first talent show. I was six years old, and I sang "Happiness Is a Warm Gun." 59

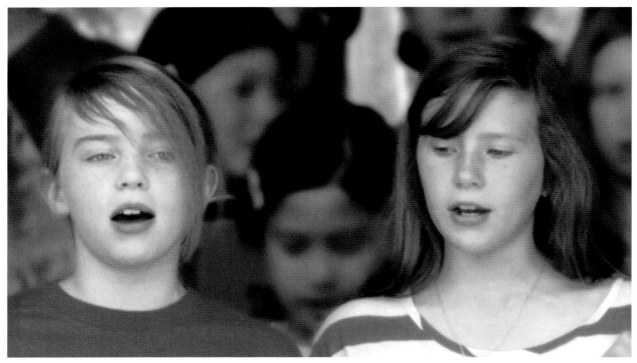

My best friend Drew. We met in choir, we were both nine.
This is us as babies with our matching side parts. You'll see more of her later as well.

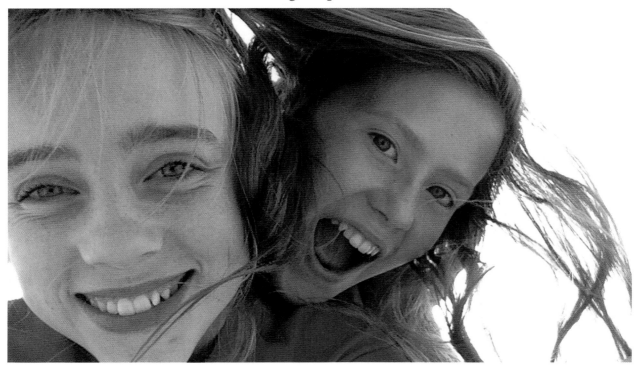

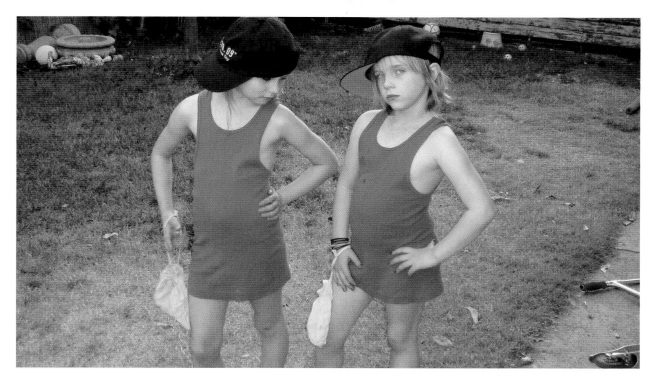

Zoe again! (Told you)

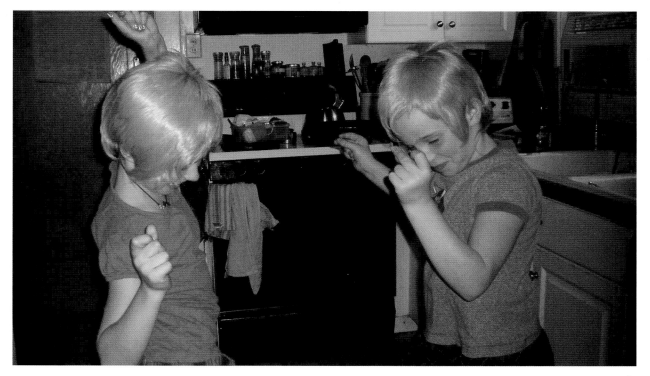

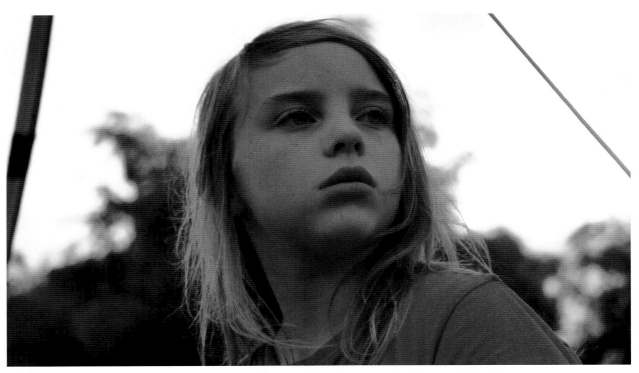

I remember thinking I was so old and mature in this period of time;
crazy to look back and see literally a CHILD.

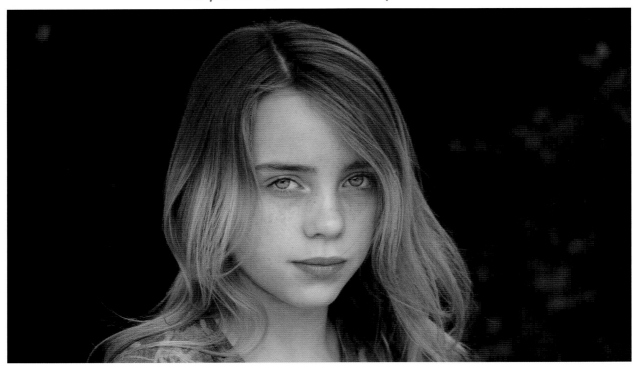

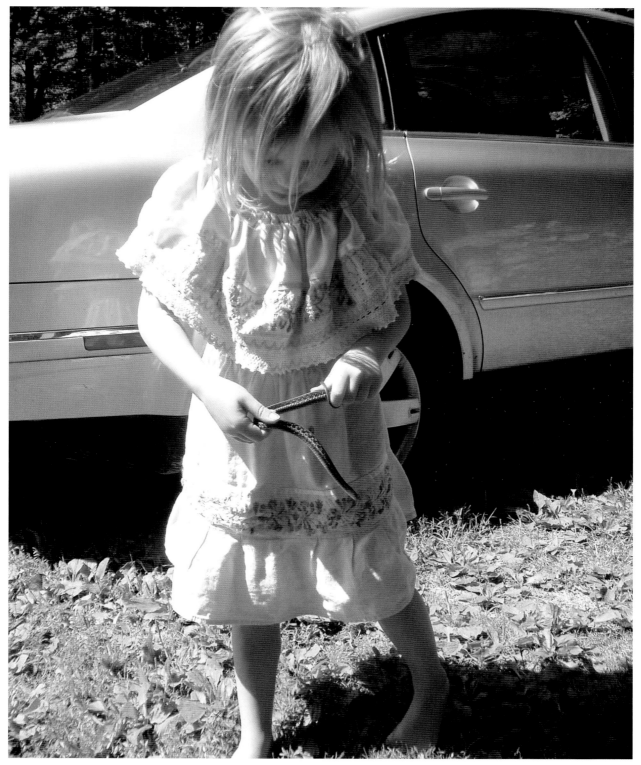

Saw a snake, picked it up. Once again, no fear. Dumb girl.

My pretty mommy

Cute little Finneas face

SO! Here are two edits I made of me and Justin Bieber that I was very proud of. Hehe.

Me and my guardian Bieber posters

My 12th birthday, waiting in an enormous group of fans just to watch Justin drive by

Only putting this picture here because... look at my iPod case

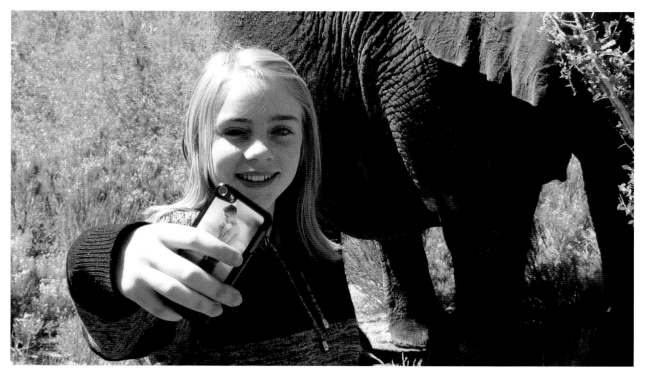

BIG MOMENT! I don't know why, but for some reason this really switched something in me. I felt like myself for the first time.

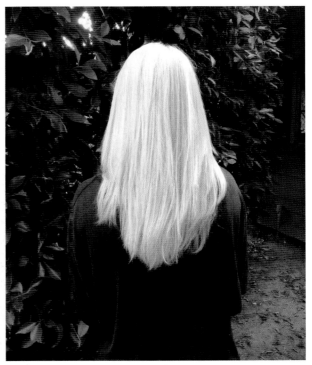

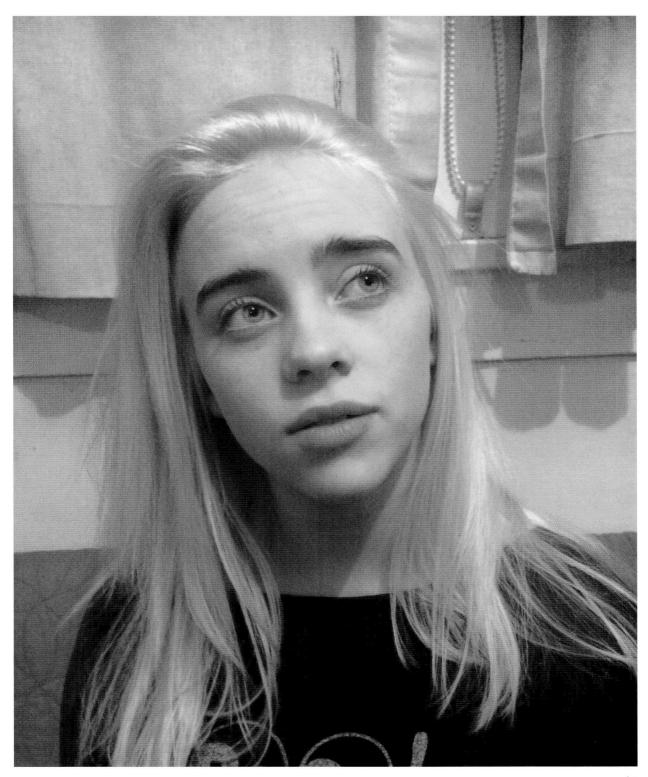

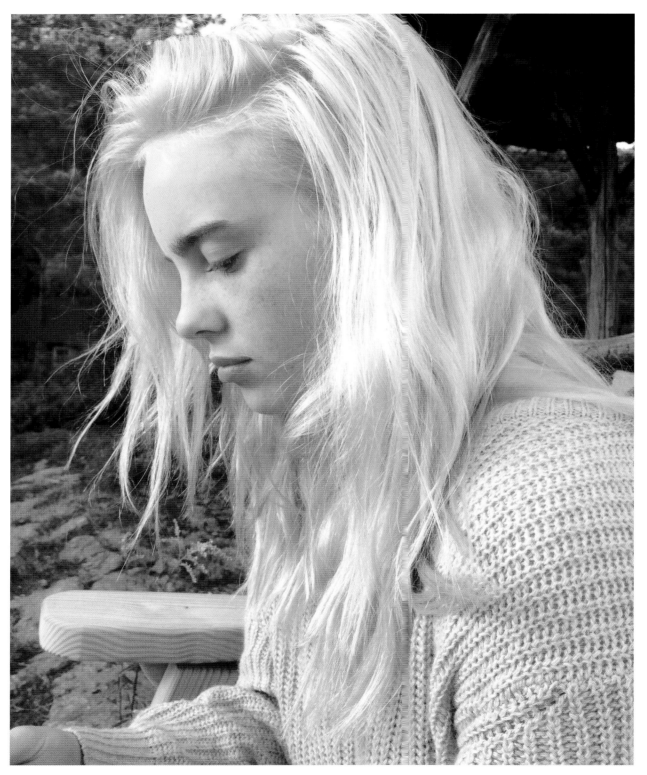

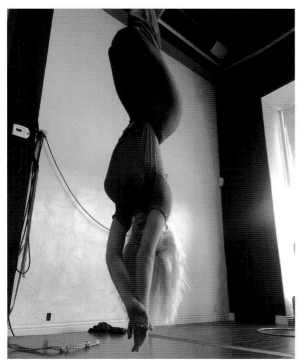
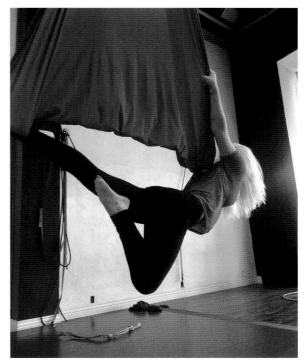

Started aerial arts when I was three. Stopped about five years ago.
My mama is incredible at it still, not meeeeee.

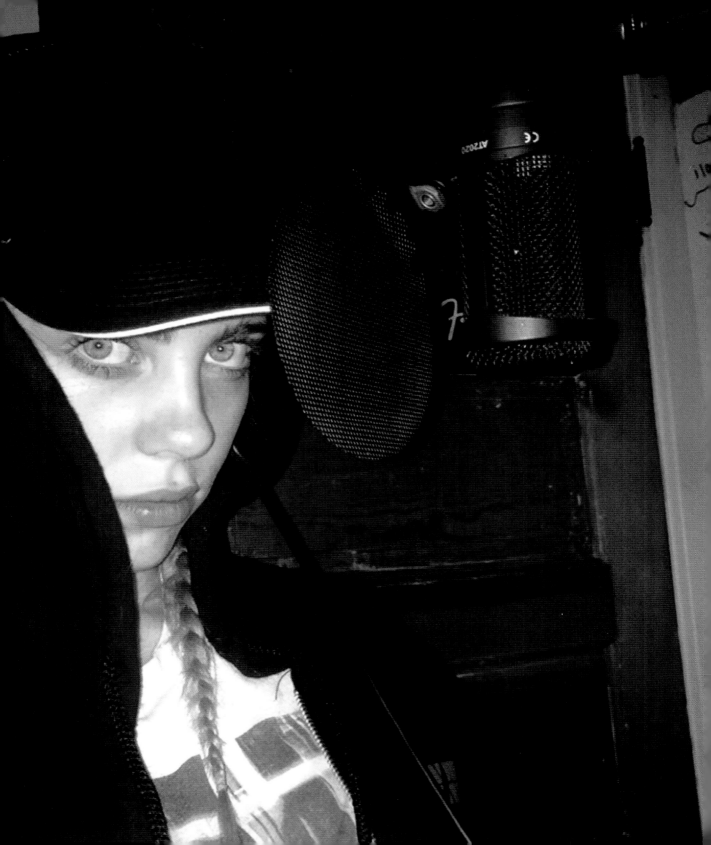

Recording "ocean eyes"!!! I was just about to turn fourteen.

When my whole dance company made me sing in front of them. I was terrible.

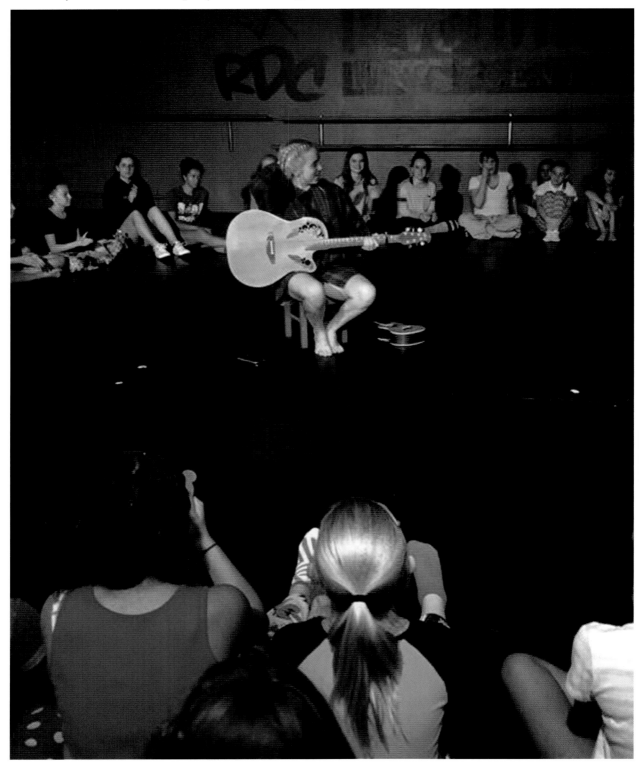

Picture of me in choir. Can you spot the only person not in uniform?
Aka an enormous yellow sweatshirt. Ridiculous.

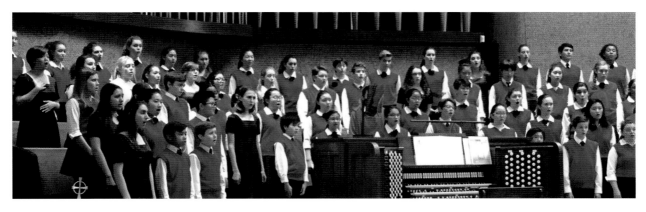

Me bored as hell.

Me when I was flexible.

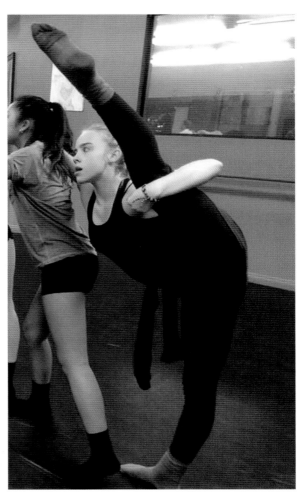

Best brother in the world.
When we first started touring. I was 14, Finneas was 18. At this point it was just the two of us,
our mom, and sometimes our manager.

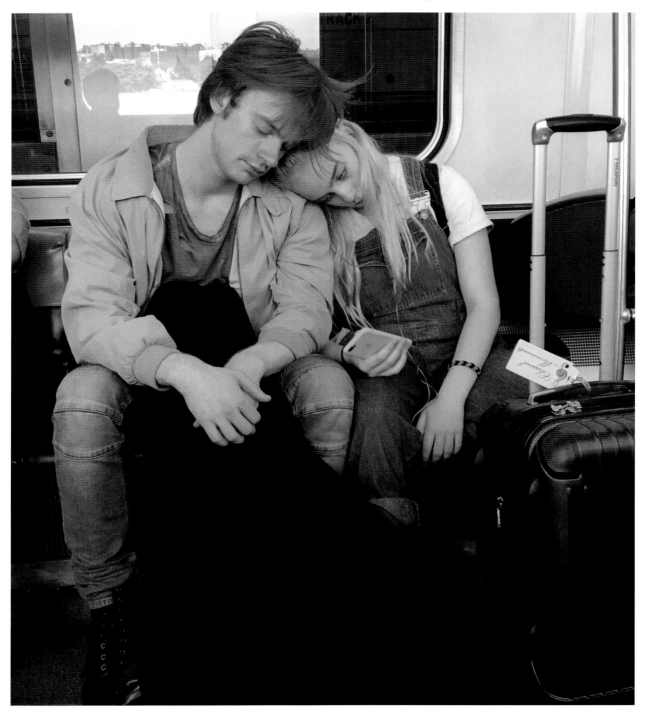

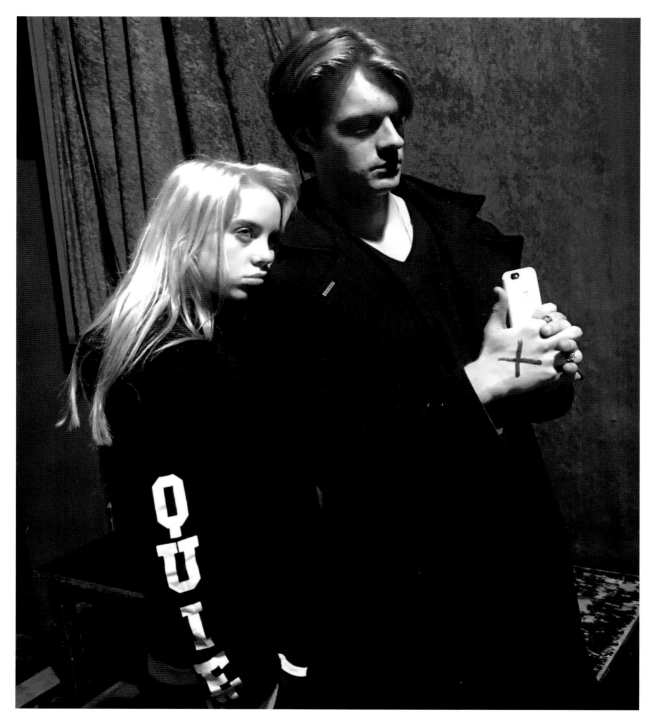

Only playing in tiny venues that were 21 and up.
We couldn't even be inside until the show.
See the X's on our hands? Torture.

Flip to 279 for a lil side by side moment. Then come right back

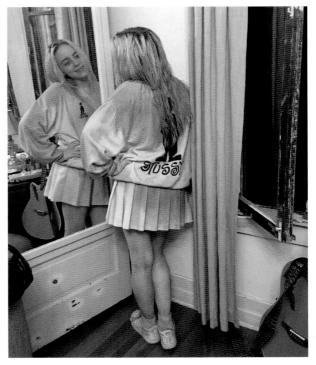

Me after going to my first music festival, the day I realized the happiest I'd ever be is in a mosh pit. At the start of the day this outfit was fully white and not...wet

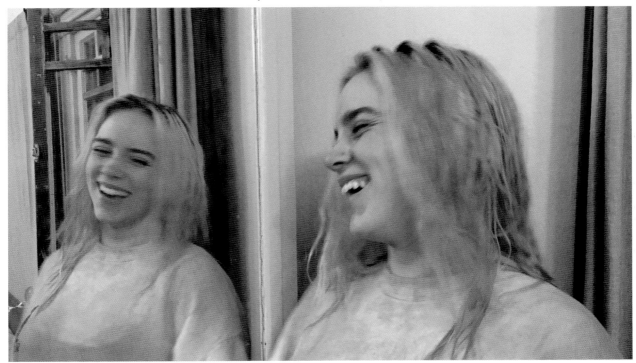

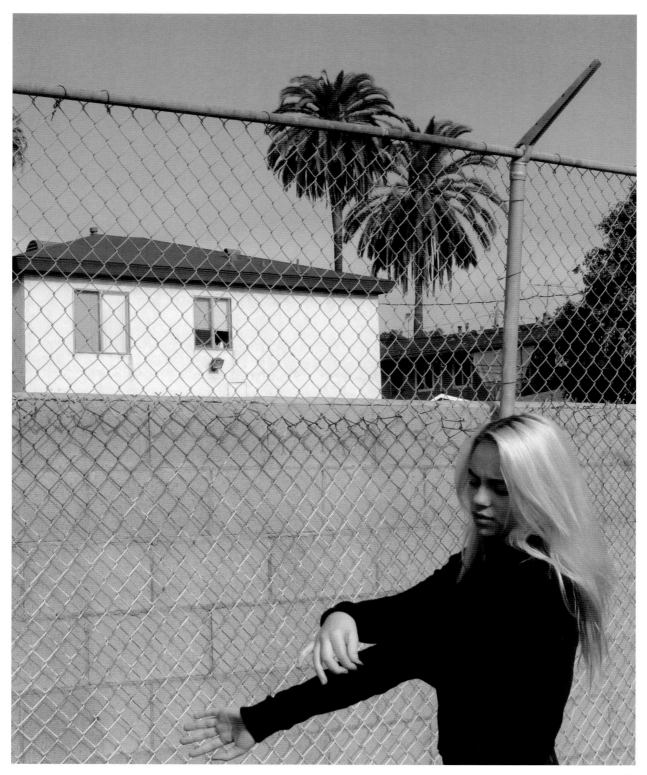

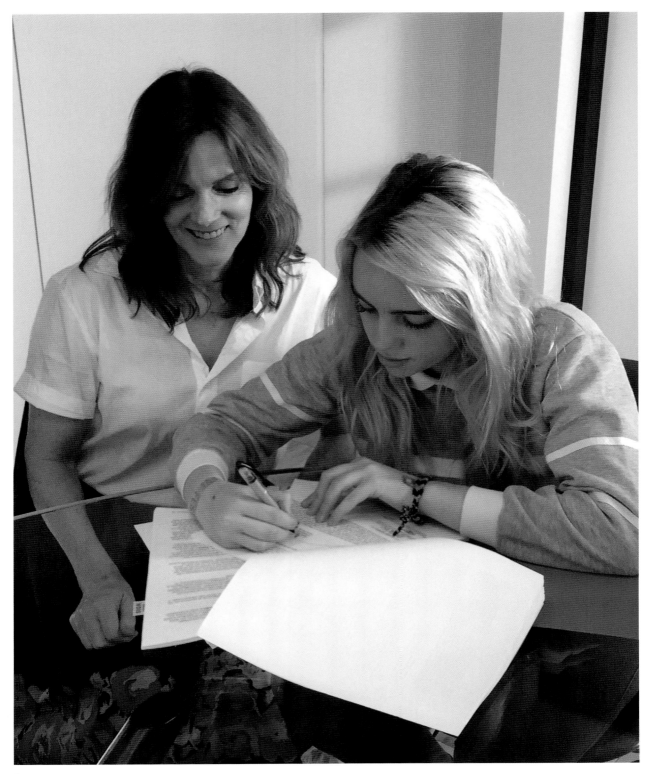

Signing my record deal! This was after a year of a million boring meetings with adults who had no idea how to talk to a fourteen-year-old.

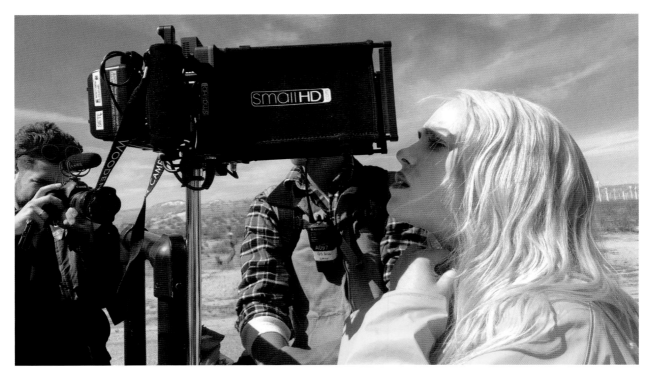

Shooting the music video for my song "bellyache" when I was 15

Playing my first-ever music festival, CRSSD in San Diego.
Like ten people showed up, which was my biggest crowd yet at the time.

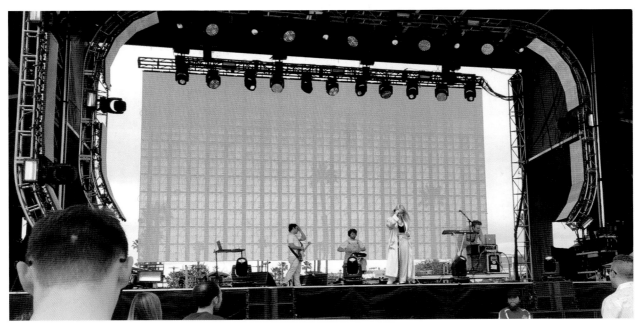

Making my first project, *dont smile at me*.
To this day, this was the last time we worked in a studio.

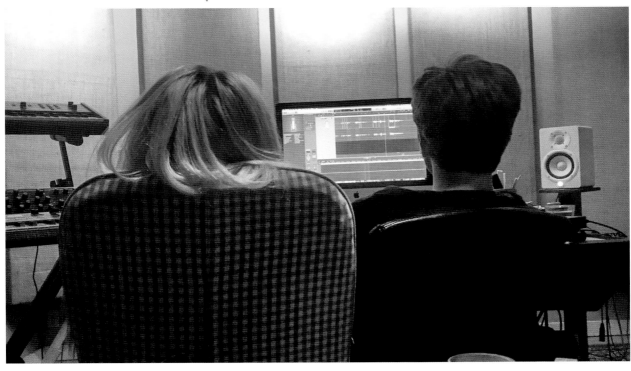

"bored" shoot!

Filming the music video for "idontwannabeyouanymore." This shoot did not go as planned. This was before I started directing my own stuff, hard to convince a bunch of experienced adults to listen to a 15 year old's ideas... lol. You can see it in my face. Still a cute video though.

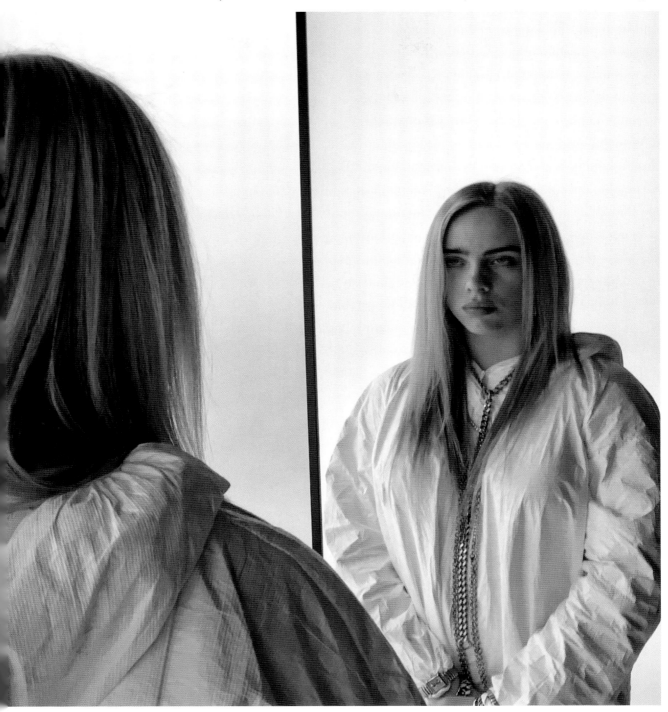

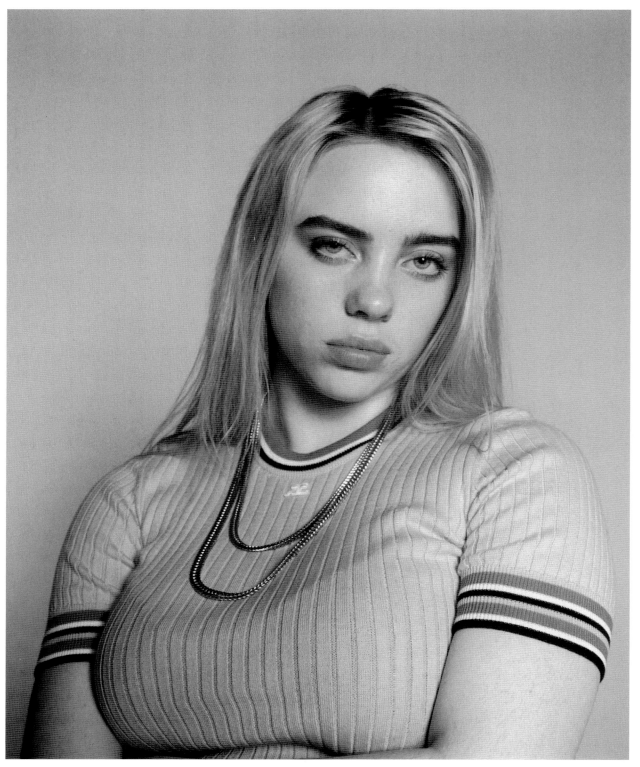

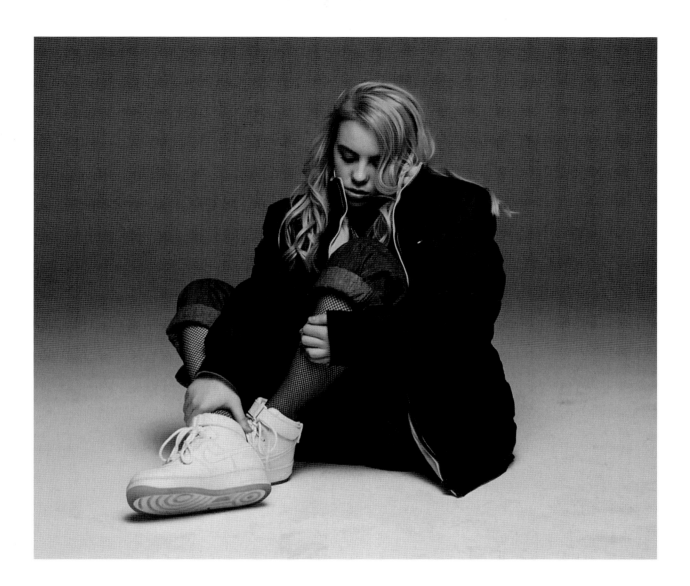

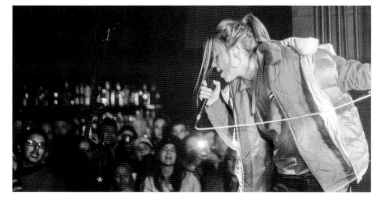

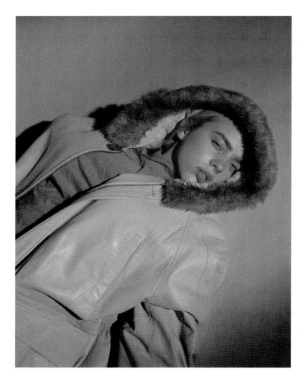

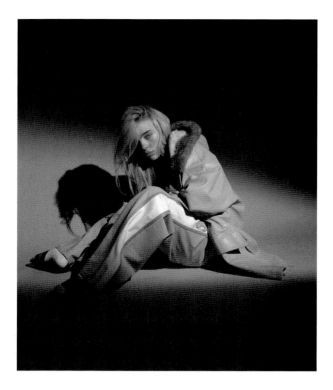

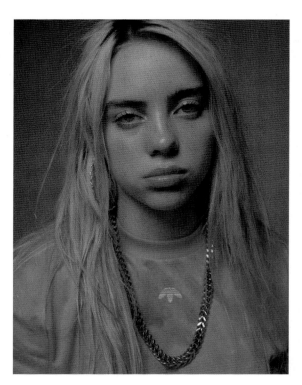

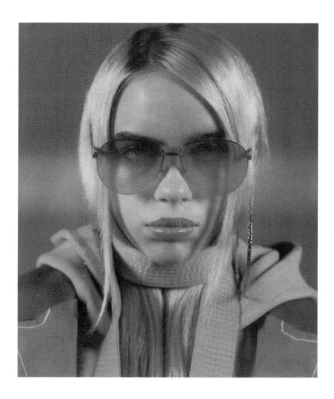

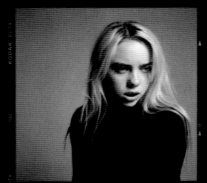
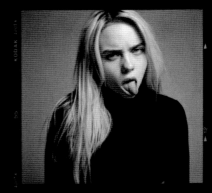

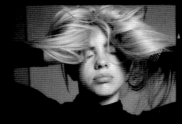

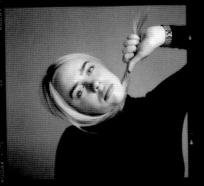
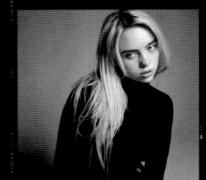
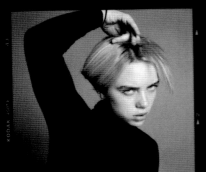
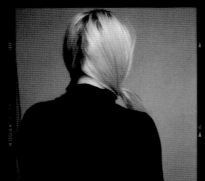
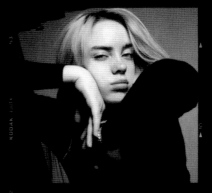
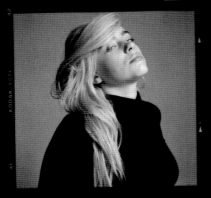
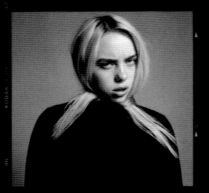
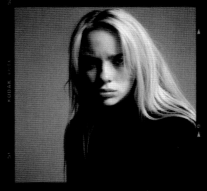

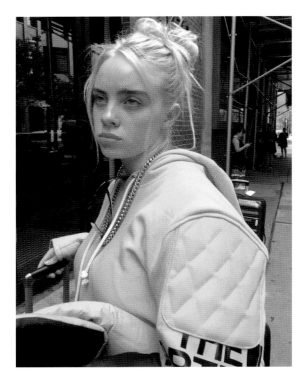

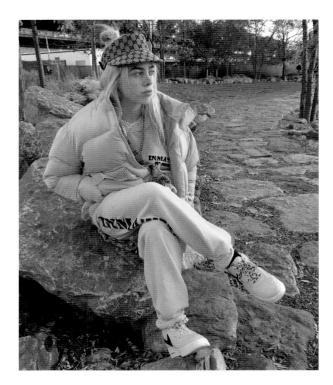

Yellow phase

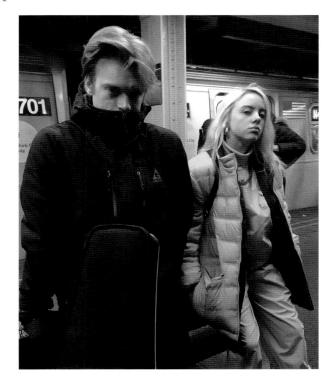

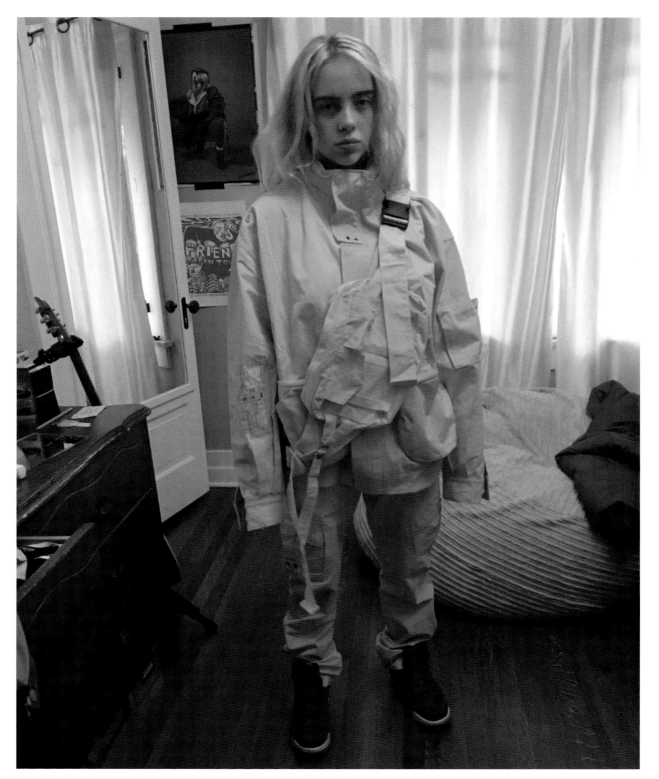

First time in Europe

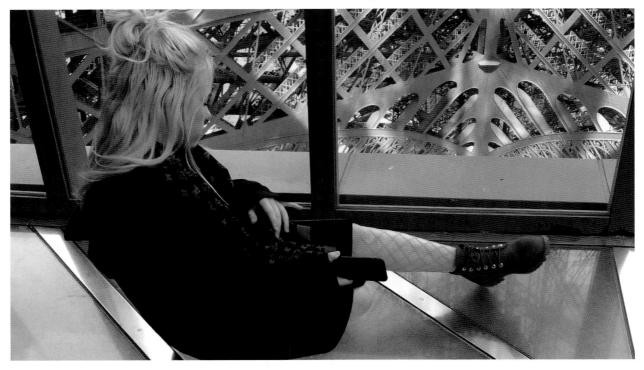

Angry at the airport

When I made all my own clothes

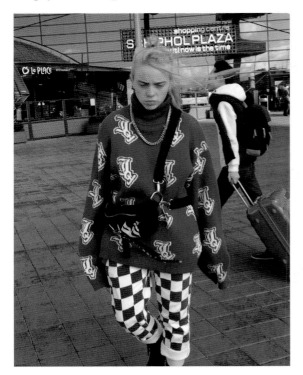

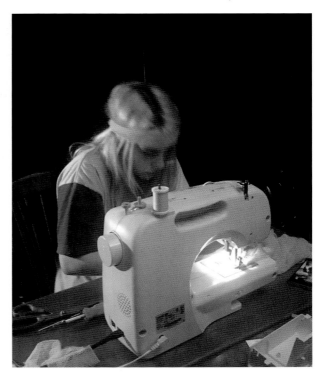

First fan to ever wait outside a venue. She was precious.

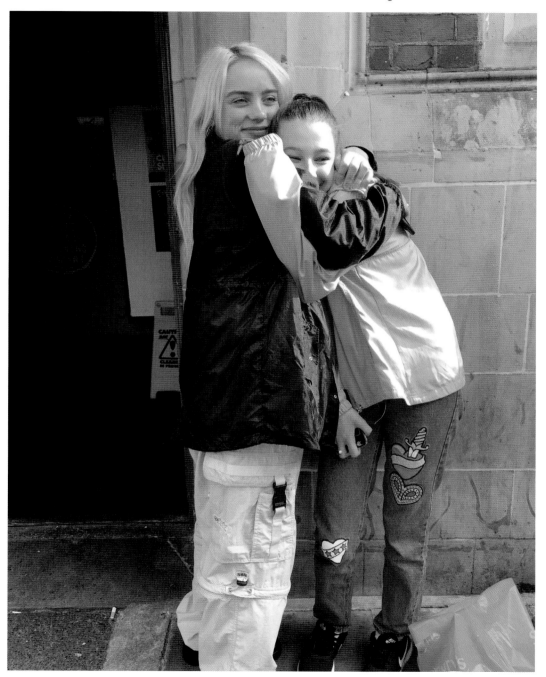

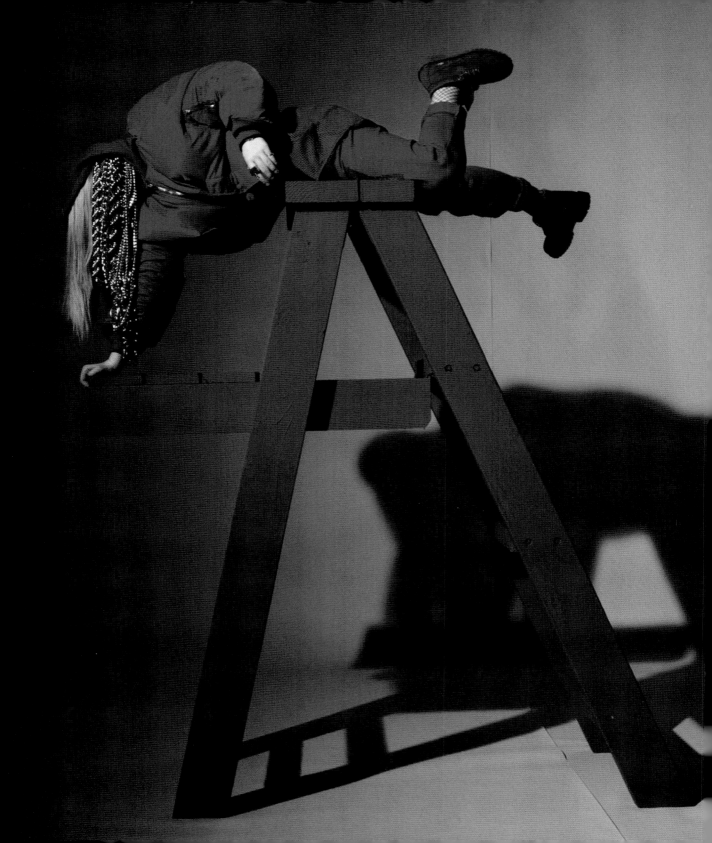

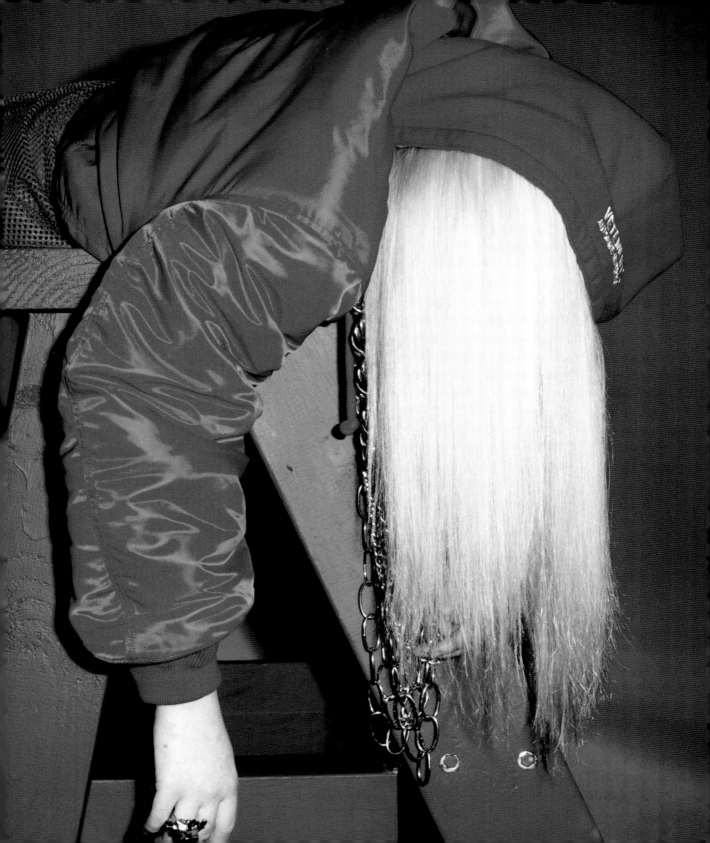

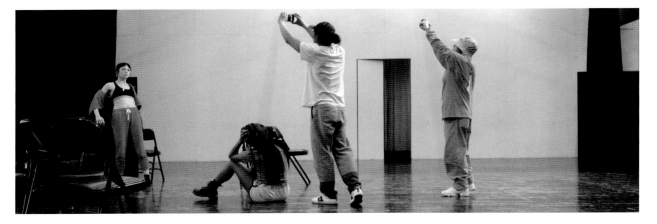

Isn't it lovely?

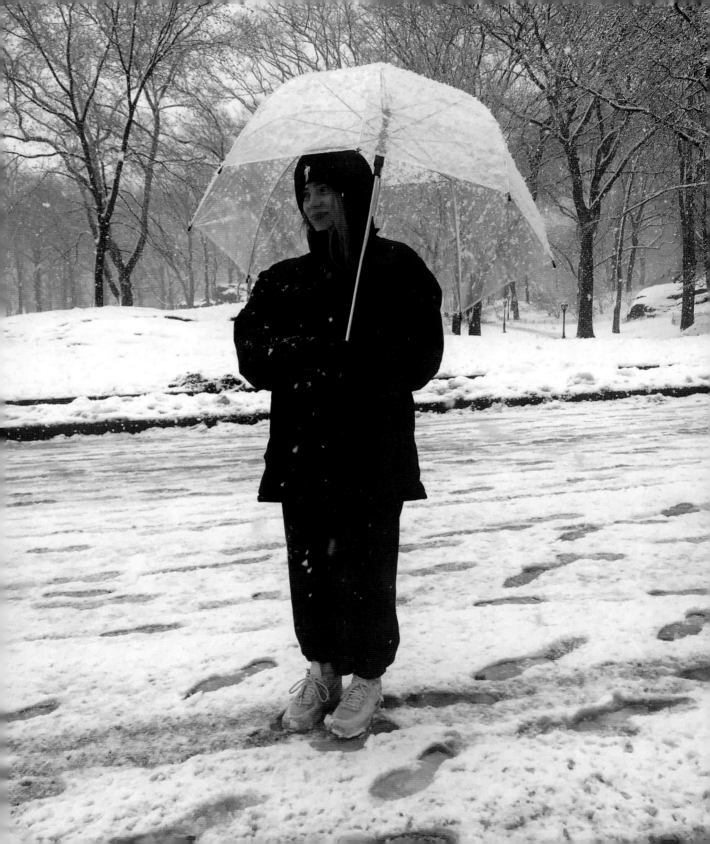

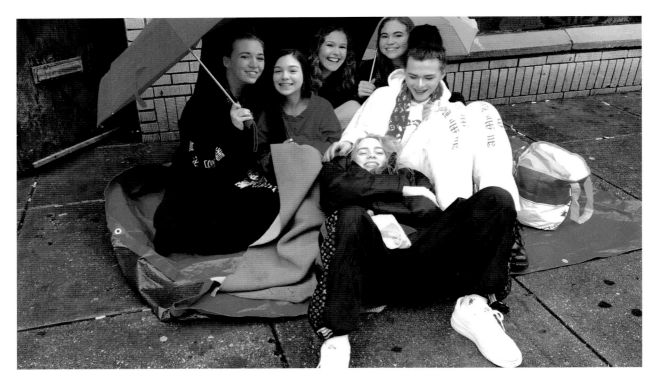

Some OG fans

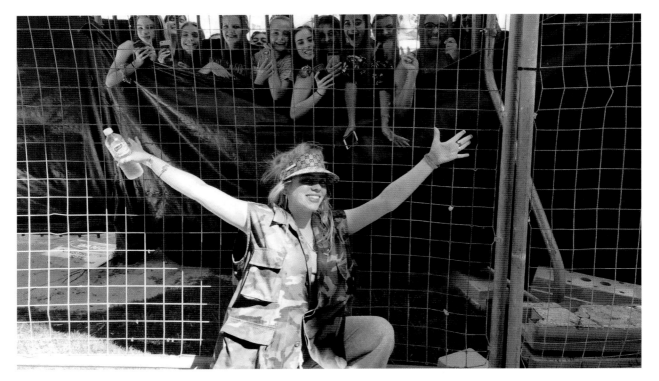

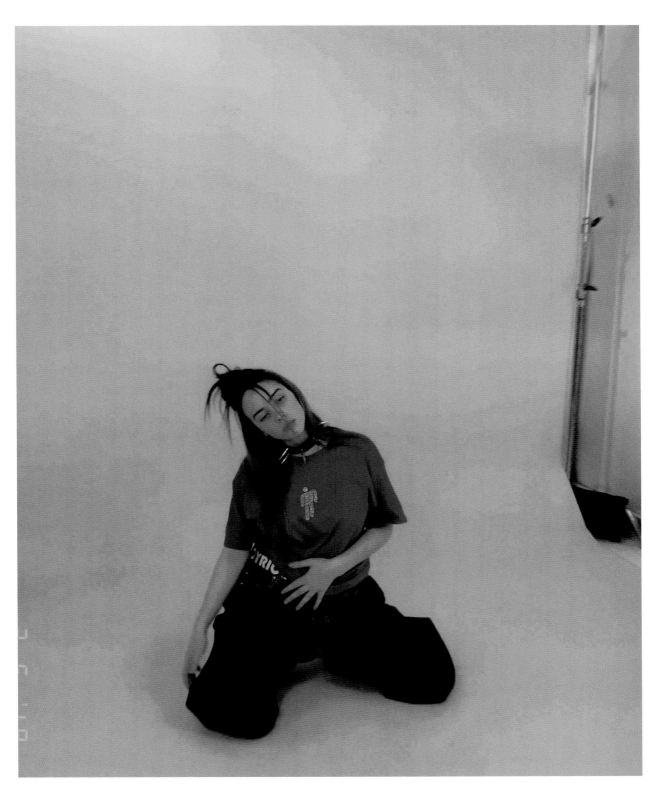

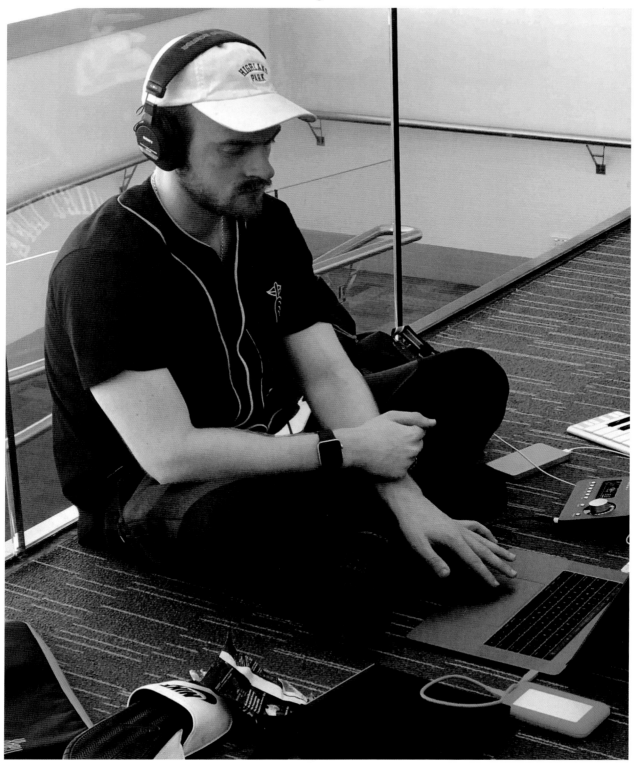

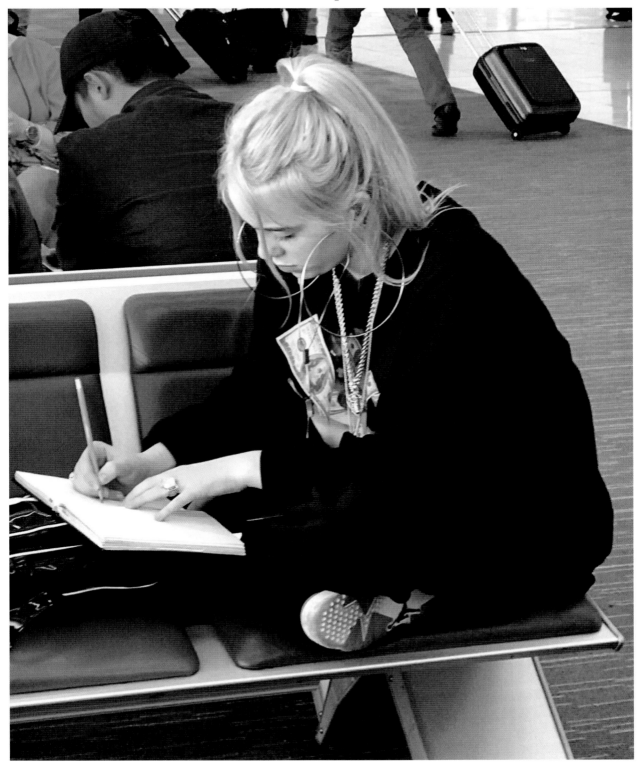

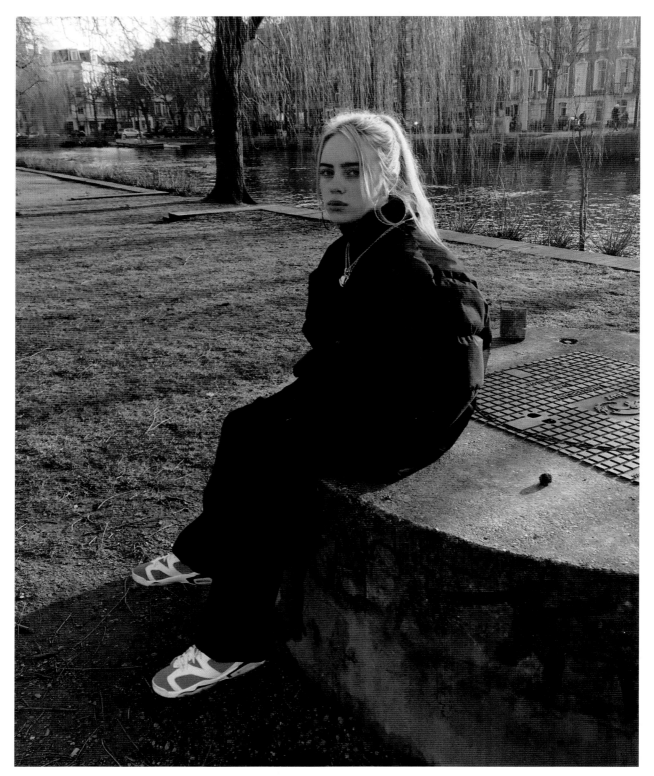

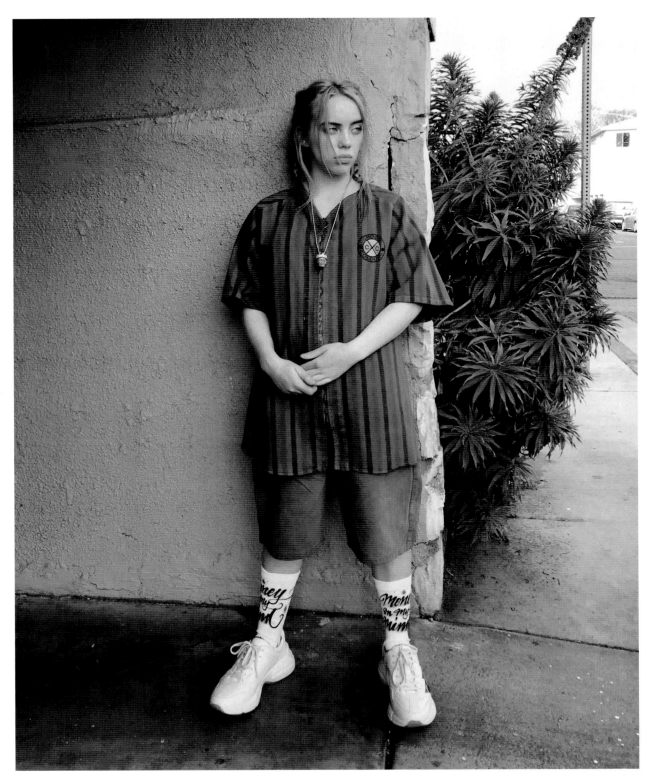

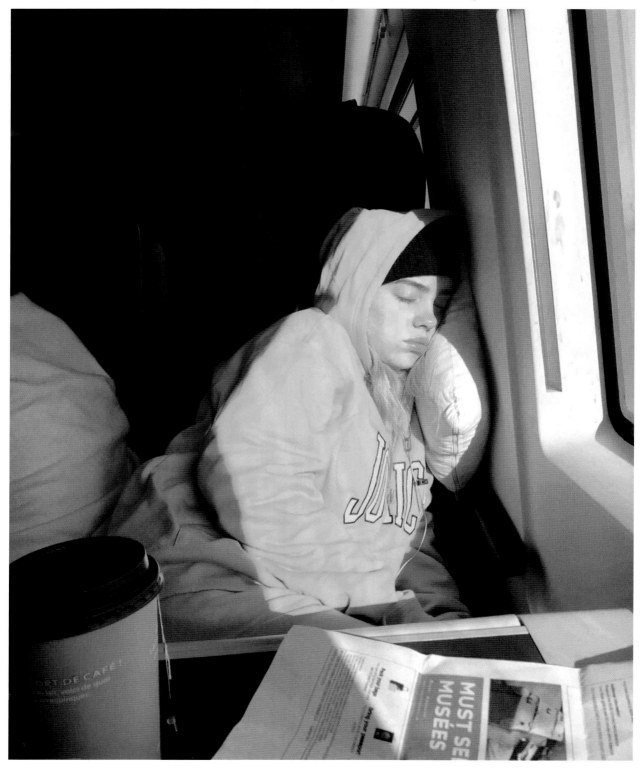

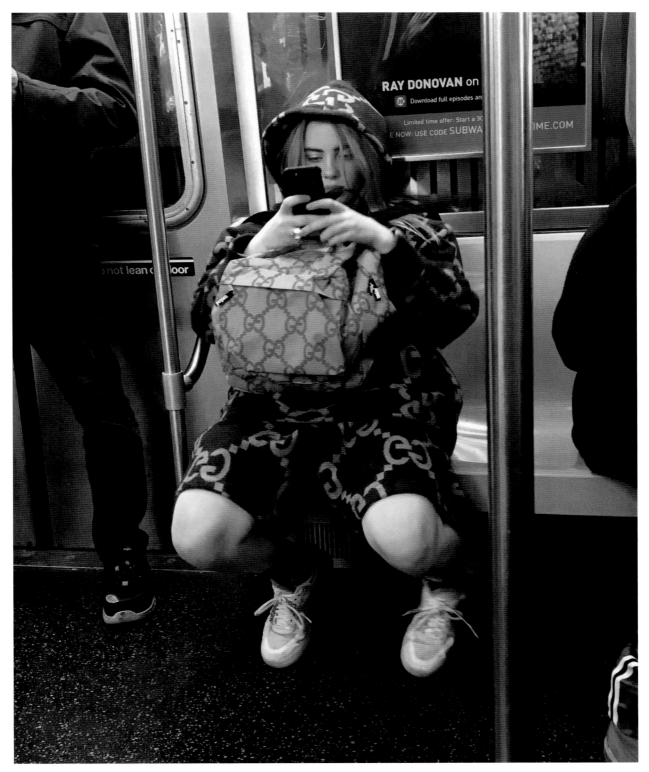

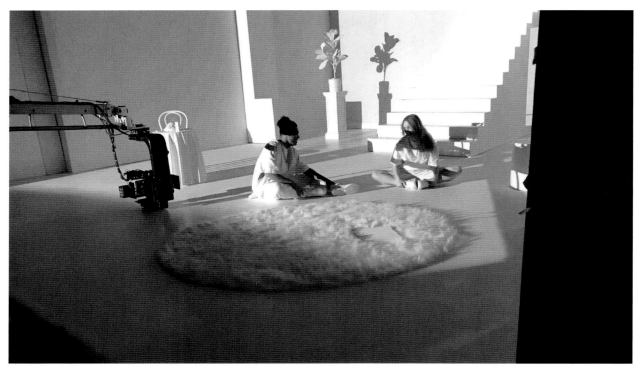

"hostage" shoot. We shot this on my mom's birthday in Toronto.

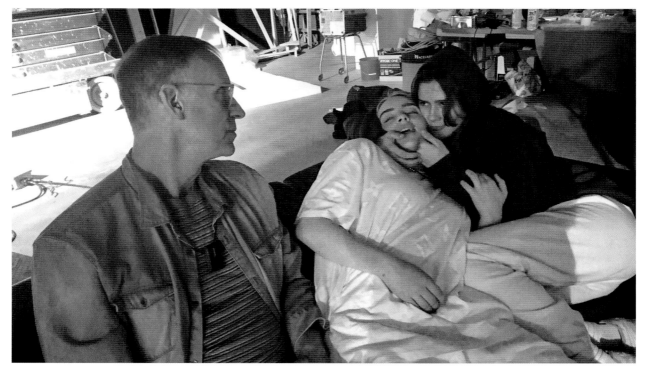

My baby Drew

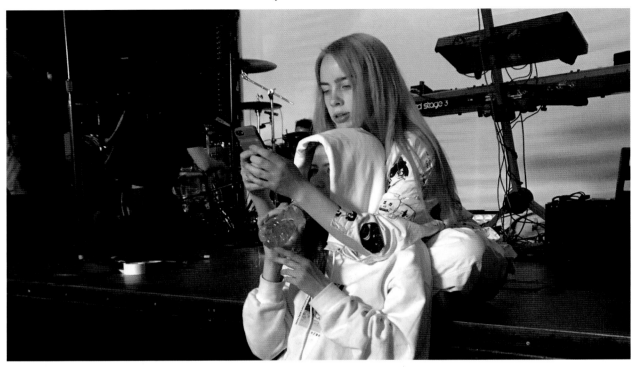

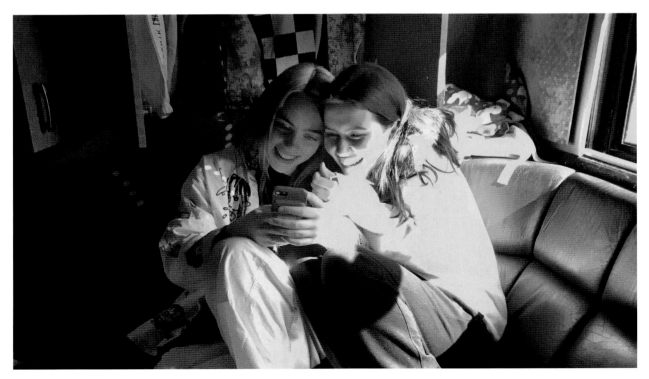

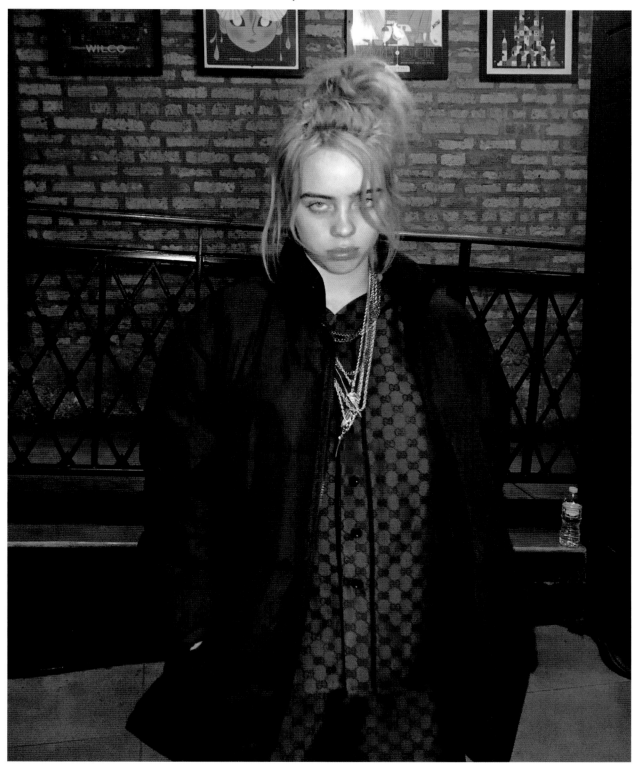

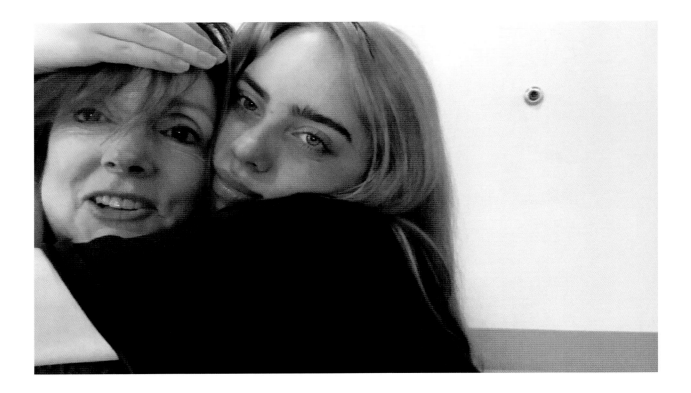

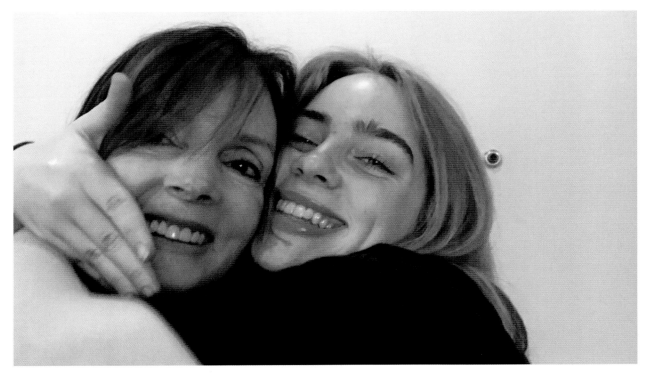

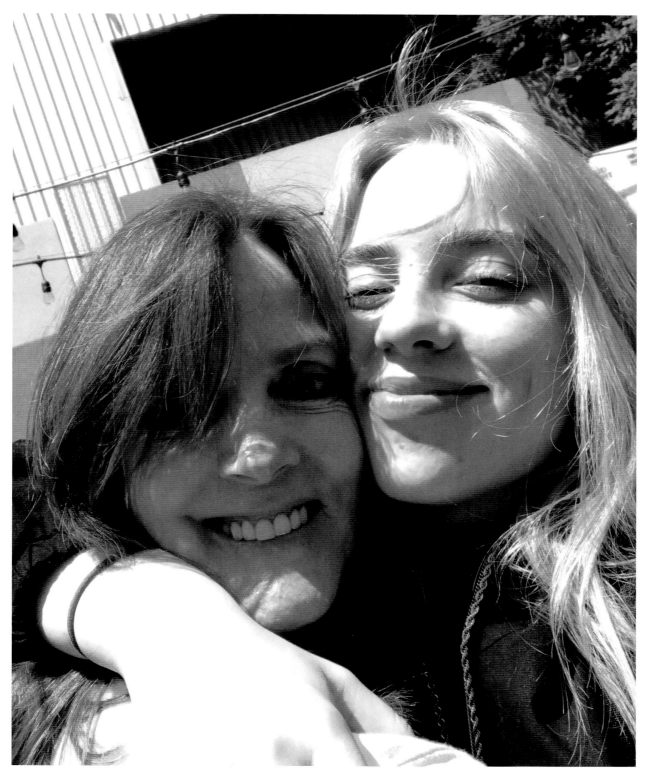

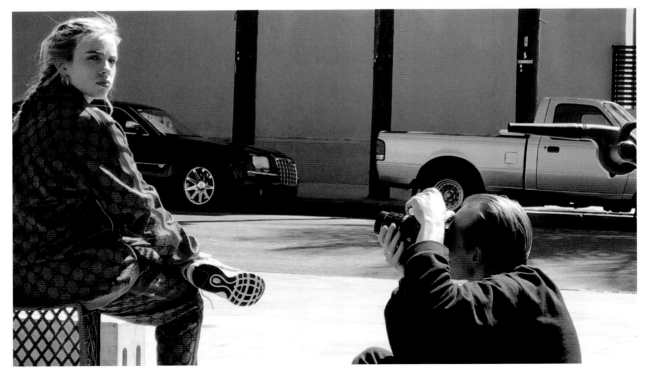

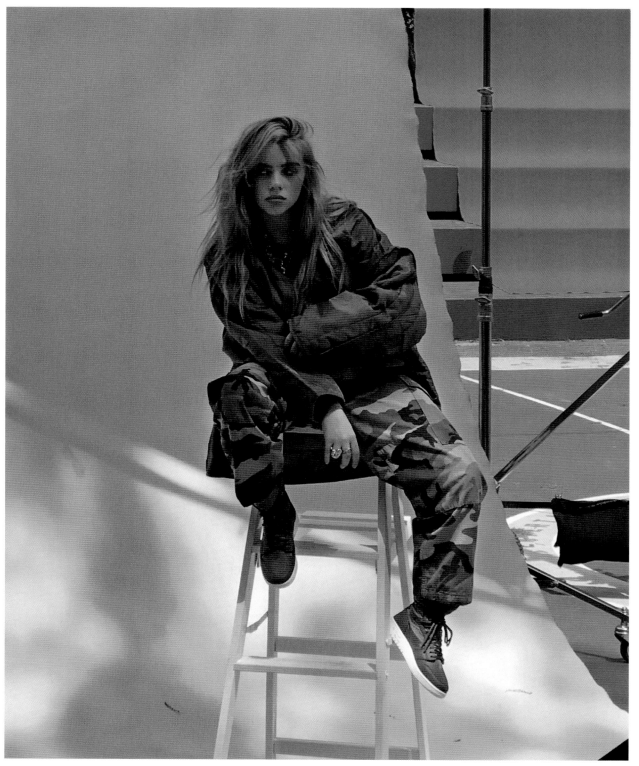

The day of this shoot was the night we wrote about in "i love you" 115

My first big festival. I was expecting nobody to show up or care, and then I was standing backstage and I heard the voices of thousands of kids chanting my name. I could not believe it.

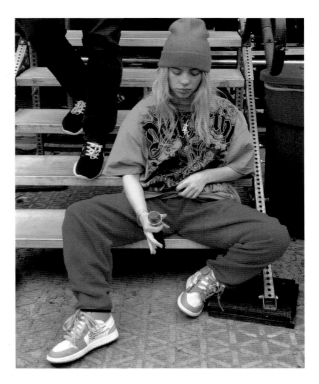

Governors Ball in New York City

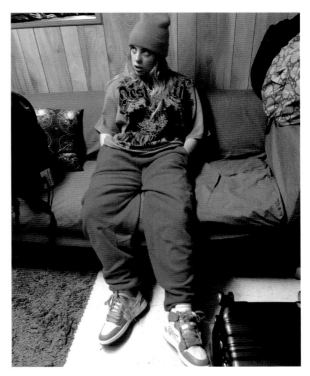

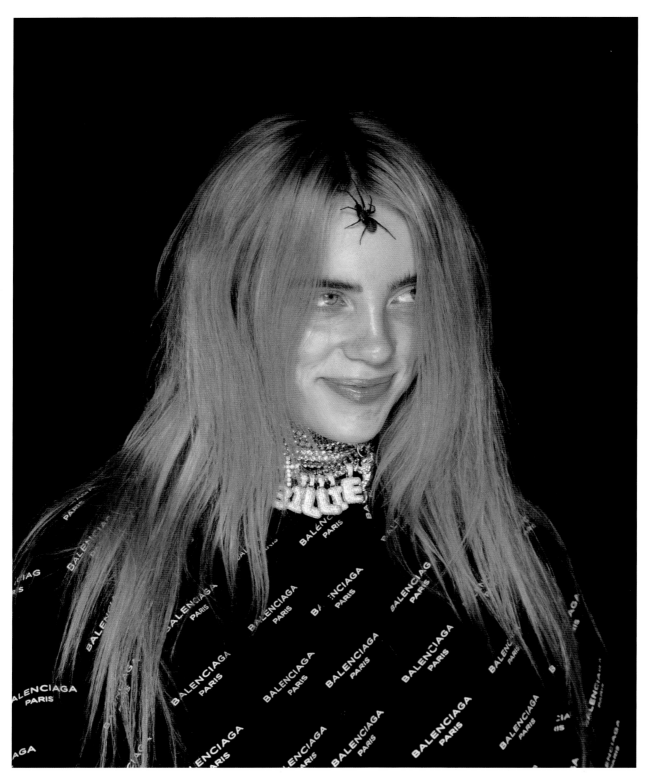

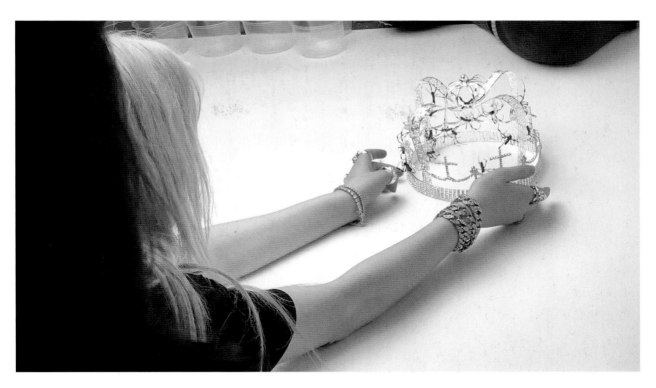

The ONE shoot I did that made everyone associate me with spiders and creepy shit from then on..........

This was a very sad week. Can you see it in my eyes?

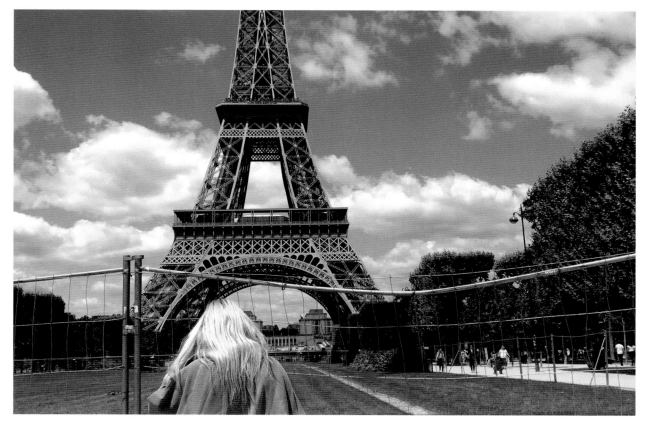

This is one of many injuries. Still did three shows right after tho teehee

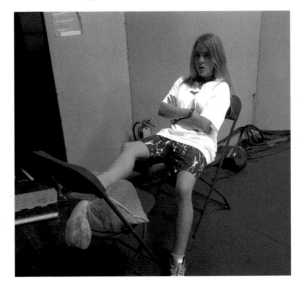

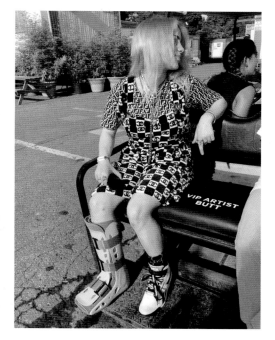

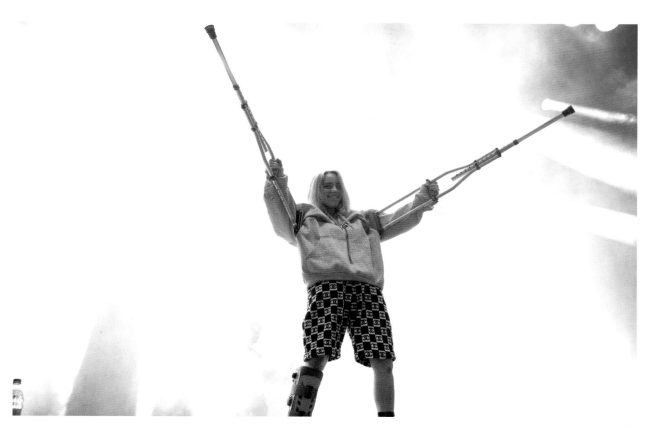

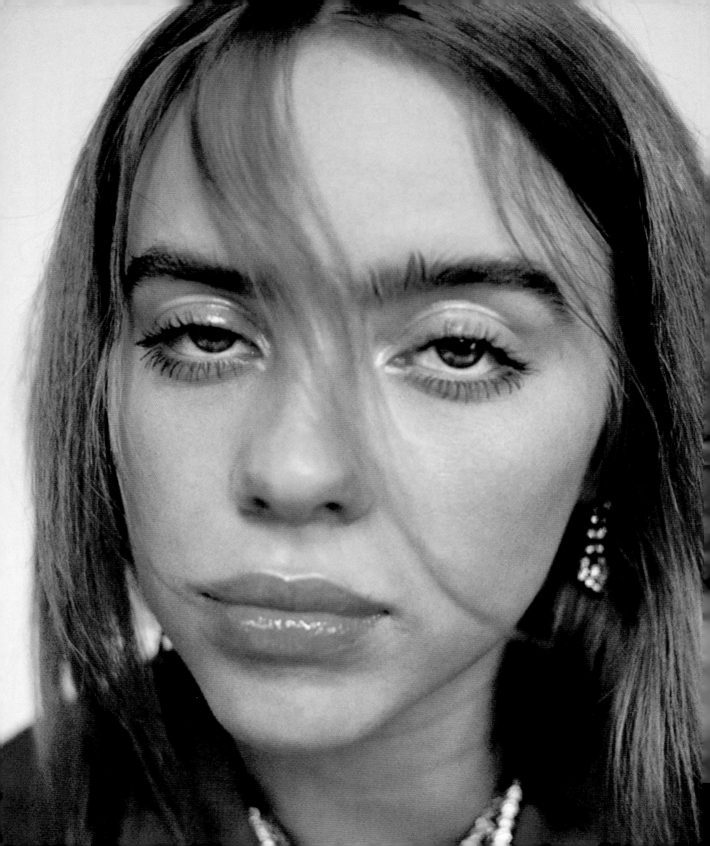

At 16

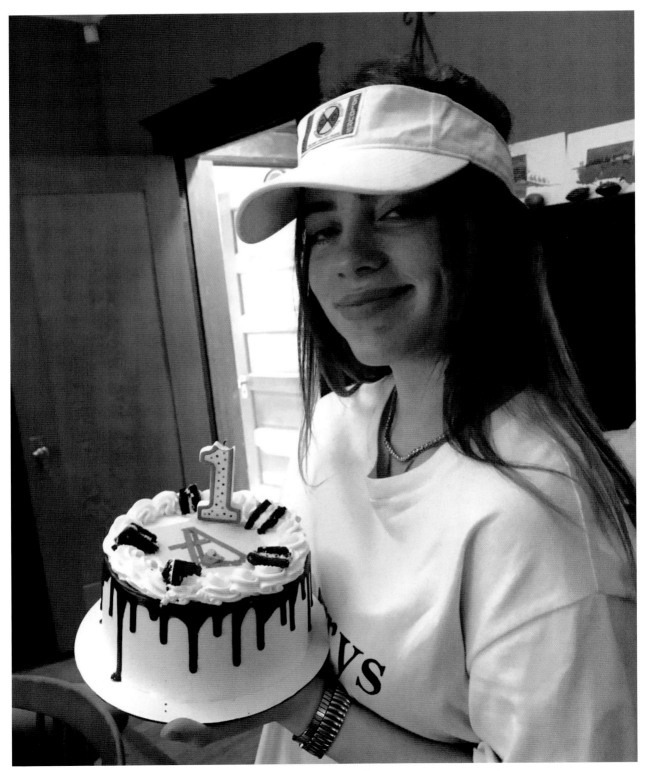

dsam 1st birthday

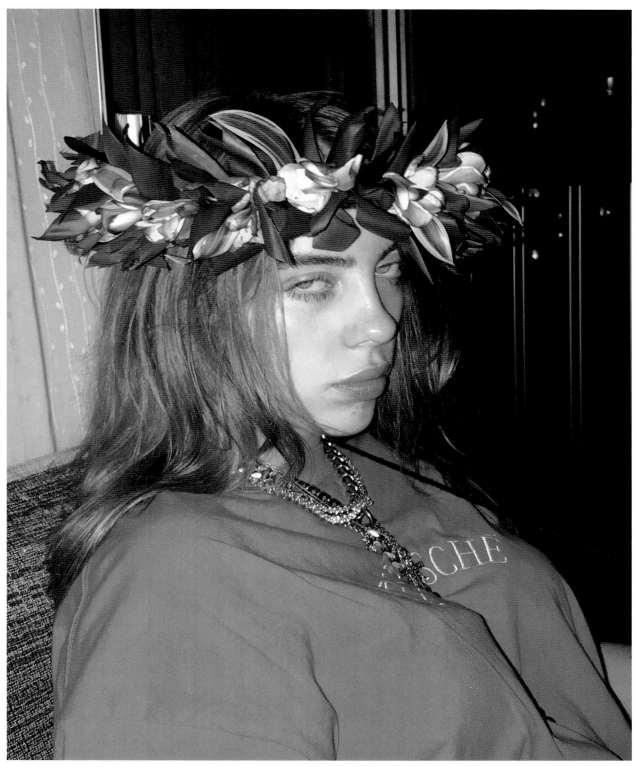

First trip to Hawaii. I fell in love with it.

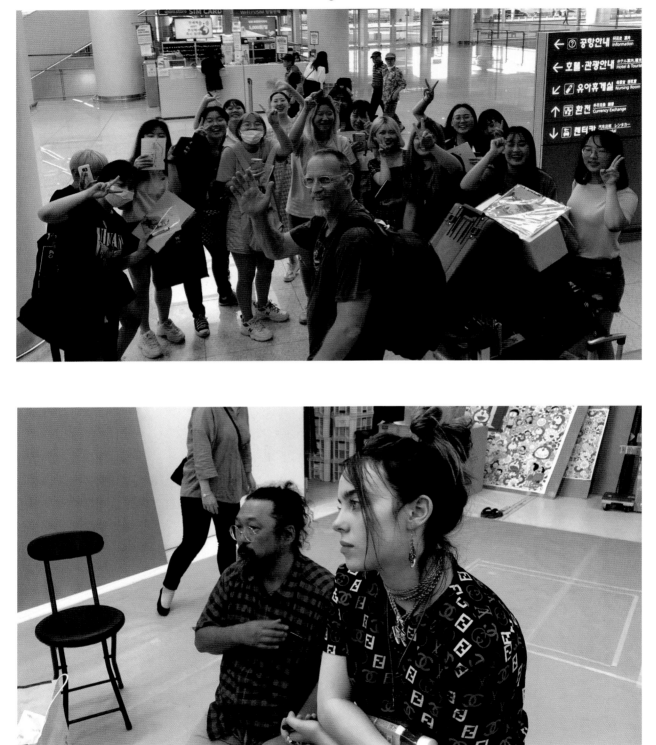

First time meeting Takashi Murakami. Us discussing how we wanted the
"you should see me in a crown" video to look. He is amazing

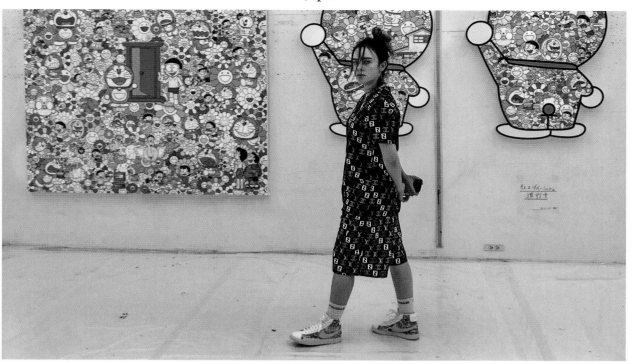

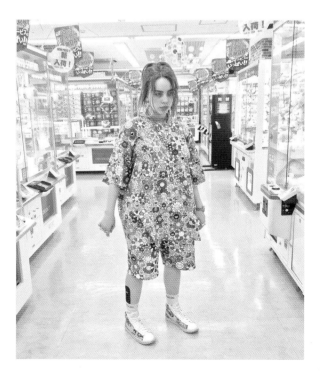

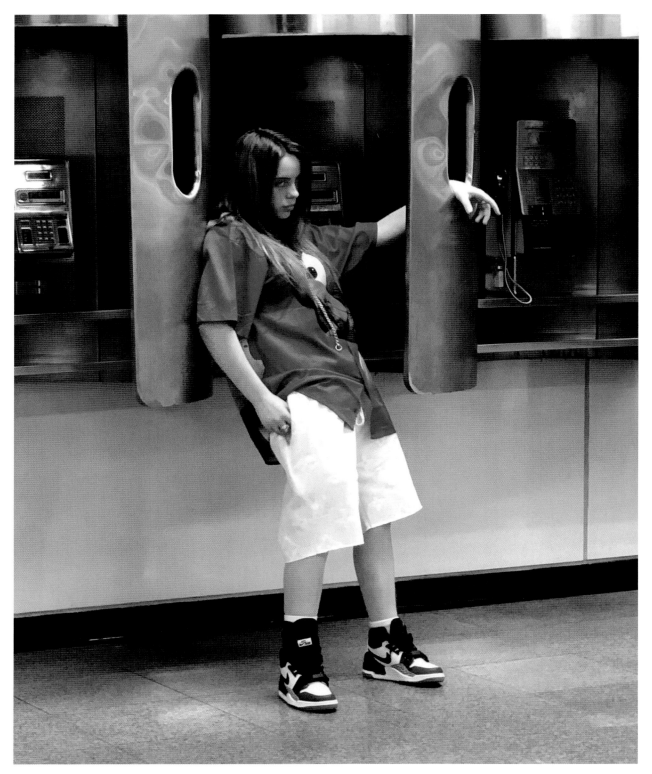

Wandering around Japan

My brother wearing my merch

Music Midtown, Atlanta. A very high point

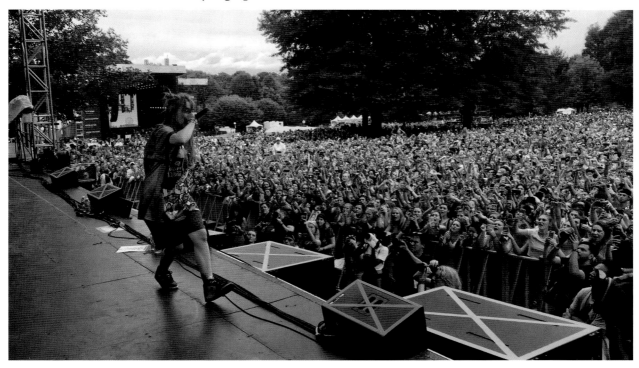

The day I got my blohsh chaaaains

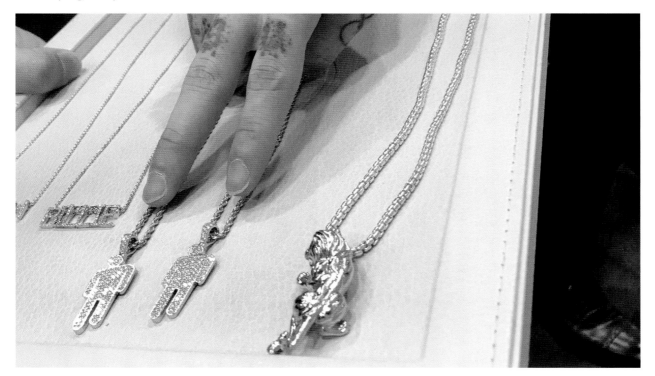

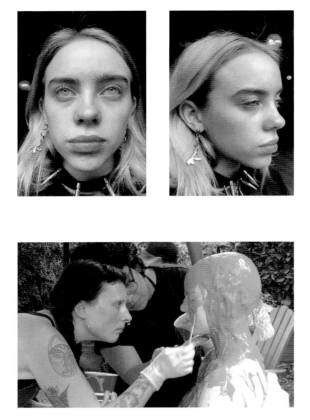

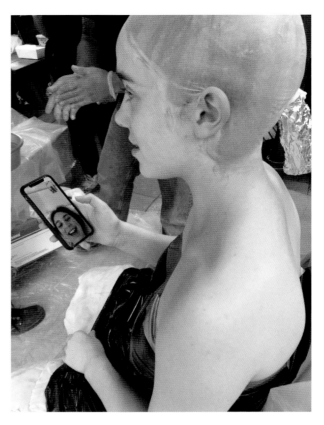

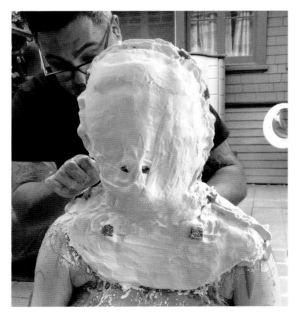

A terrible, terrible, terrible, terrible experience all around.
You ever felt like you're suffocating for an hour straight? That's what this head mold felt like.

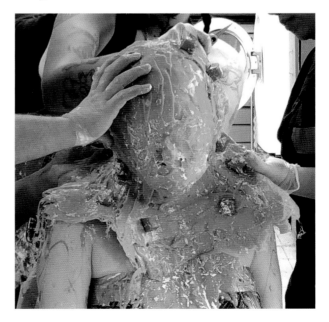

As soon as we popped that mold off my head I hopped right up on the fabric.

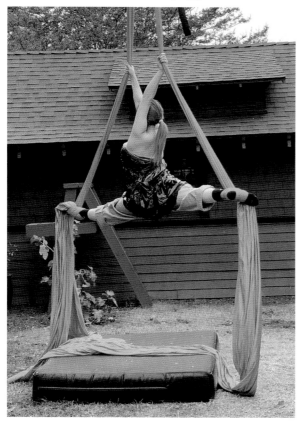 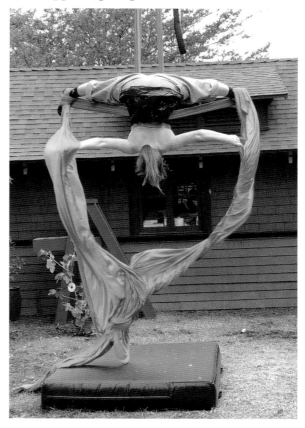

Cool photos tho. Love you Takashi & *GARAGE*

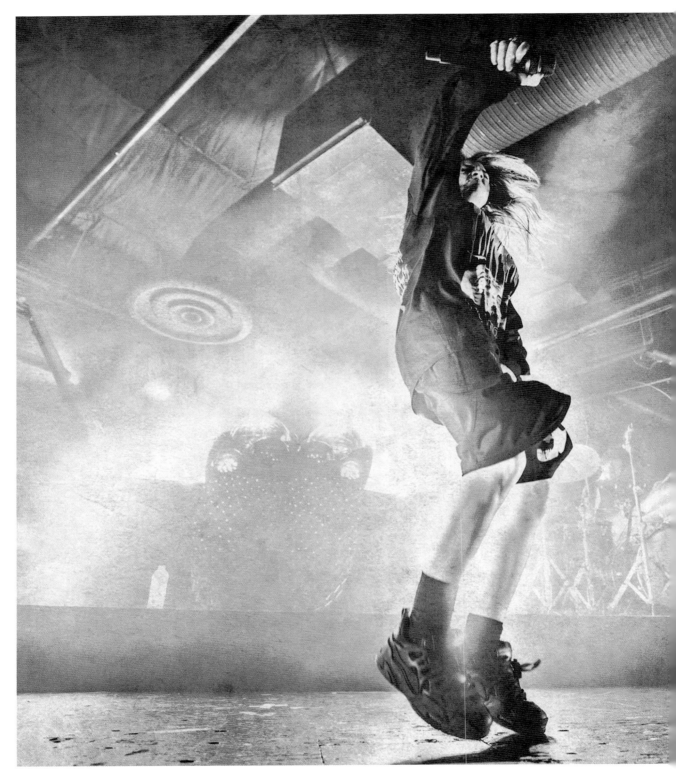

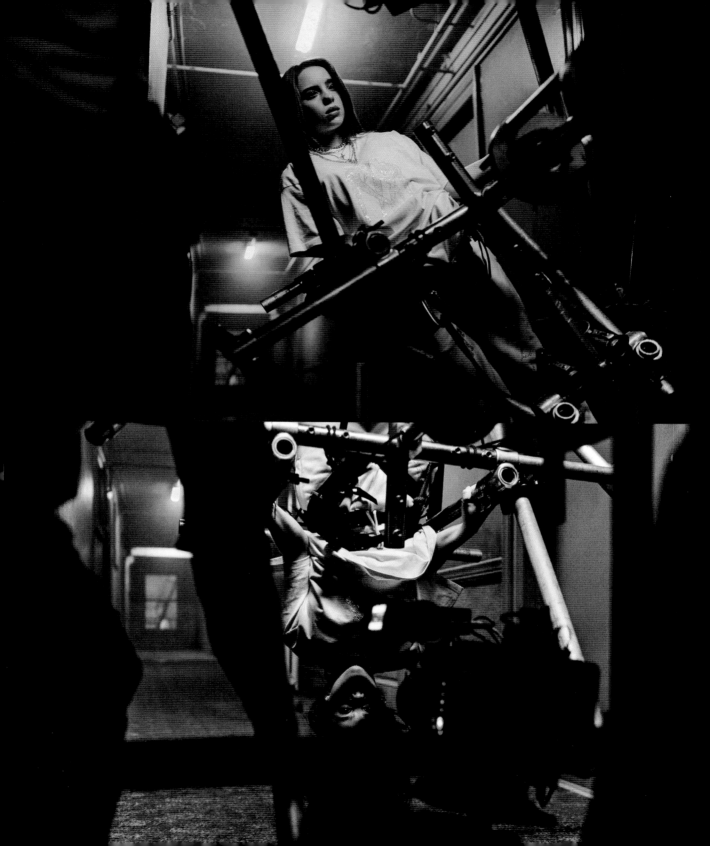

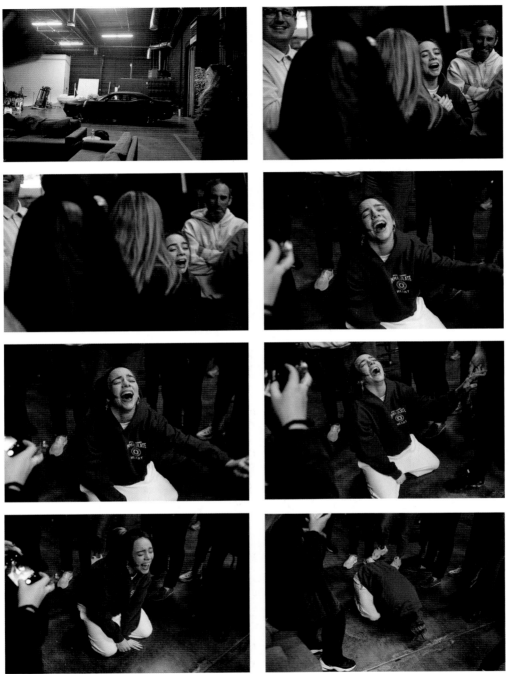

This was the day before my 17th birthday. We did an 11-hour photoshoot and we shot 12 looks, shot the album cover and those wing photos I accidentally leaked (you know which ones I'm talkin' about).

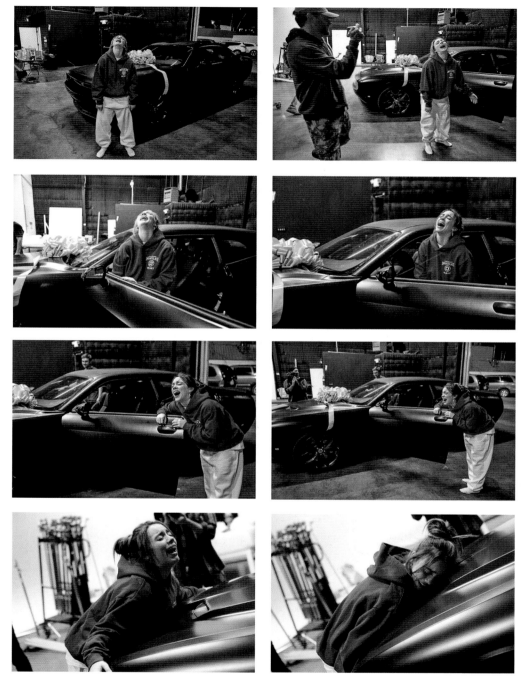

Right at the end, I was getting mad that no one got me a birthday present and no one sang me happy birthday, then I heard a noise and I saw my lifelong dream car with a green bow and I sobbed for three hours straight.

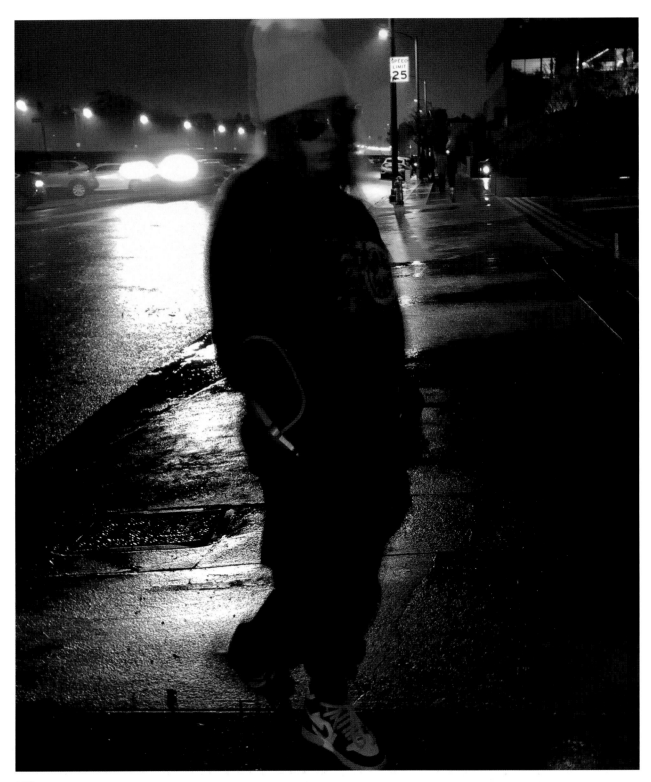

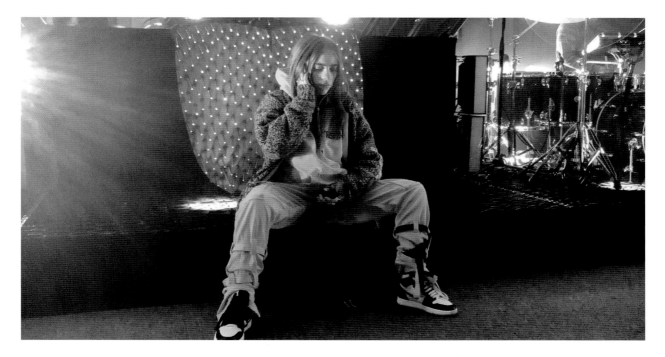

I probably was in the worst mental state that I've ever been in for this tour. It was also a really difficult tour. Every time I see pictures from this period of time, my chest clenches remembering the way it felt. Sounds cheesy lol but it's true. The shows were incredible though, and the fans always lifted me up every night.

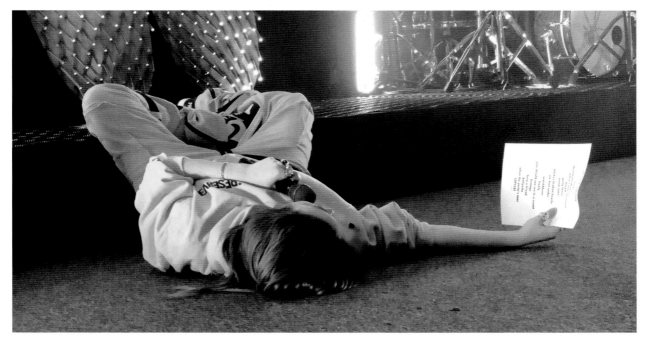

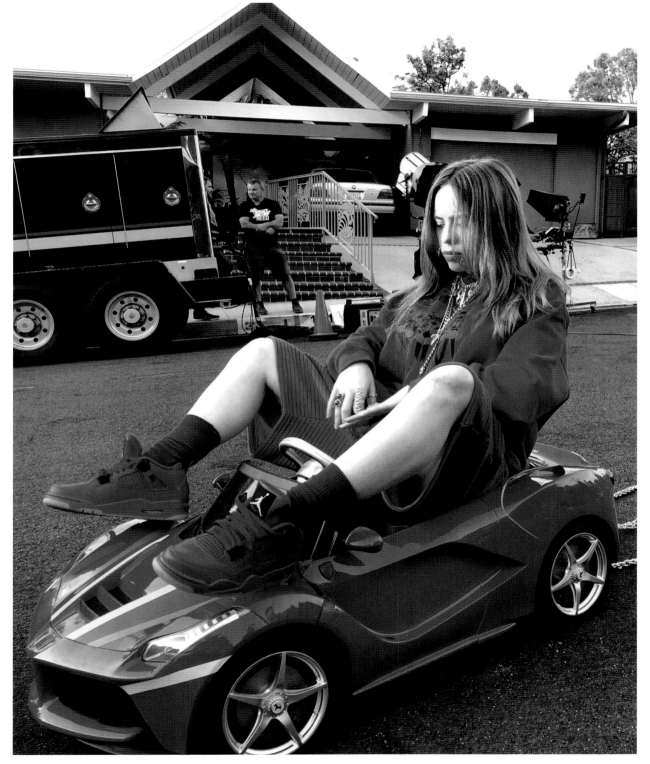

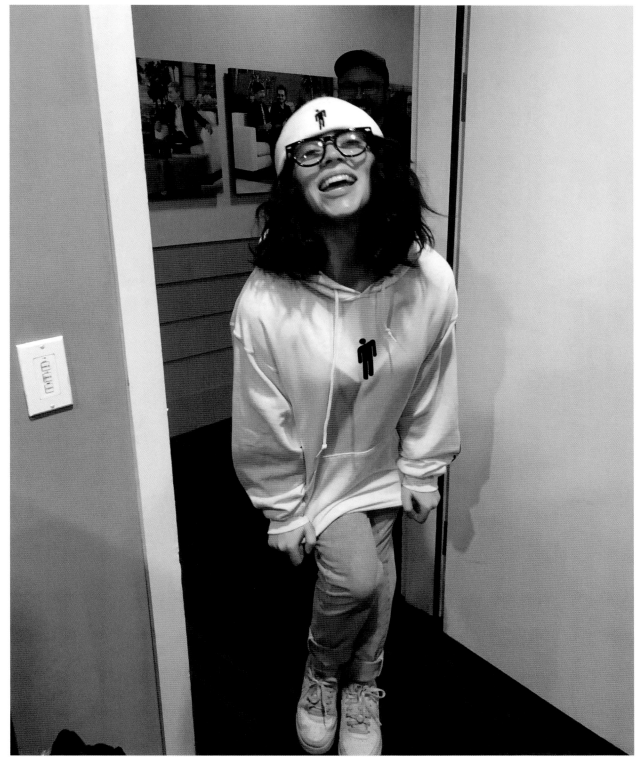

Ellen made me dress normal and this is me very embarrassed. 151

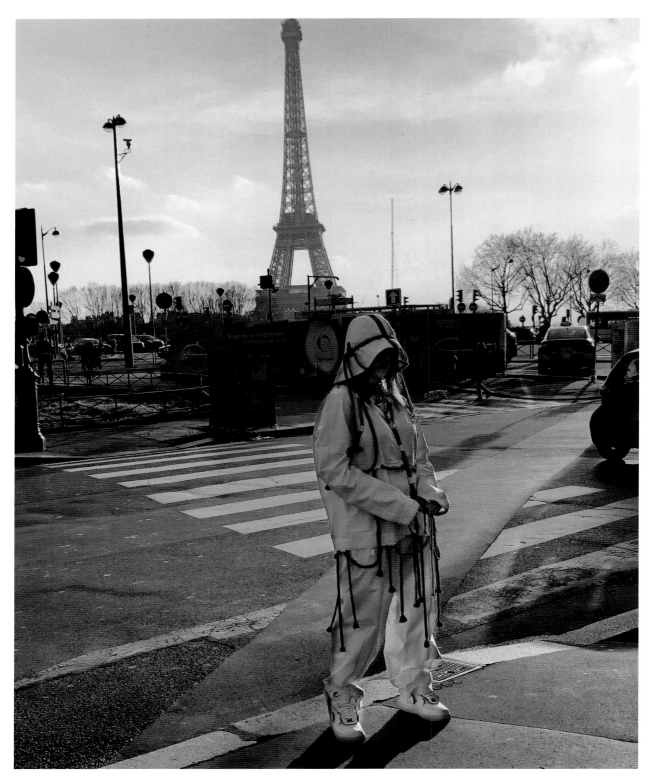

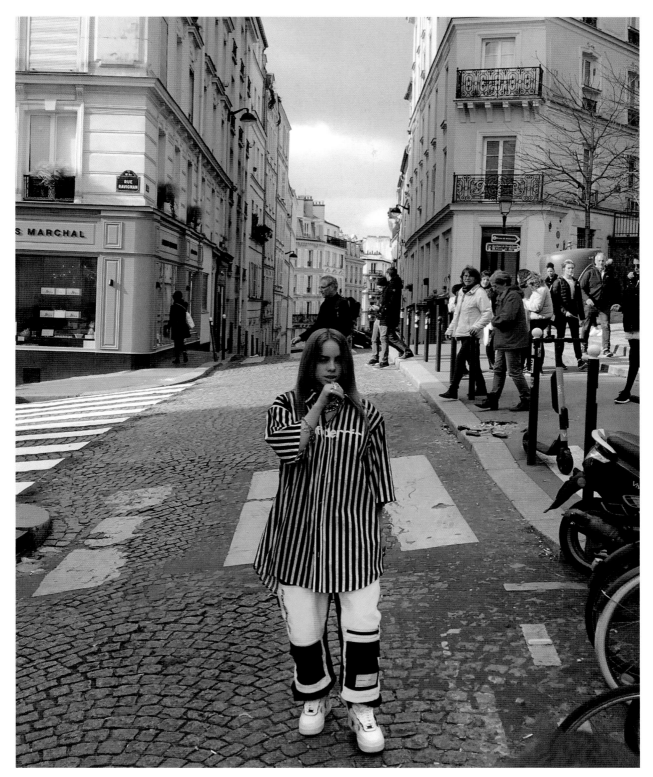

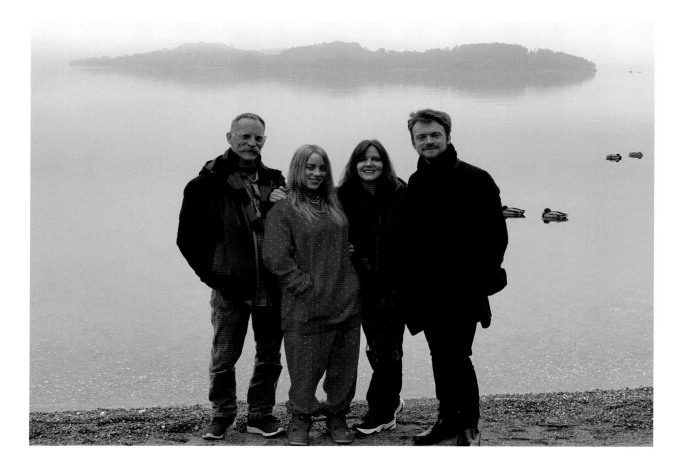

Familyyyyyyyy

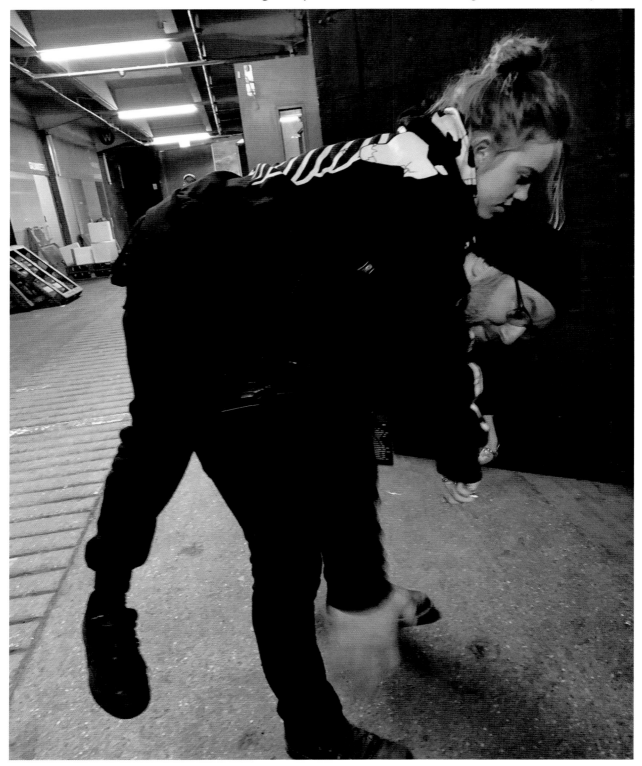

ha ha

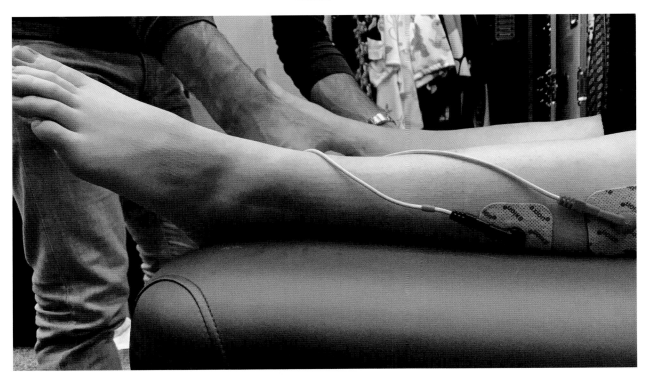

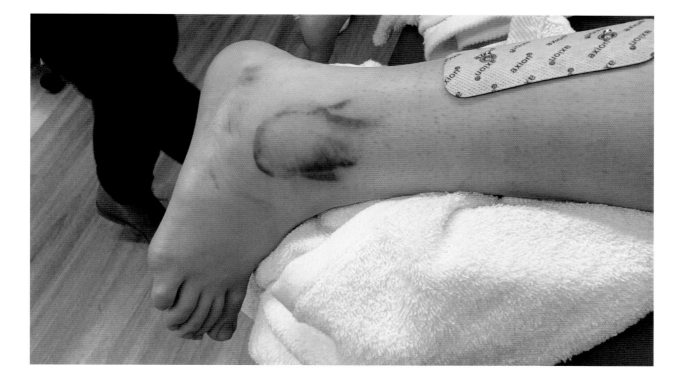

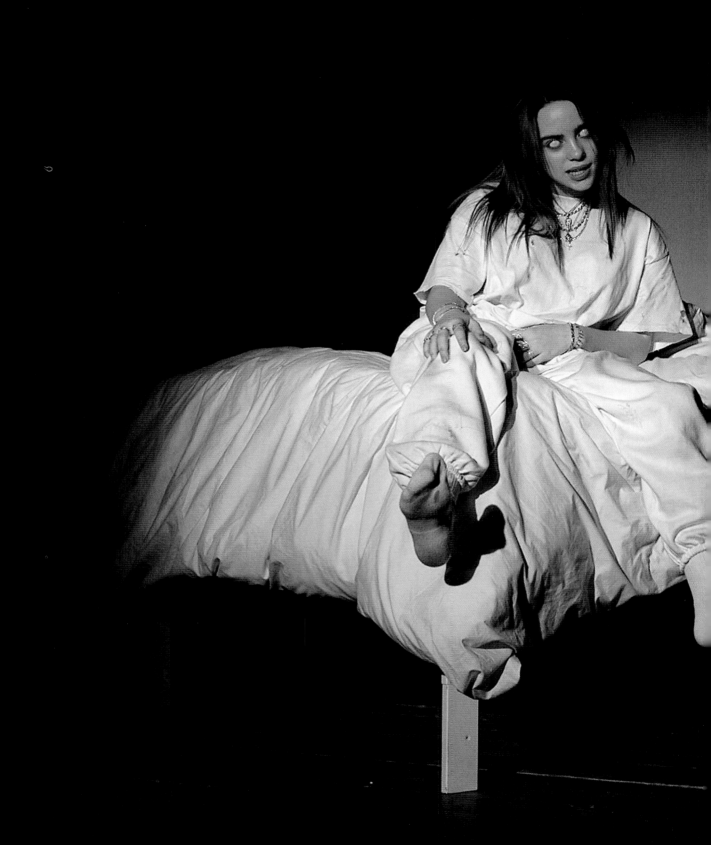

My debut album came out!!!!

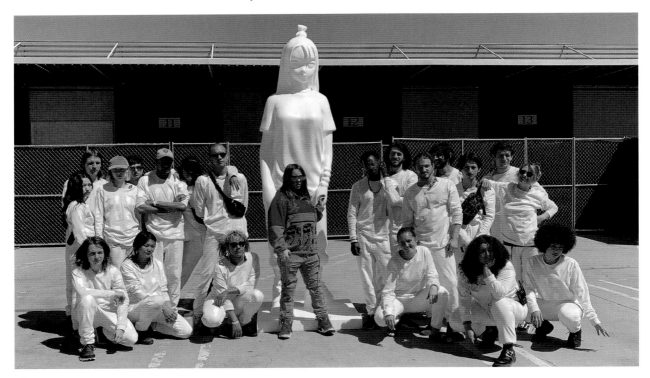

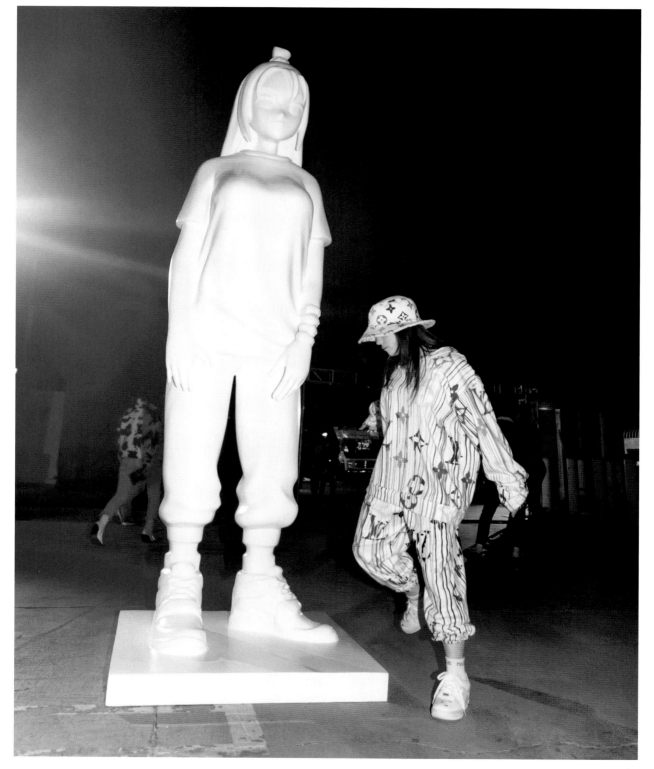

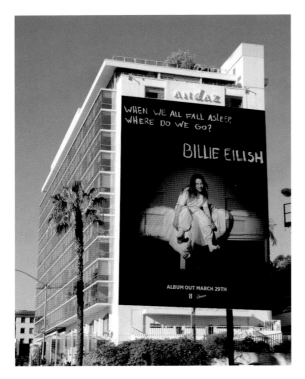

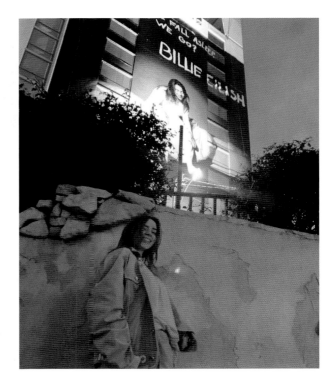

Then it was lots of billboards and exciting things for the next few months.

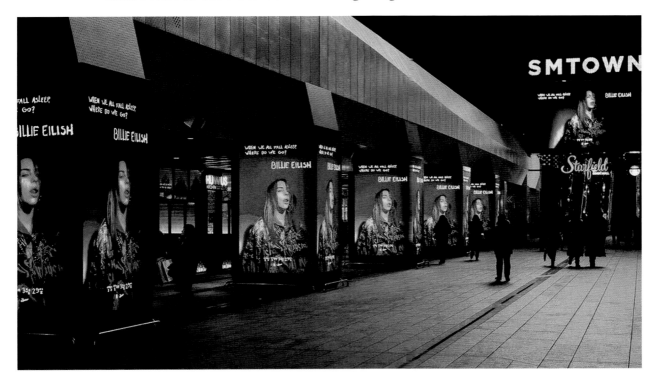

The biggest inspiration for
WHEN WE ALL FALL ASLEEP,
WHERE DO WE GO?

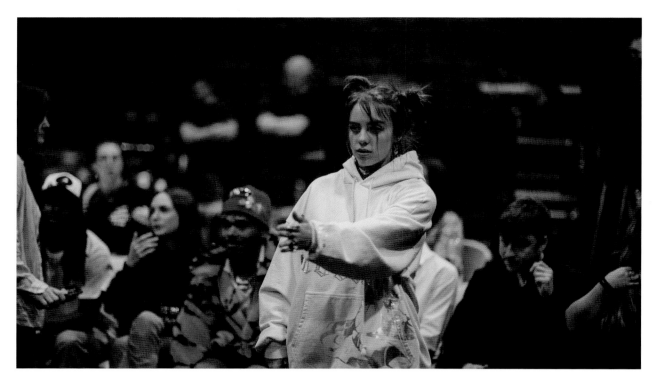

Coachella rehearsals! Also the first time I would be performing any of the songs off my album.

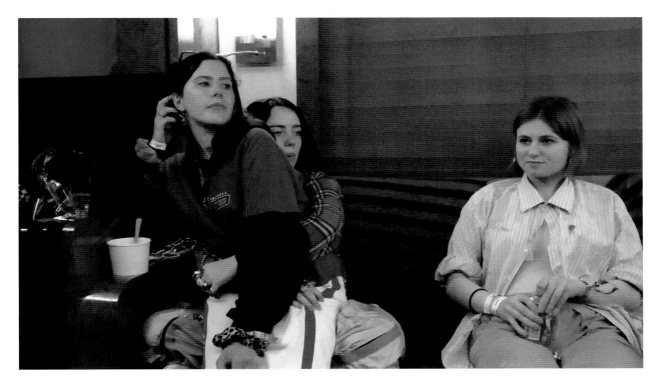

Coachella!

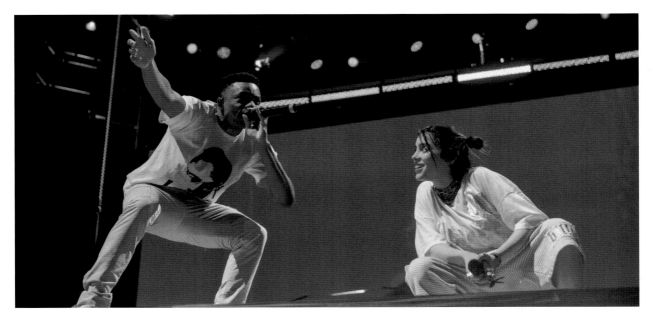

For all the rehearsals, everything kept fucking up for Vince's verse and finally when we actually got to do the show it all was perfect and we were so happy about it! It wasn't until later that we found out from the internet that his mic was off in the house...oop

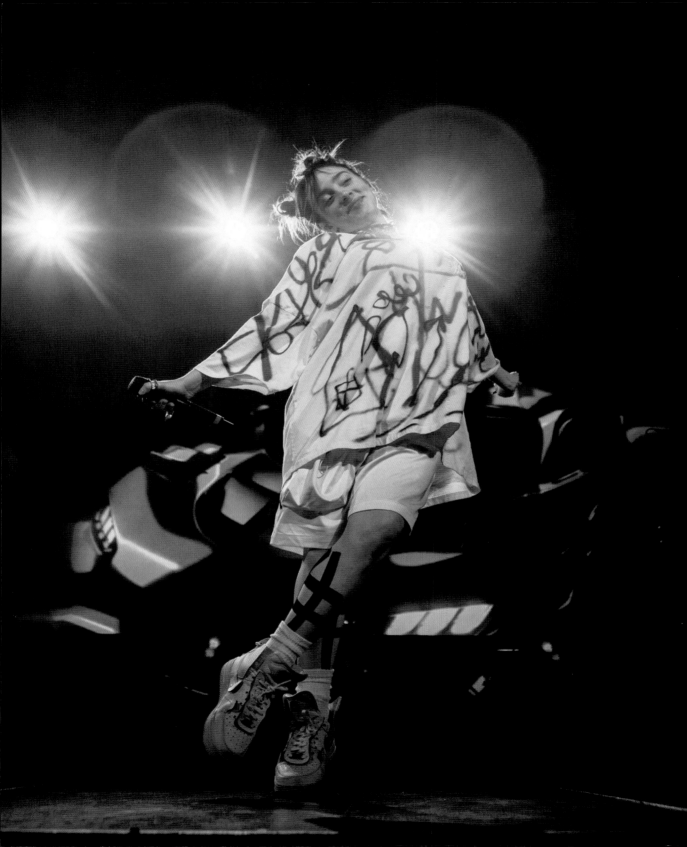

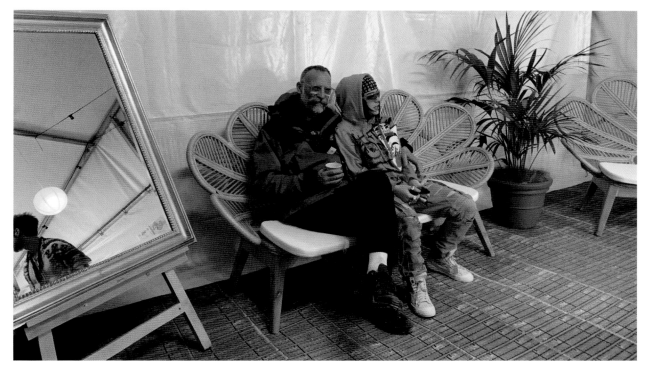

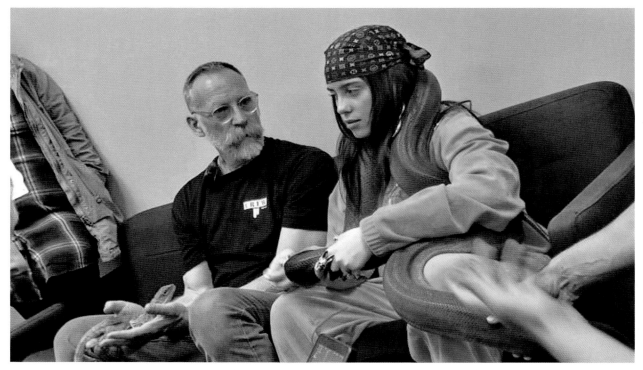

Same shit I told you earlier lol do you see what's around my neck?　　171

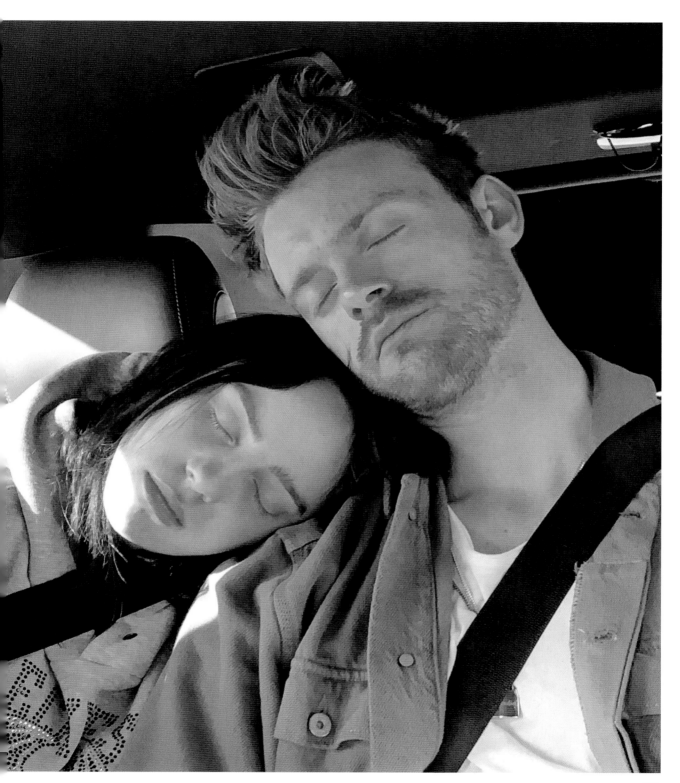

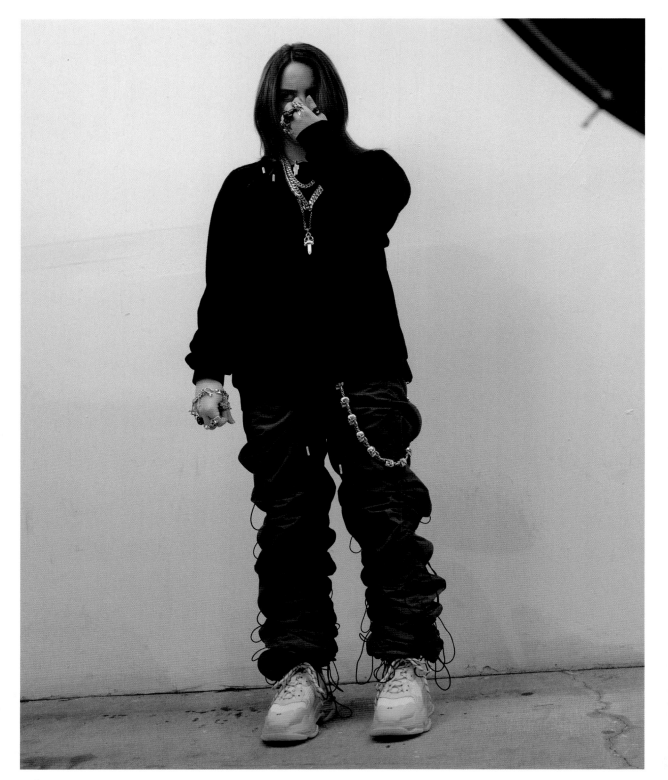

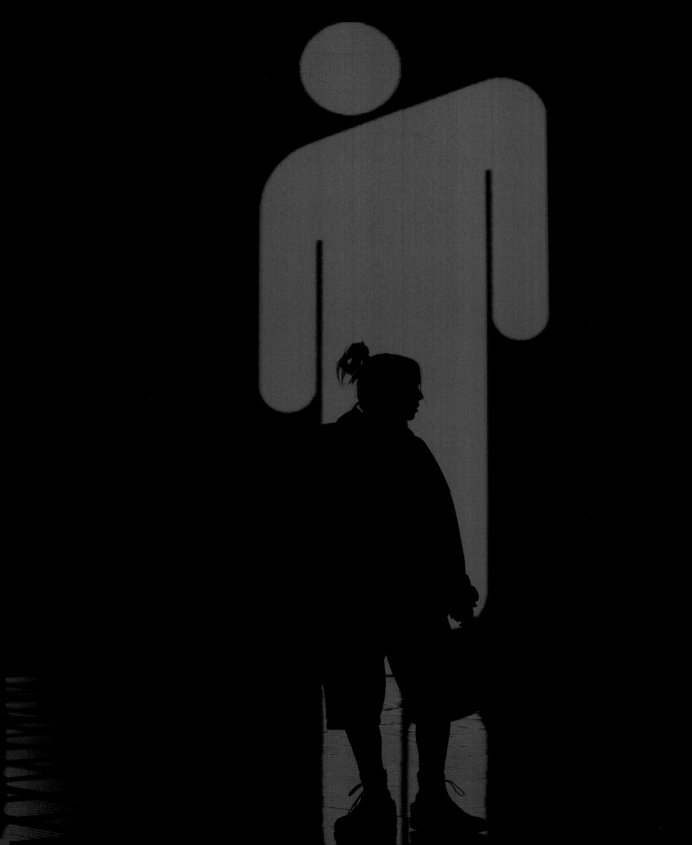

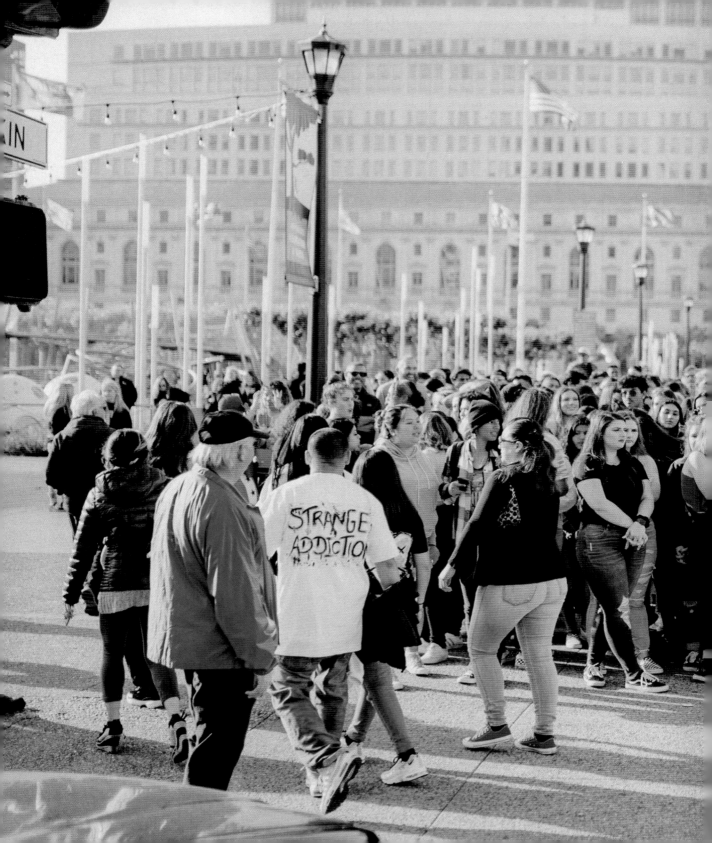

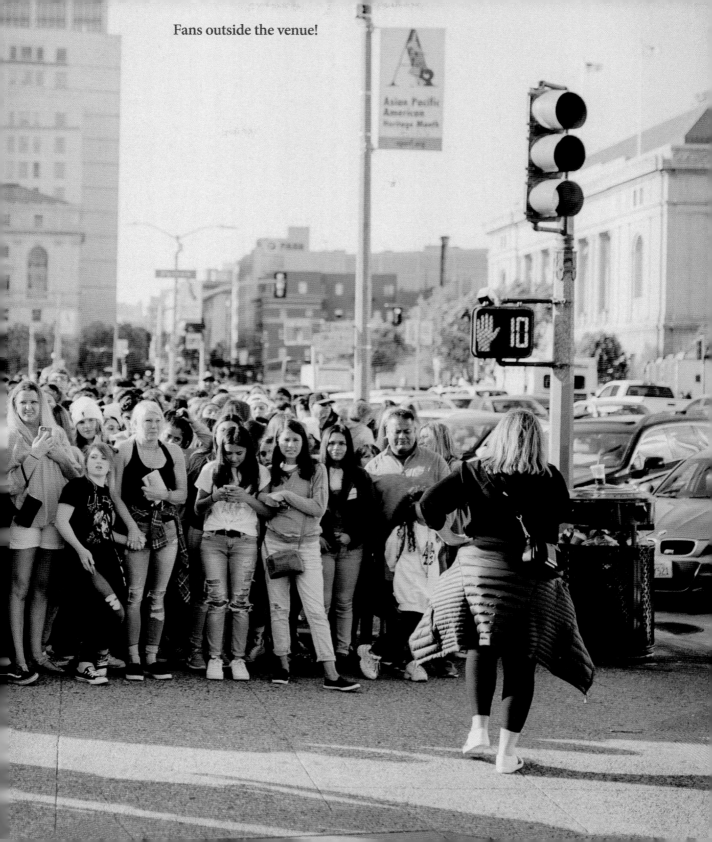

Fans outside the venue!

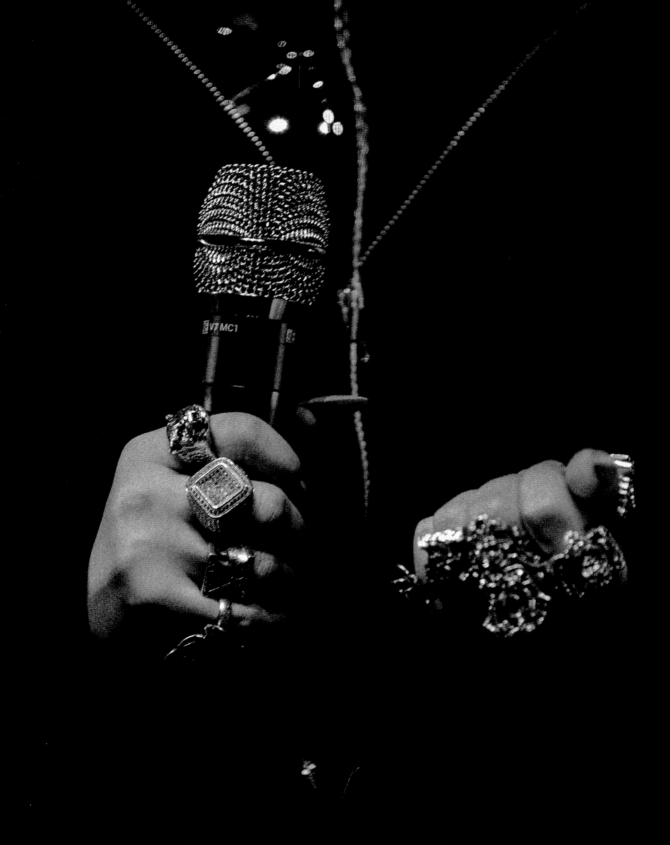

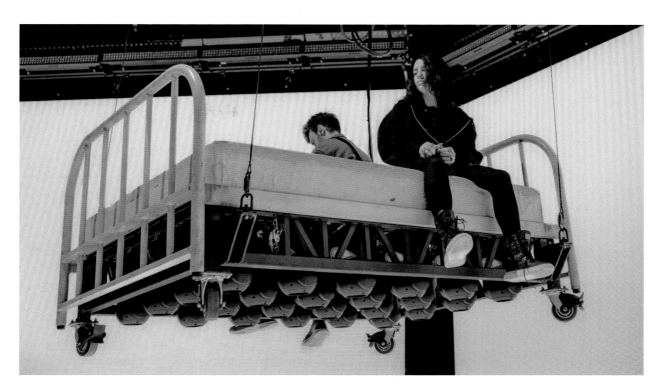

The start of a tour that changed my life

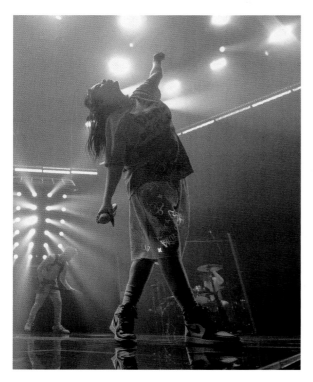

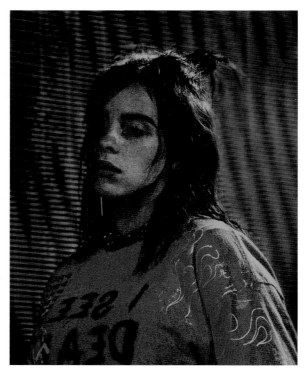

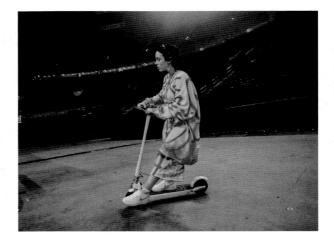

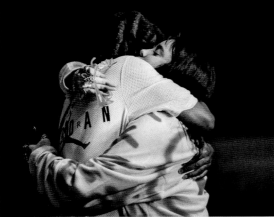

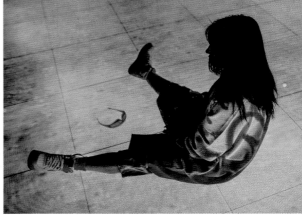

Denzel. One of my best friends in the world.

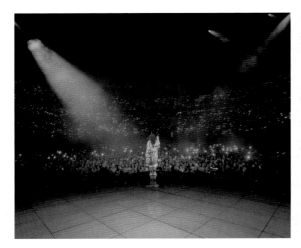

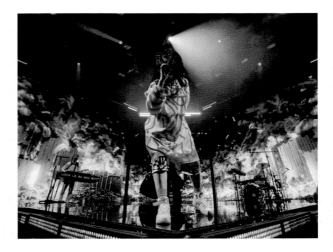

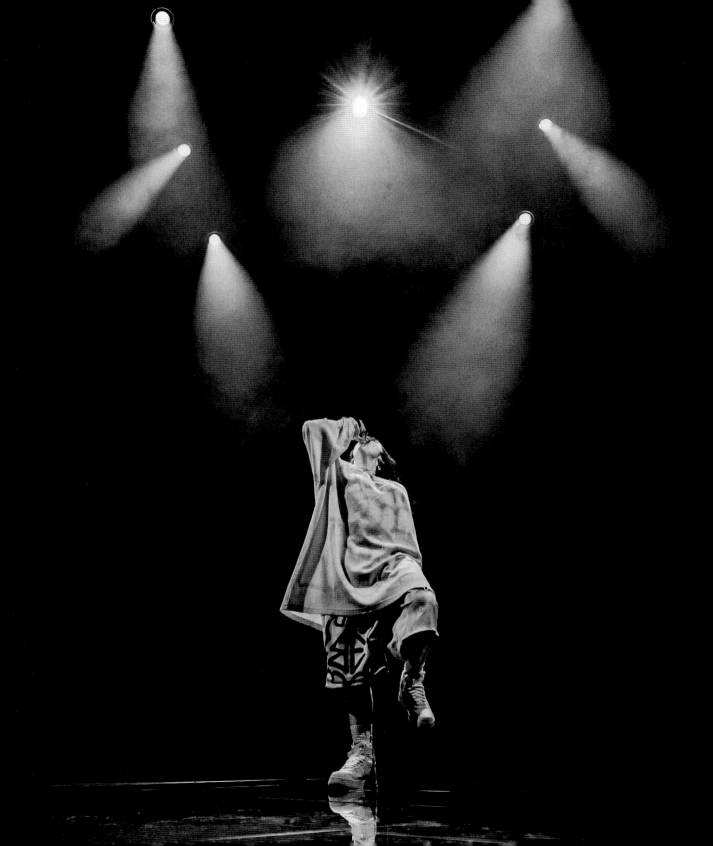

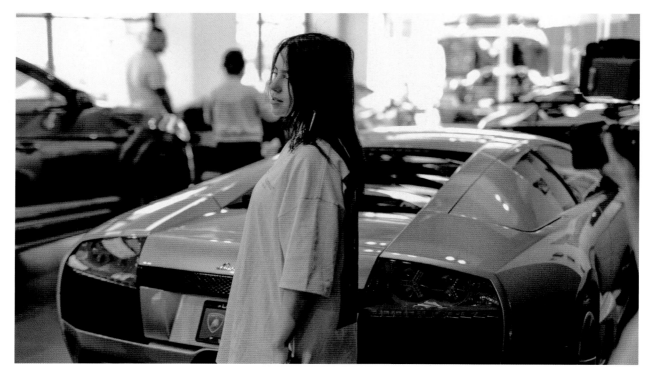

Always been in love with cars ever since I was little

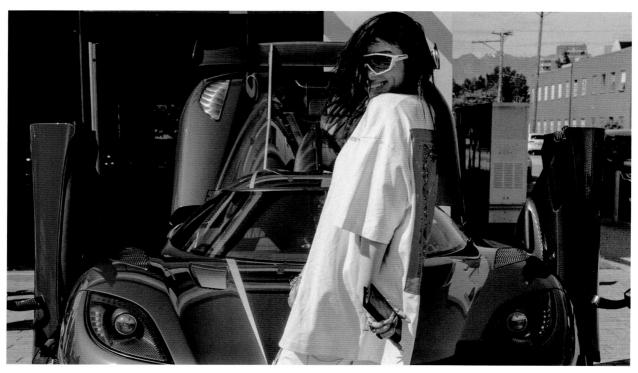

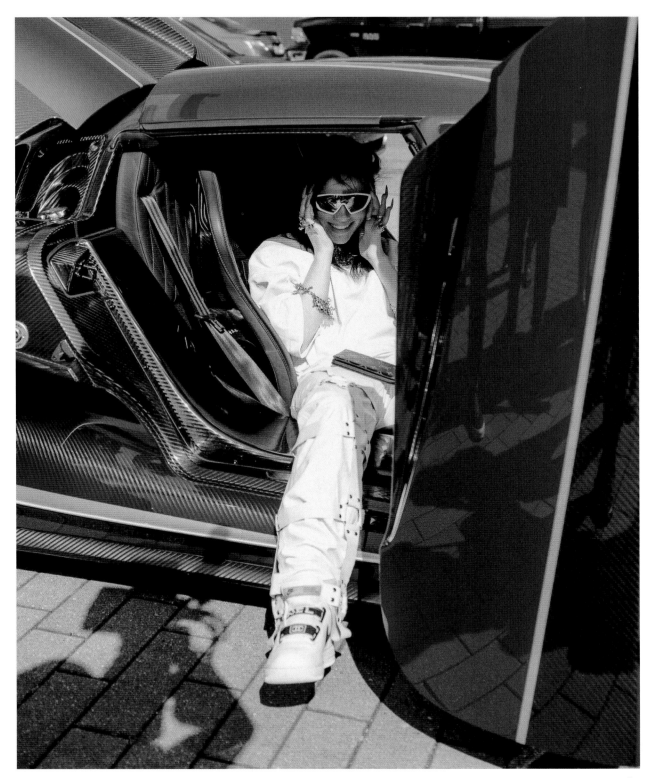

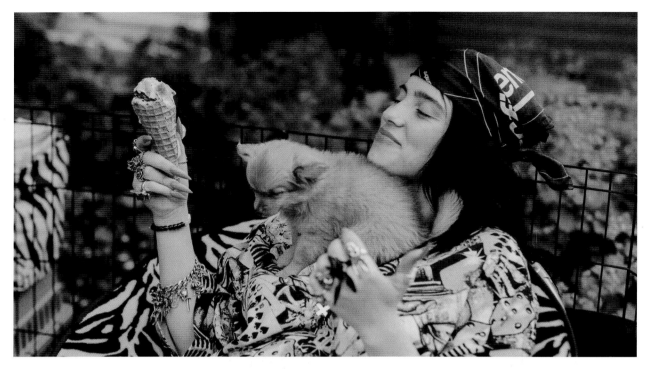

A show we did in Redmond, WA.
This was one of those days that made me wish days didn't only happen once.

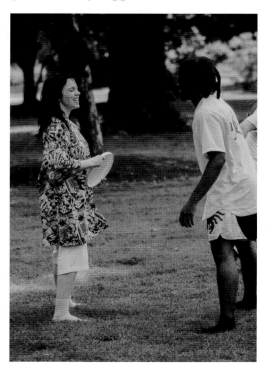

We always try to have rescue puppies come to as many shows as possible.
A lot of them end up getting adopted, it's really fun.

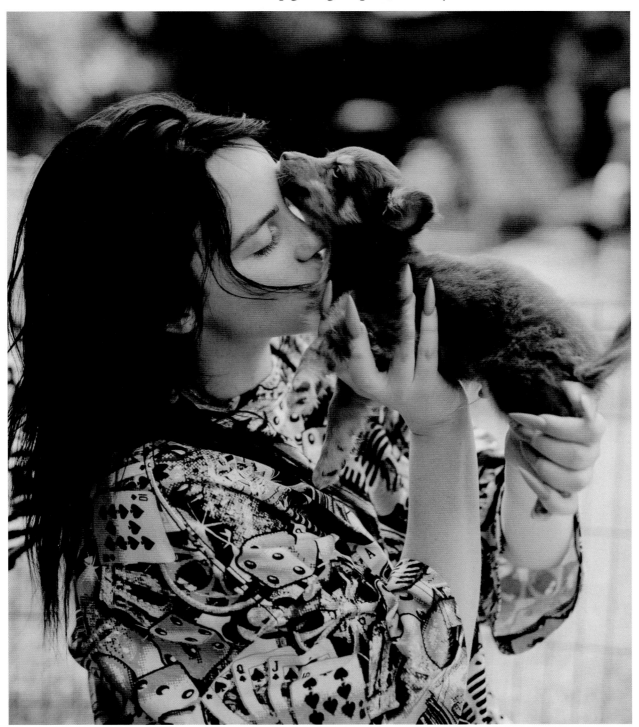

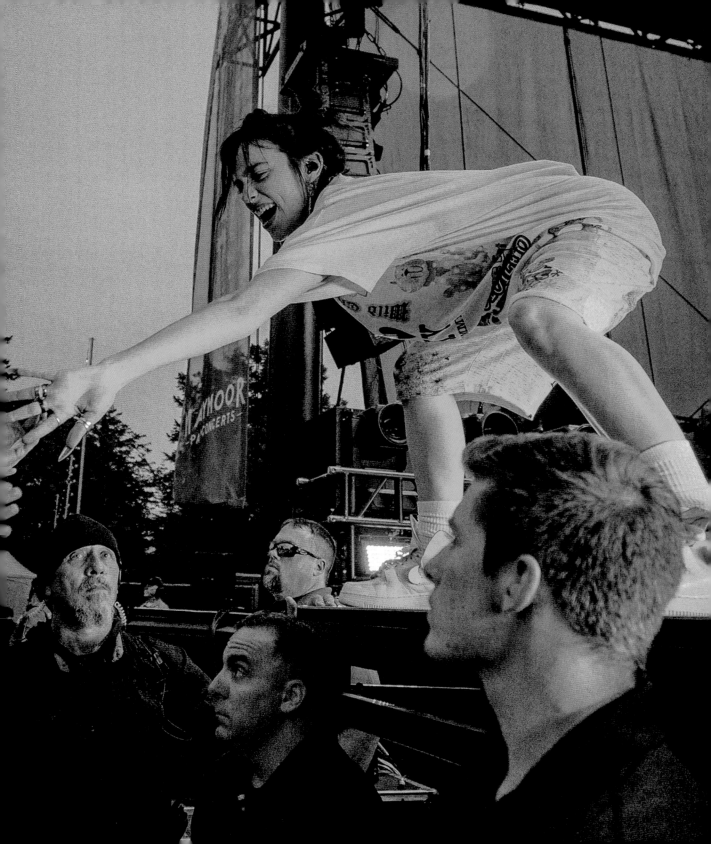

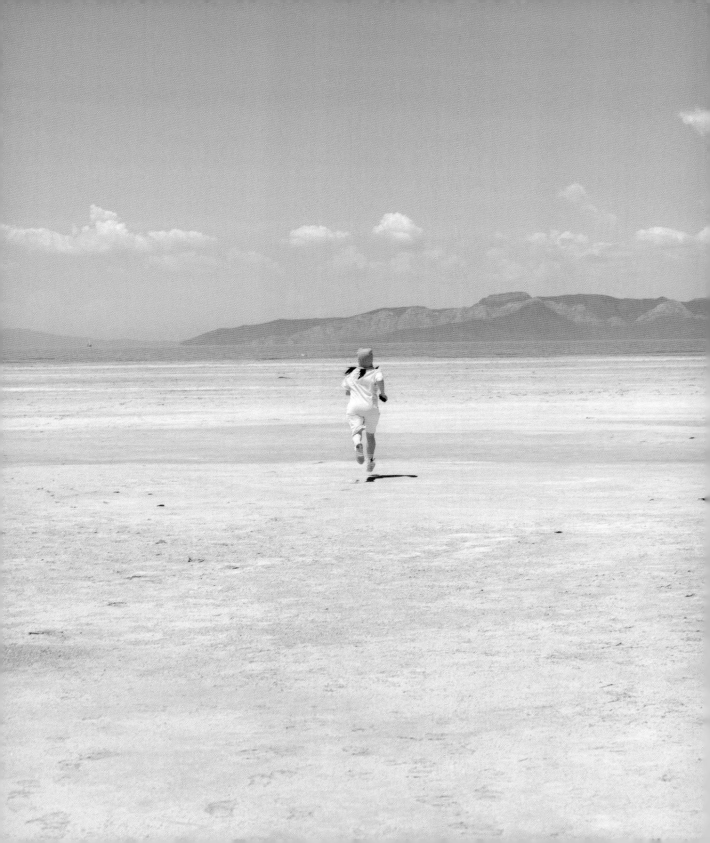

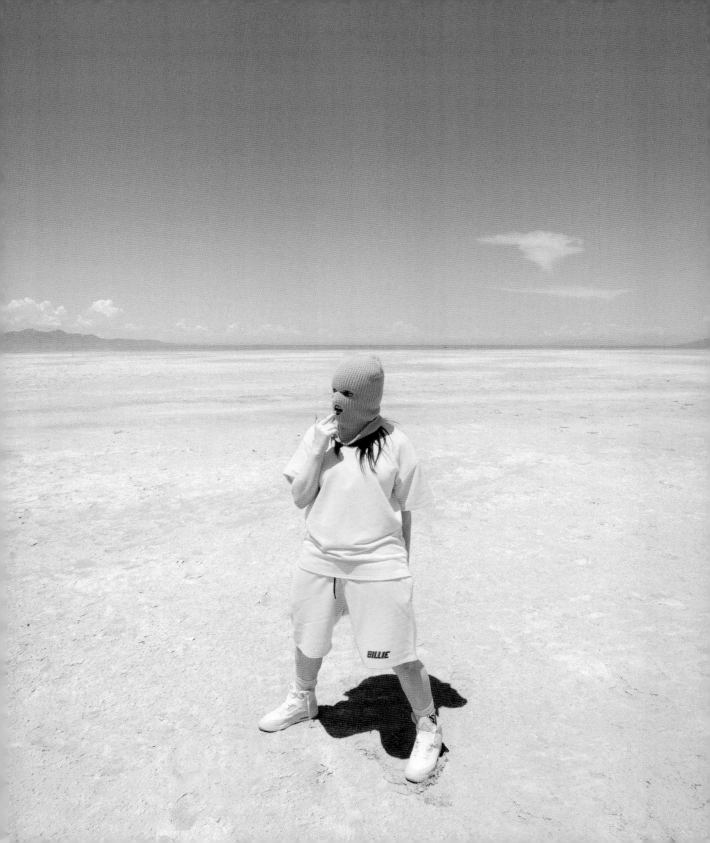

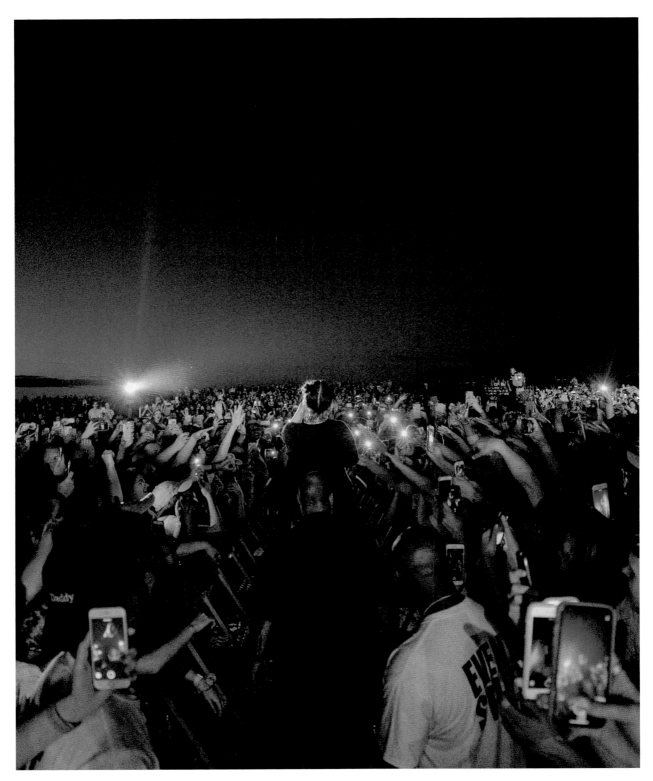

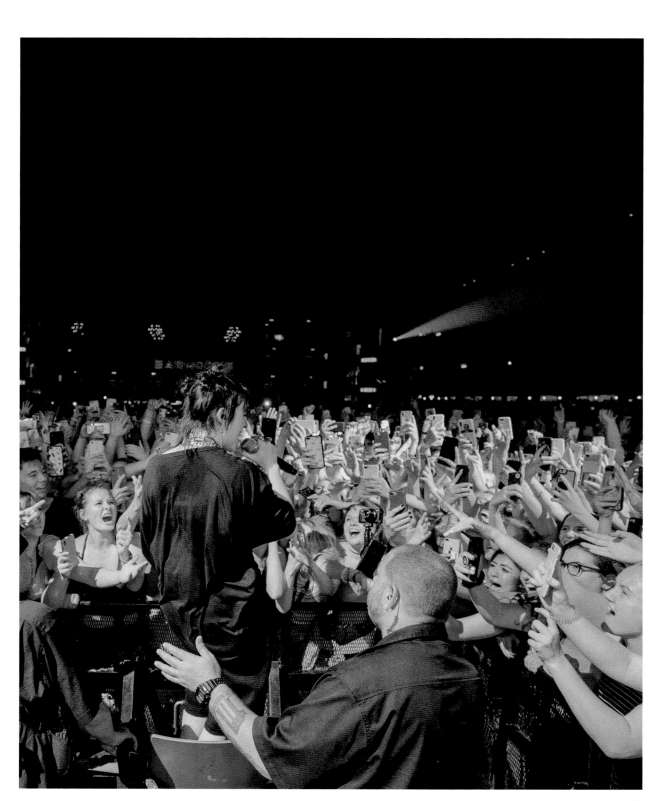

Always playing frisbee in the empty venue. Such an honor to play at Red Rocks.

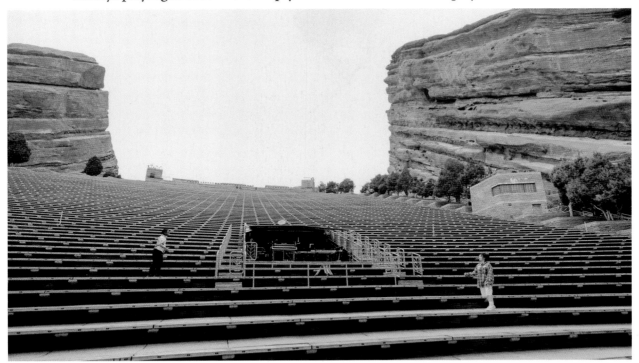

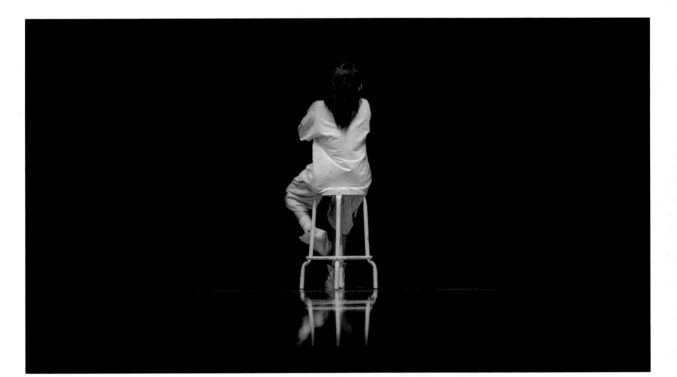

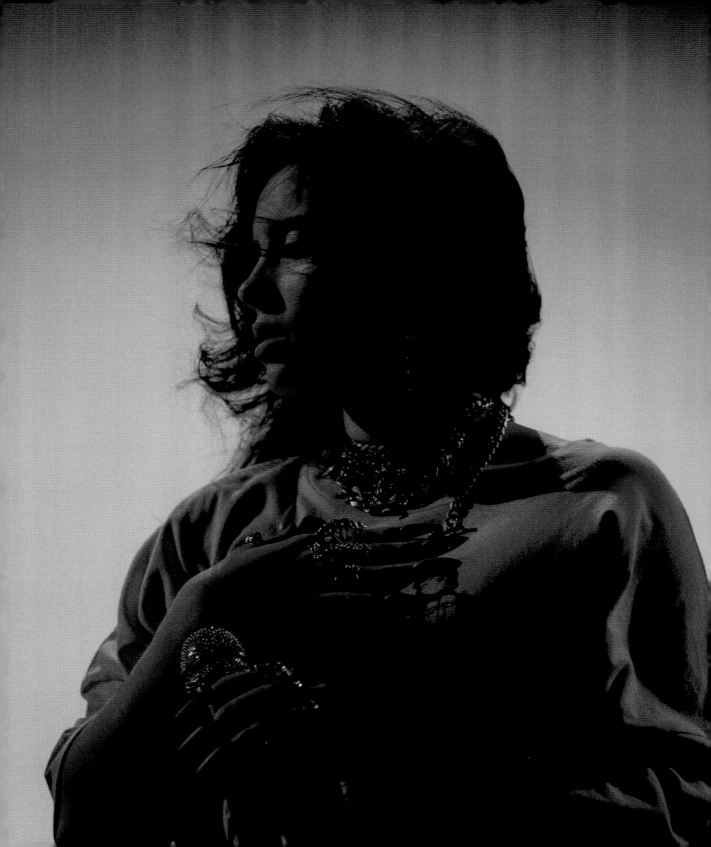

Zel opened for me on this tour and he was a beam of light in all of our lives. After every show, because of my injuries I had to keep my legs in ice water for 10-15 mins and I always wanted someone to do it with me. Denzel always liked to pretend he was tough enough to do it but would quit after two minutes.

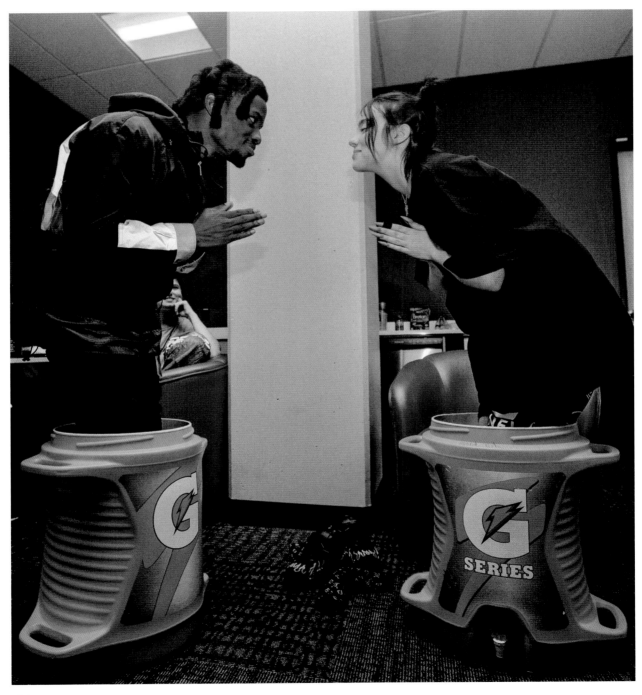

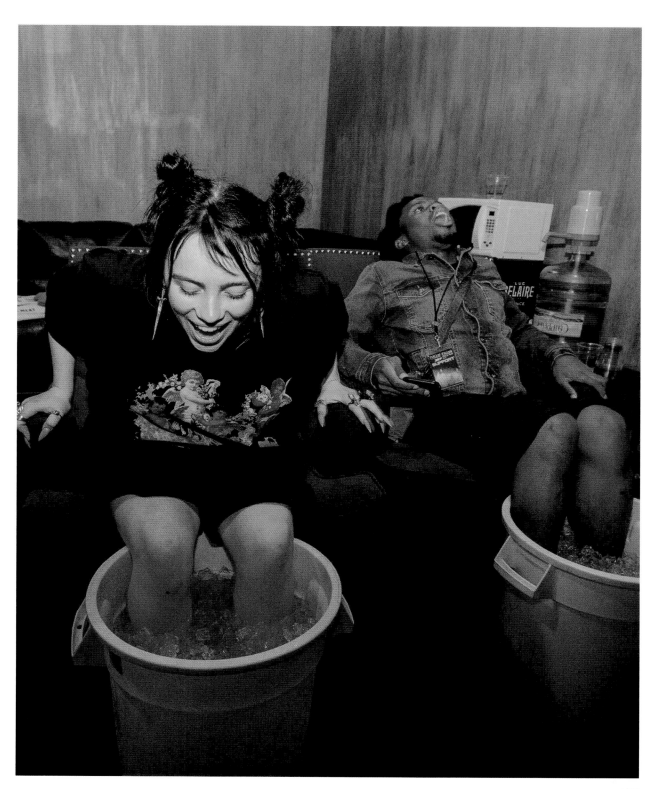

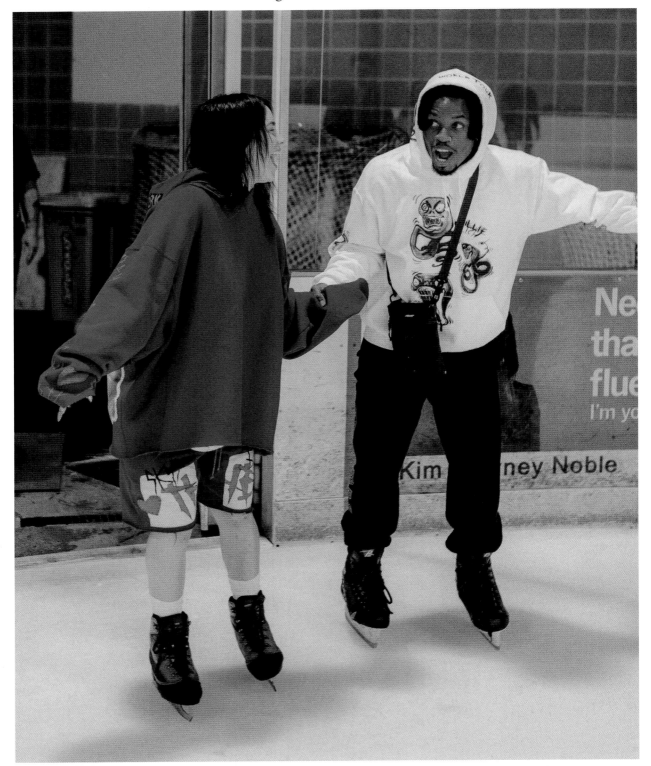

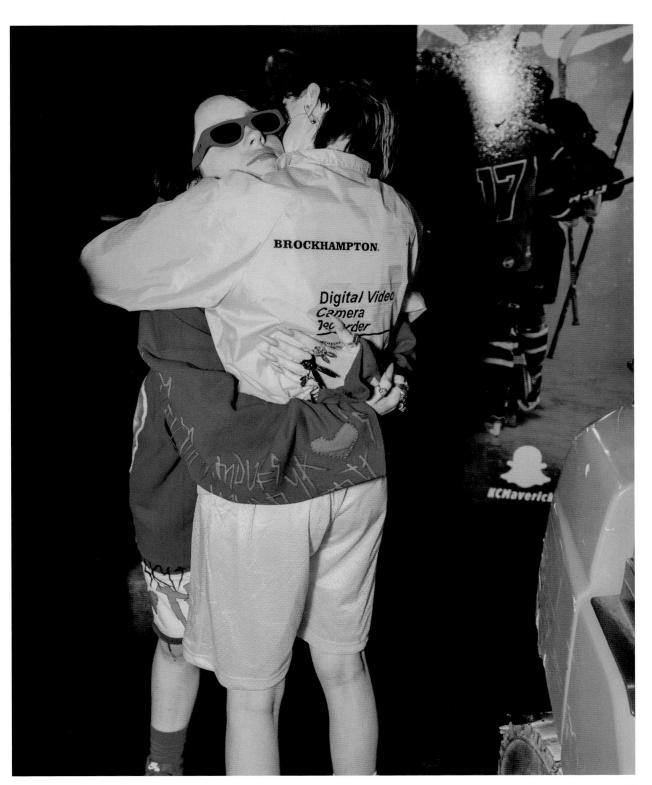

More rescue puppies!

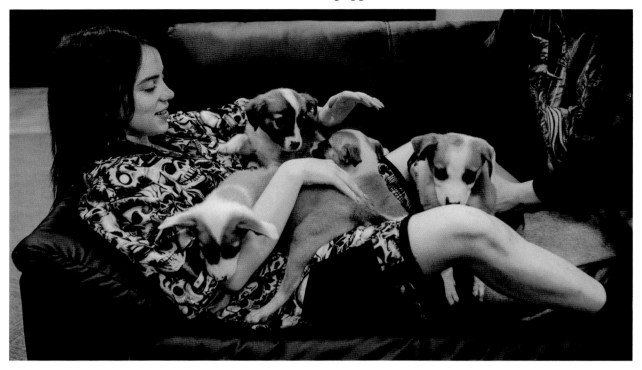

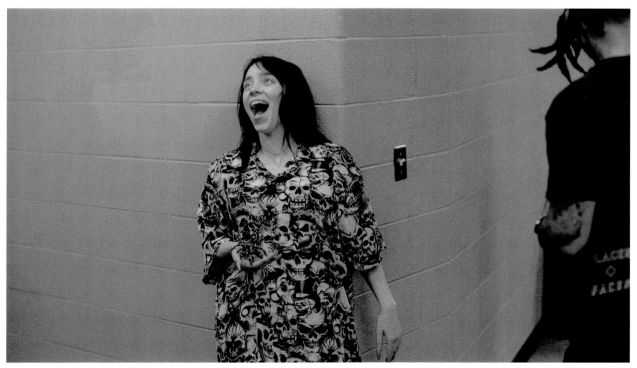

Look closely, pt. 1

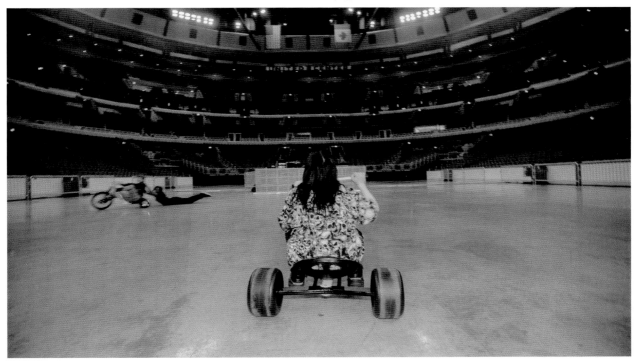

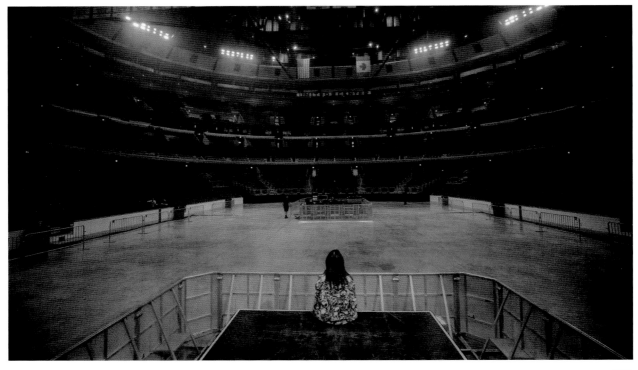

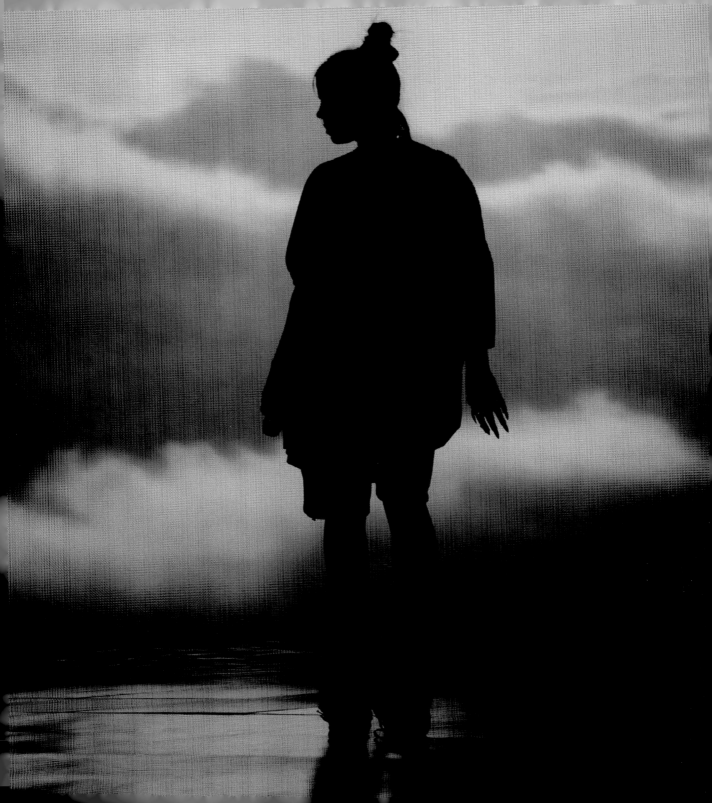

Babieeeeees

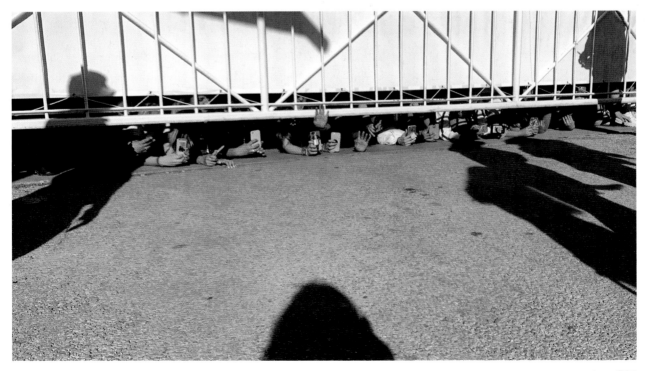

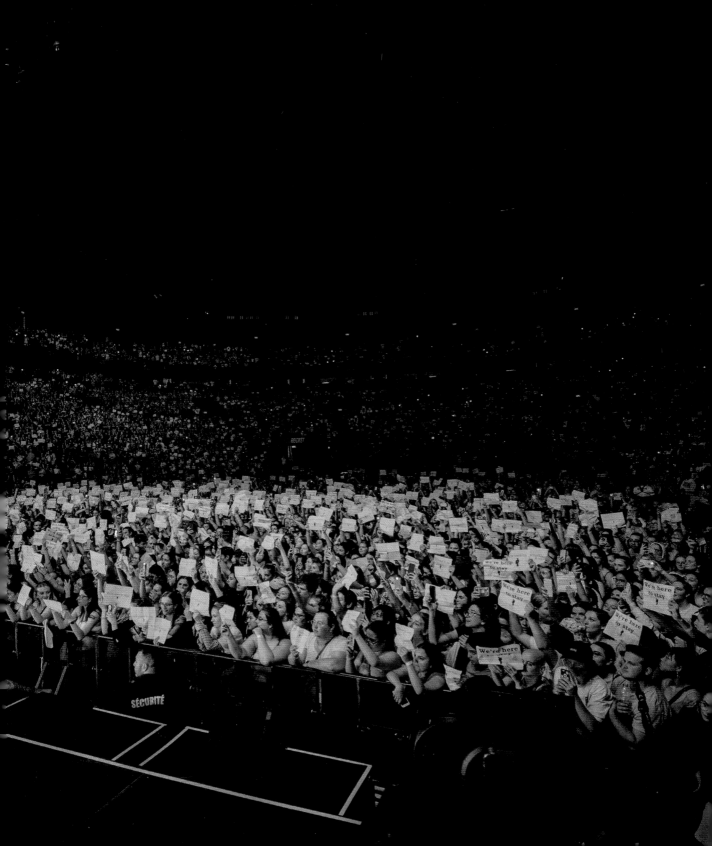

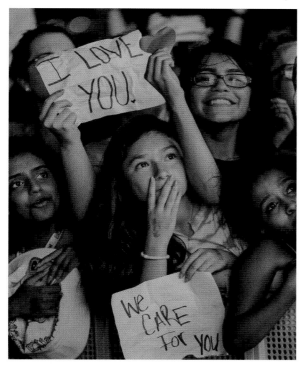

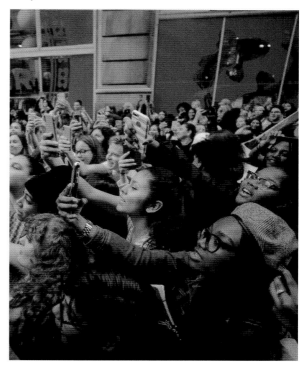

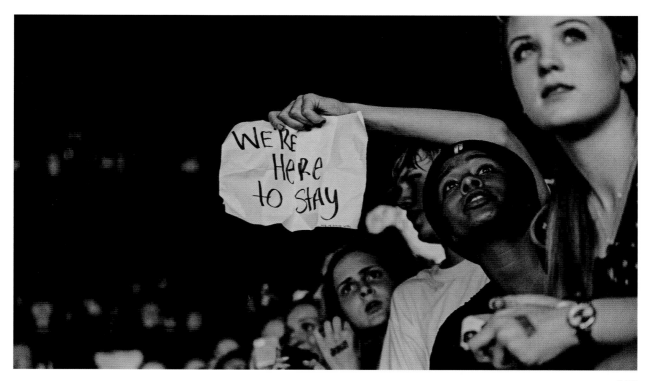

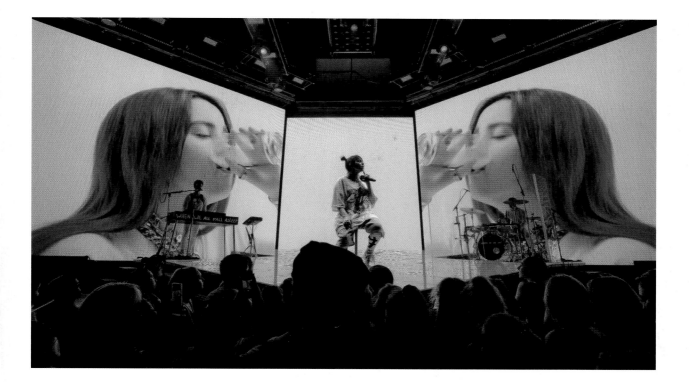

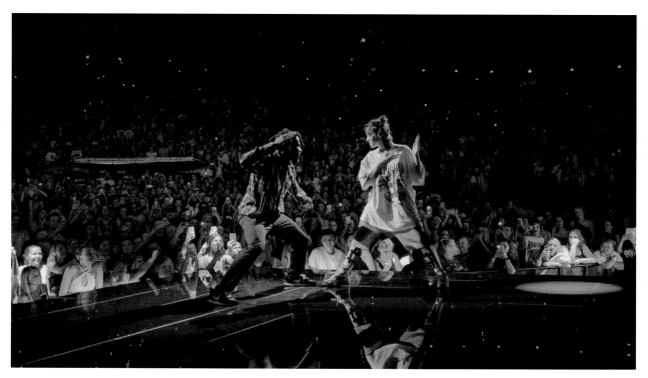

Our routine game of ninja

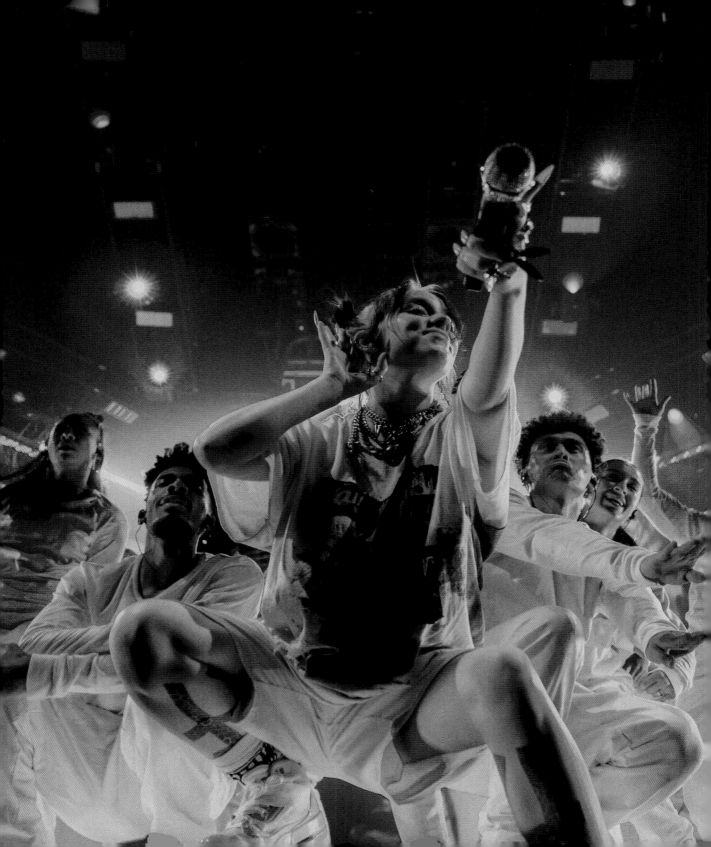

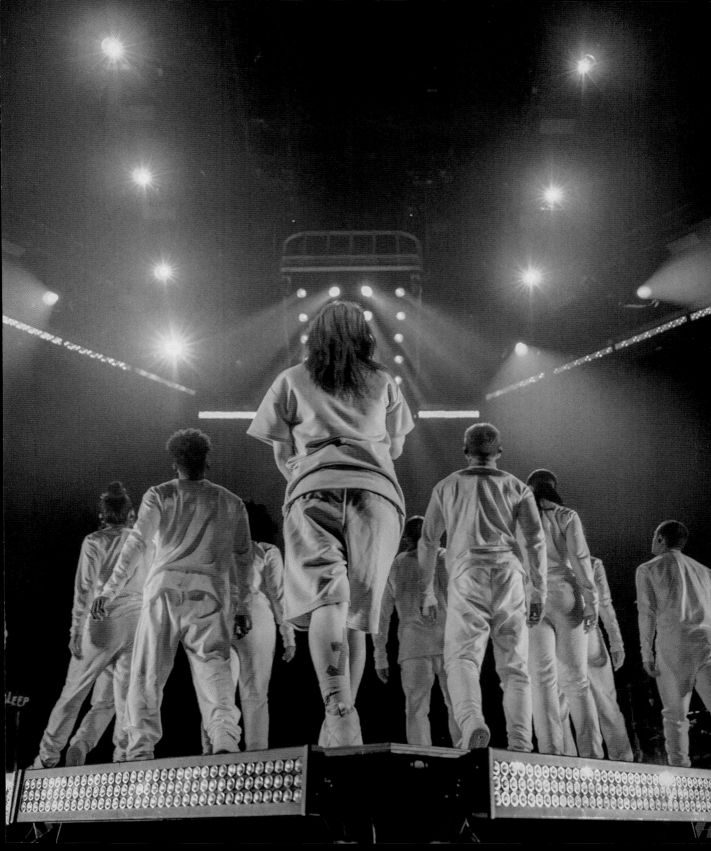

Injured again :) This was about to be the biggest LA show I had done and when I arrived I ran up the stairs to grab a scooter to ride around the venue, as usual. Walking down the stairs carrying it over my head, I tripped and seriously ate shit. Couldn't walk and did the show in a boot. Then I sprained the other ankle like a month later. It was a very bad summer for my limbs.

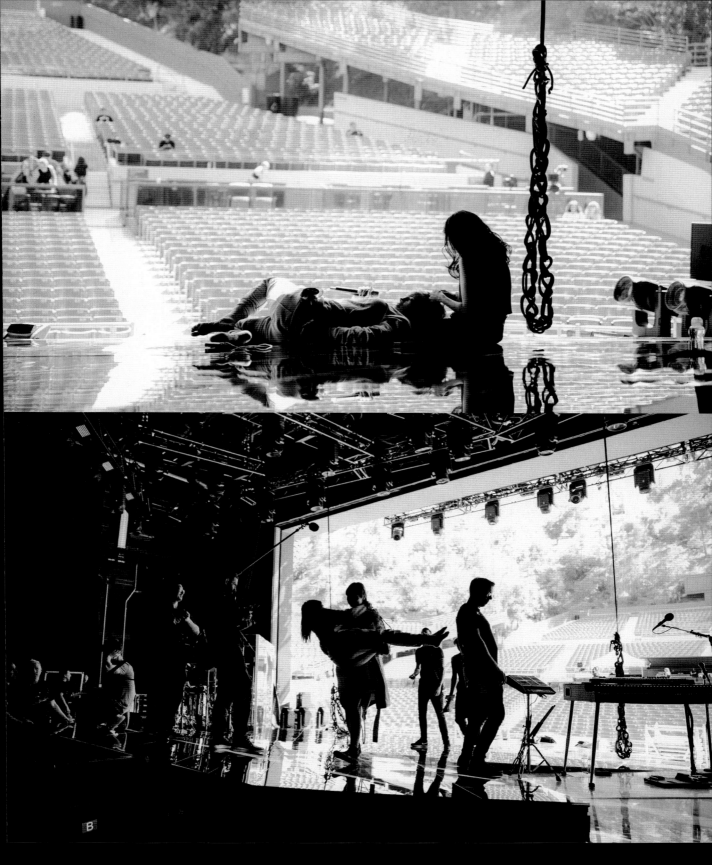

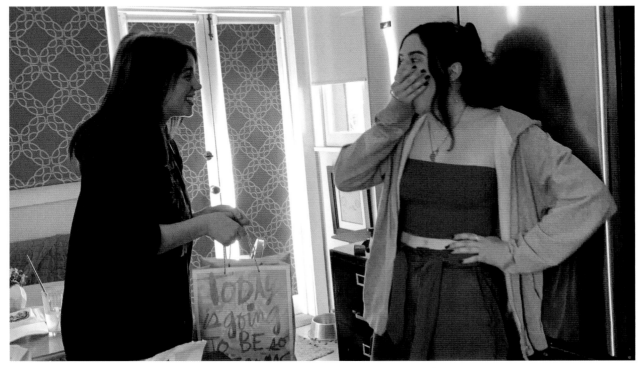

Drew's 18th birthday. I got her 18 burritos.

My Zoe being a trooper on tour with us

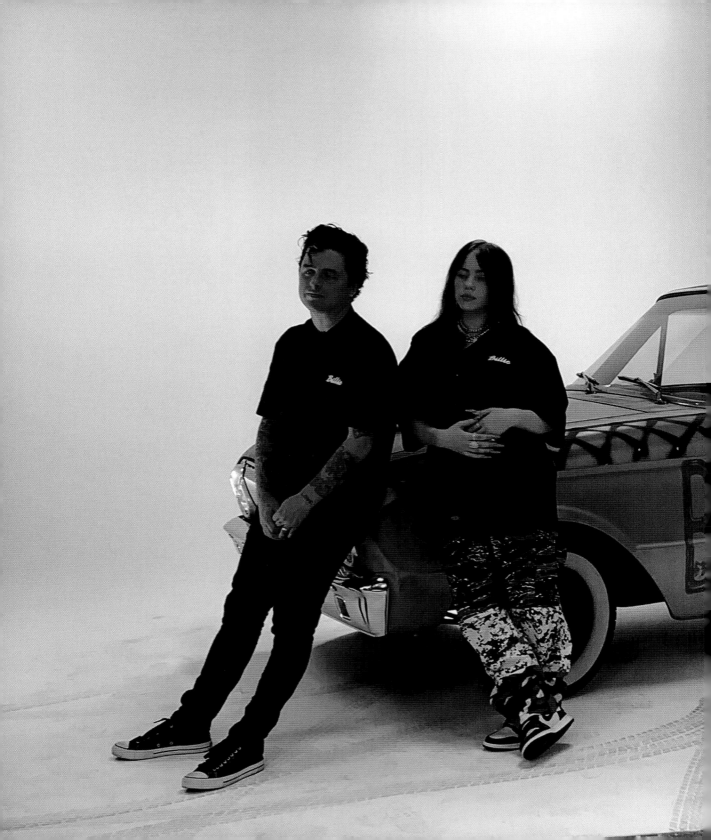

I always want to make sure that we use as little VFX as possible for my videos. That also means our shoots are pretty intense. Dangled from a crane... almost died. Then plopped myself in thick black goop with 40-pound wings on my back. By the time I had to walk with them, they weighed about 150 pounds with the extra goo... LORD

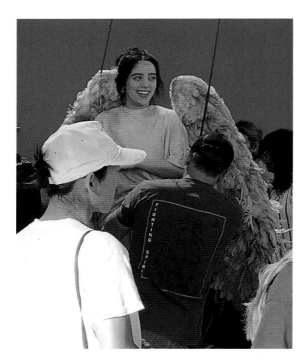

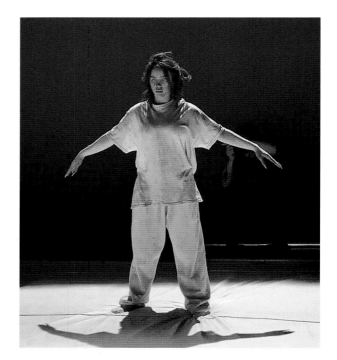

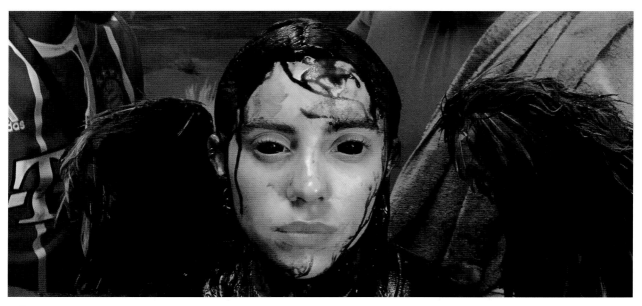

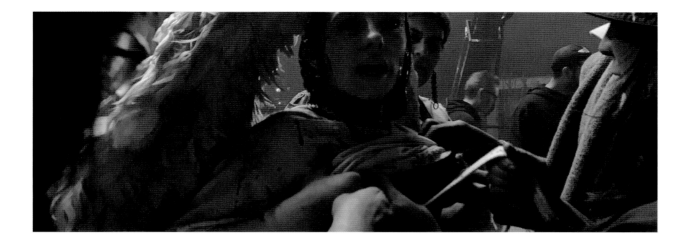

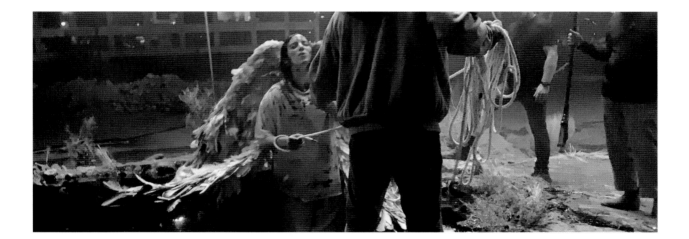

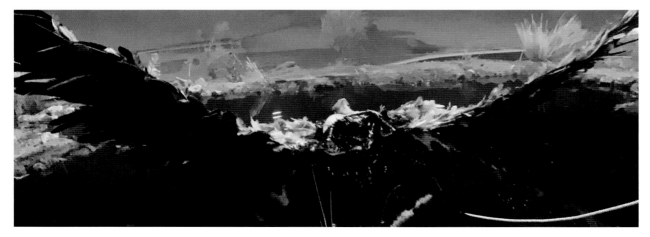

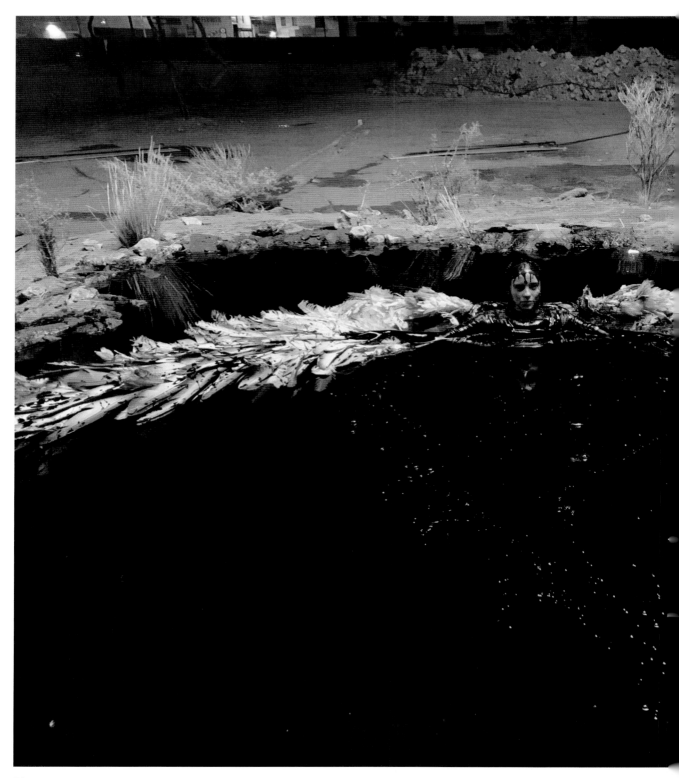

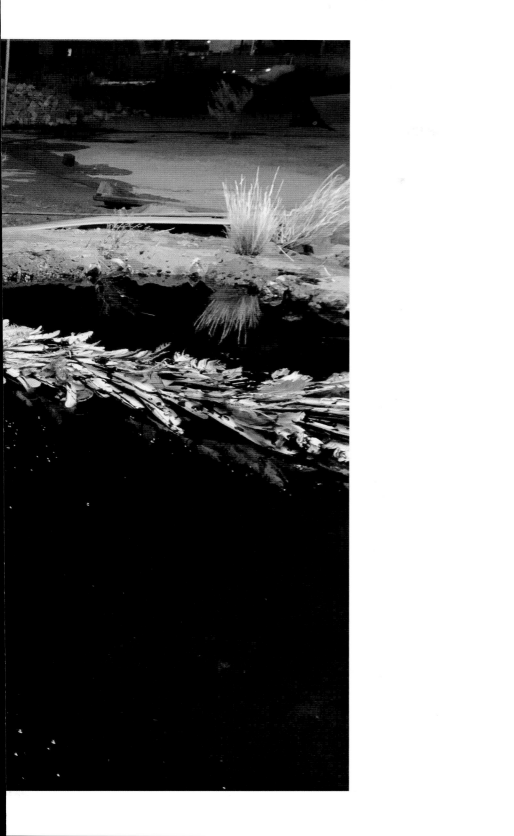

Hehehe

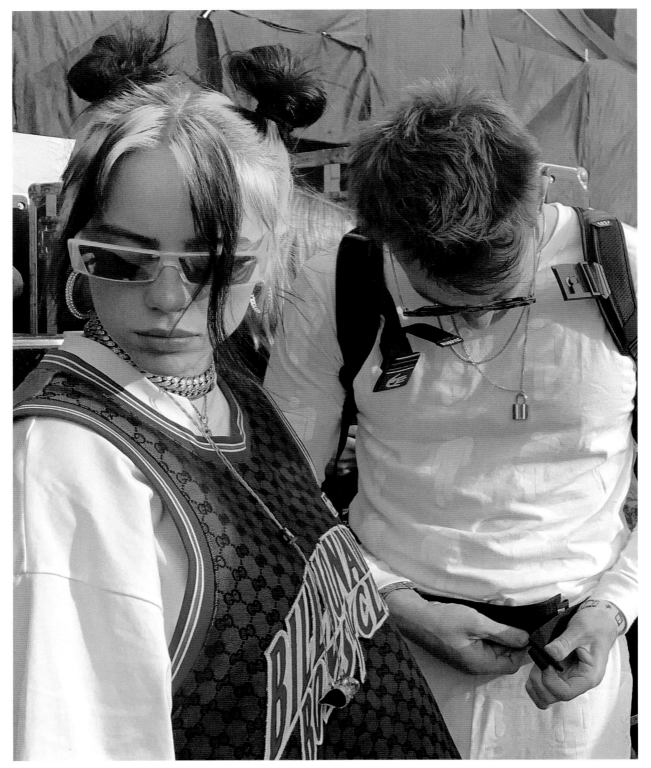

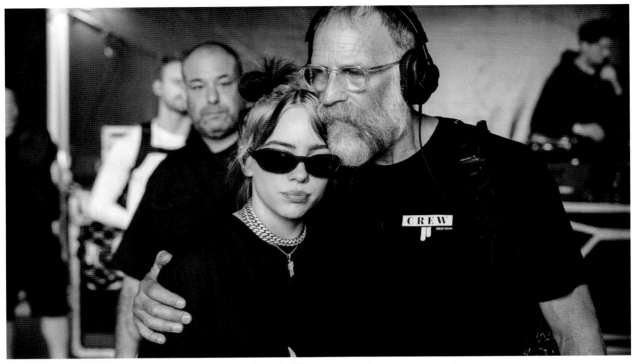

Since the beginning my dad has worked on my crew, very cute.
I'm so lucky to have my family with me always.

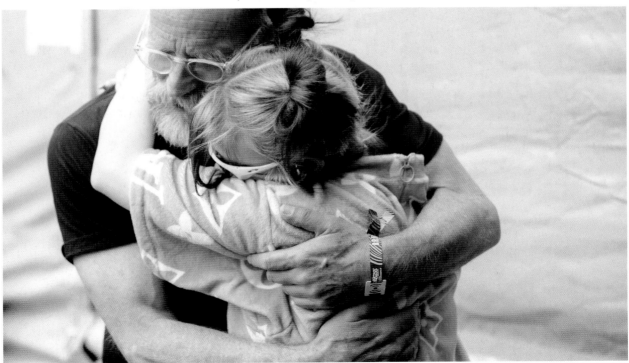

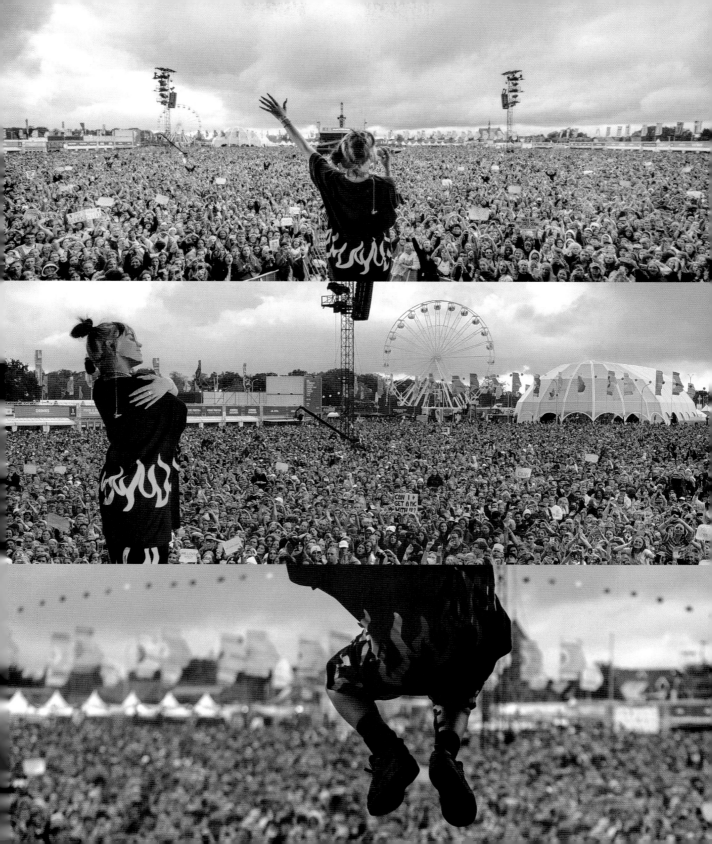

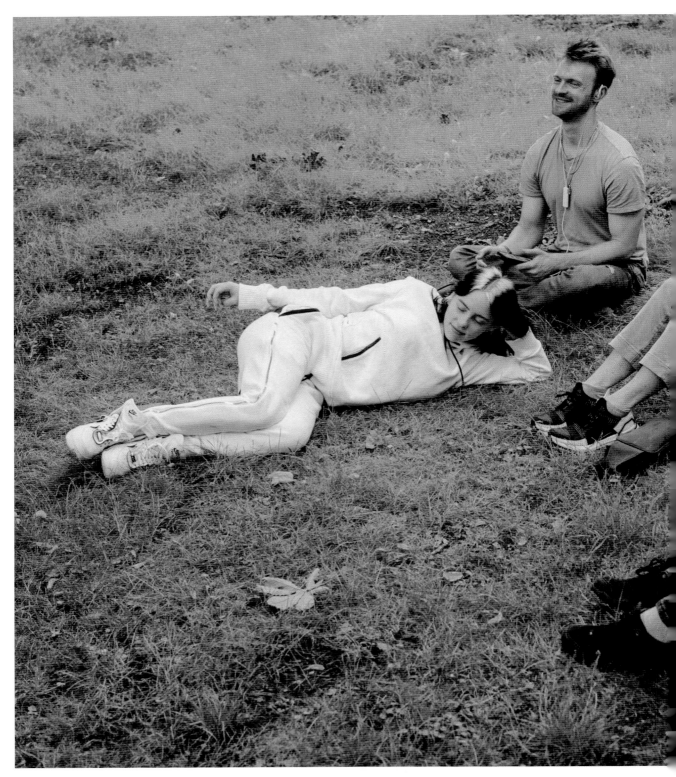

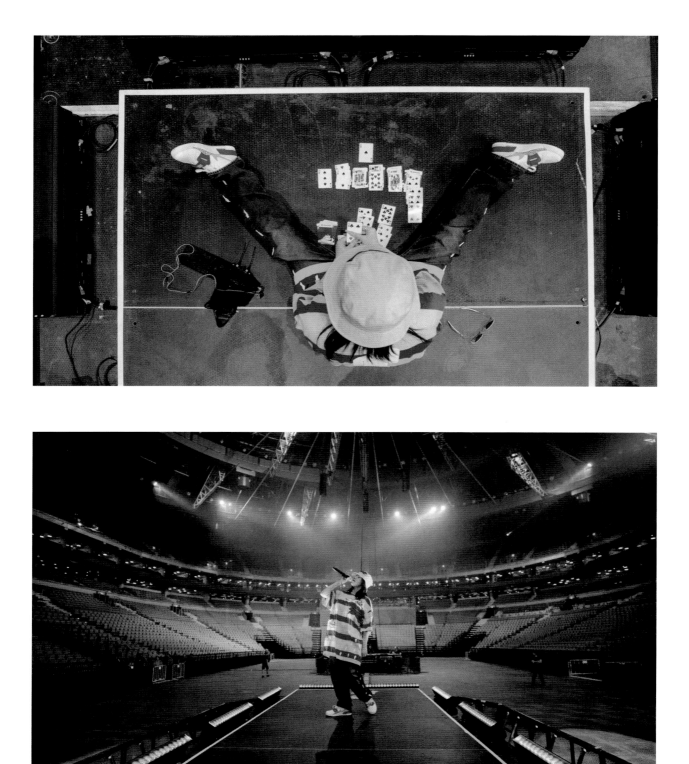

Before

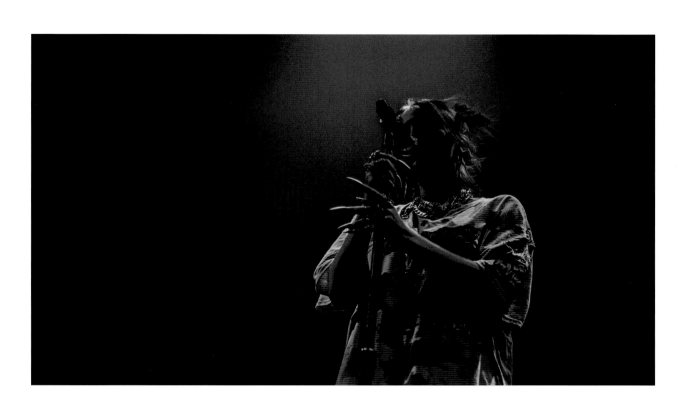

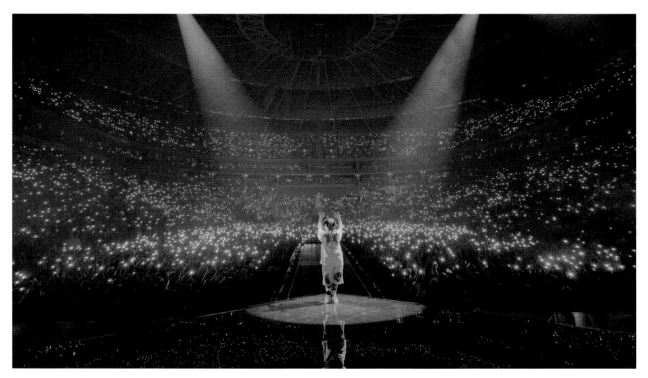

After

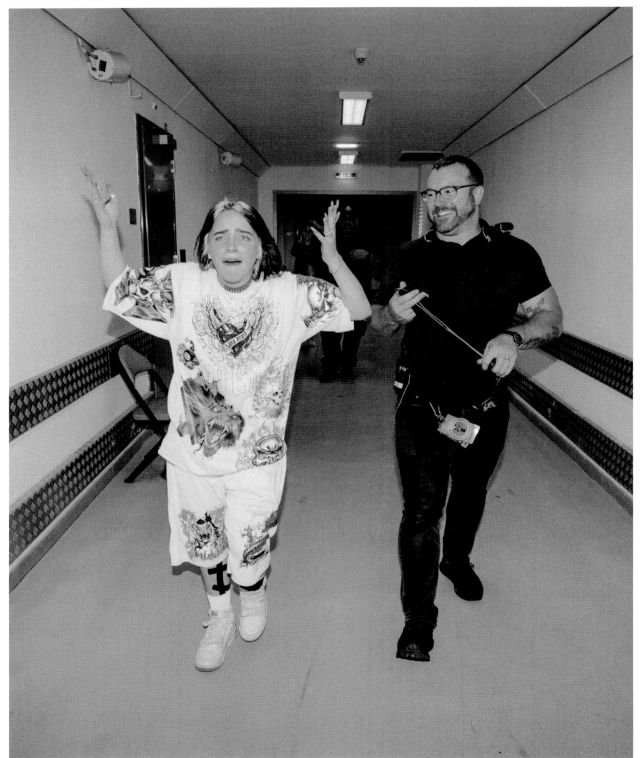

233

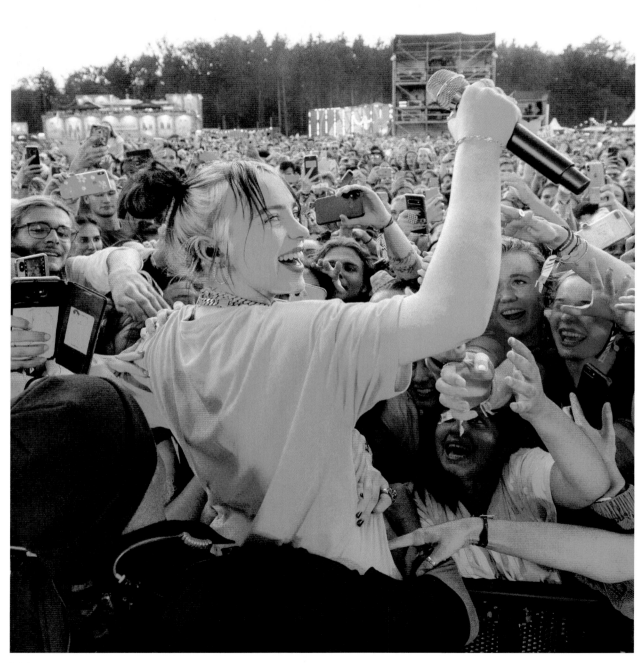

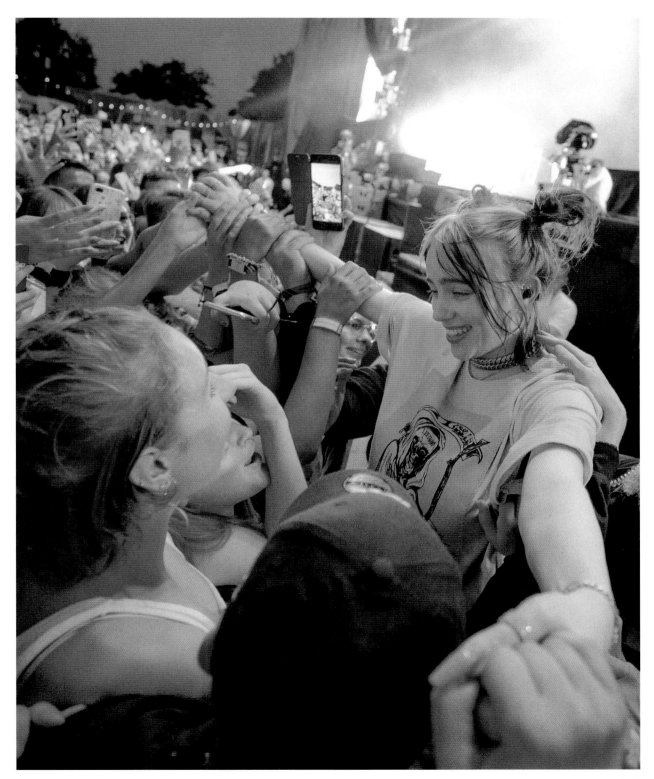

"I'm Gonna Fucking Die Disease: tummy hurts a bit too much for a bit too long"

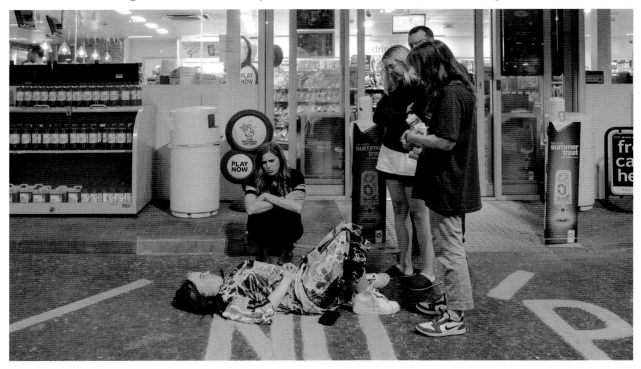

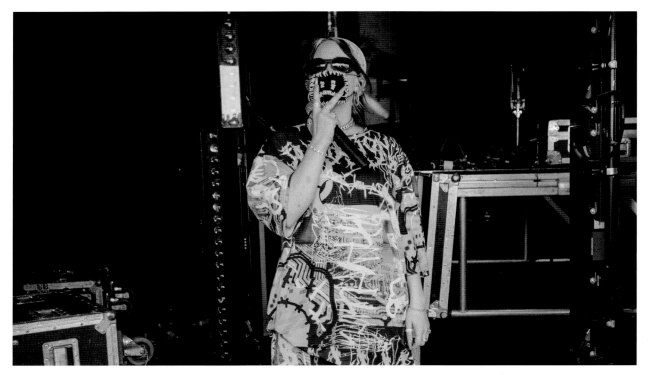

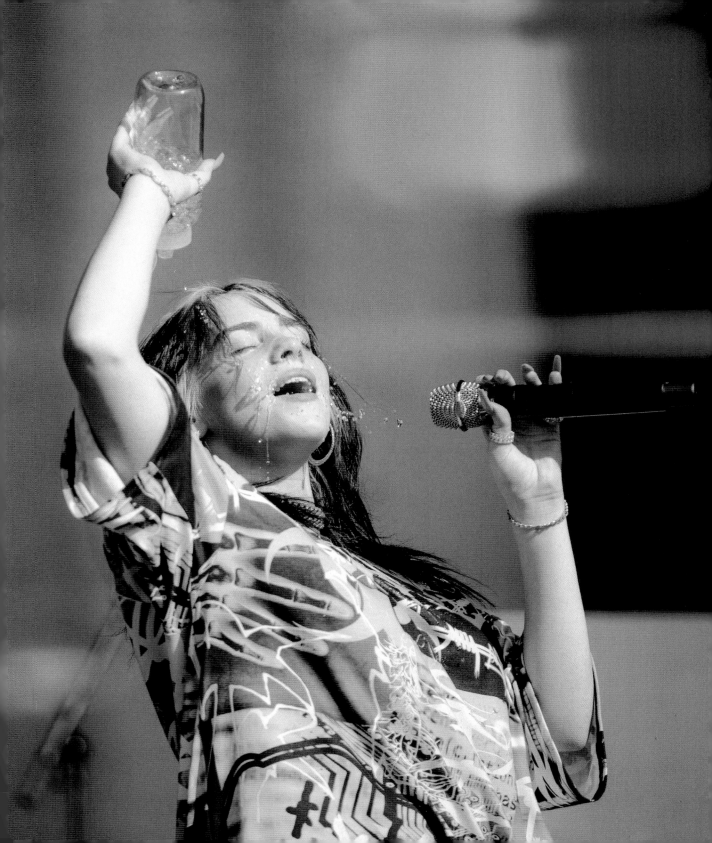

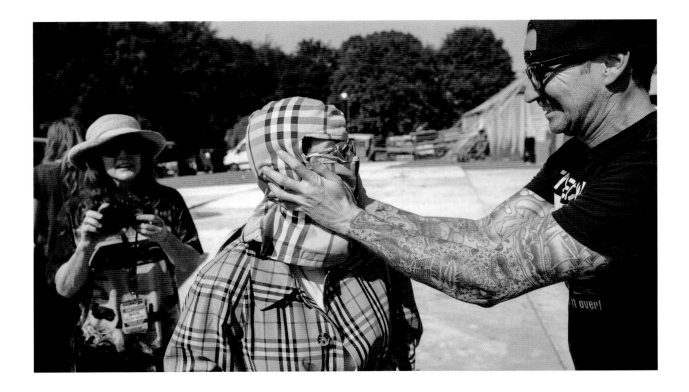

We must have spent 10,000 hours playing Speed on this tour

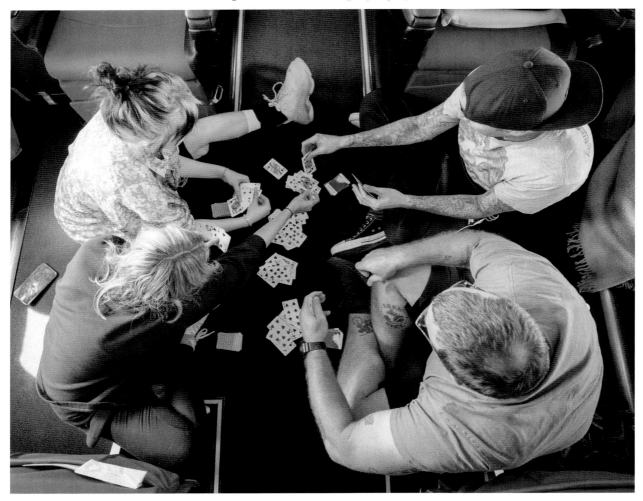

The airline had this for us every time we got on.

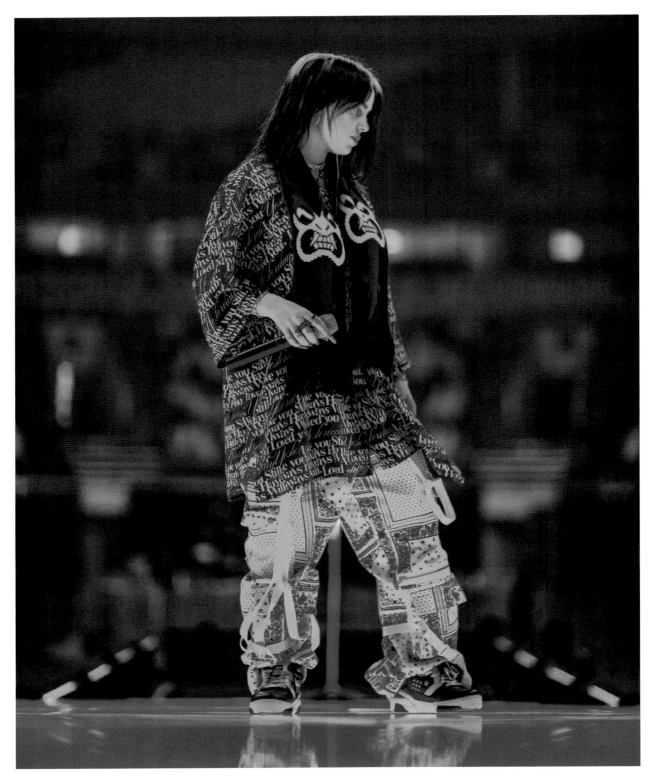

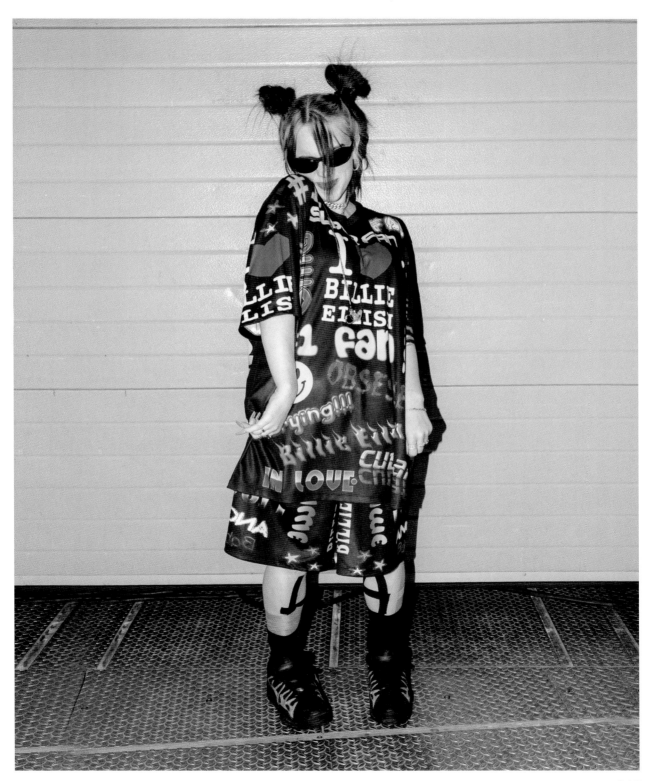

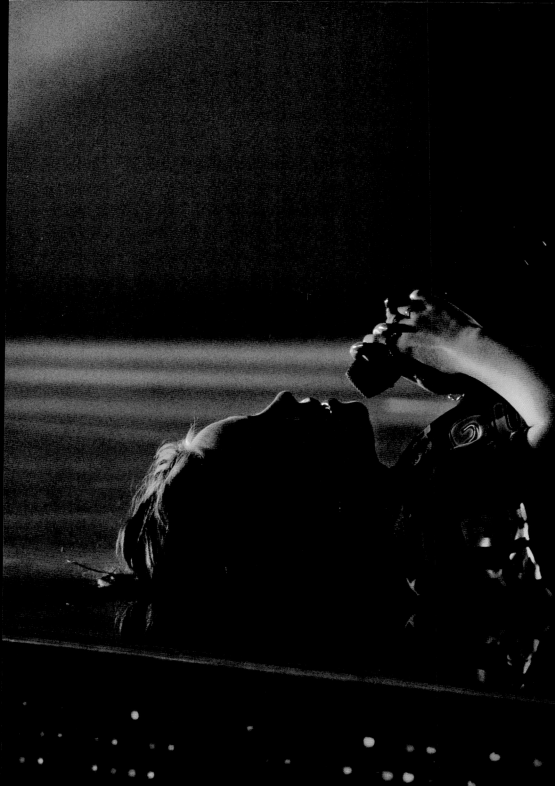

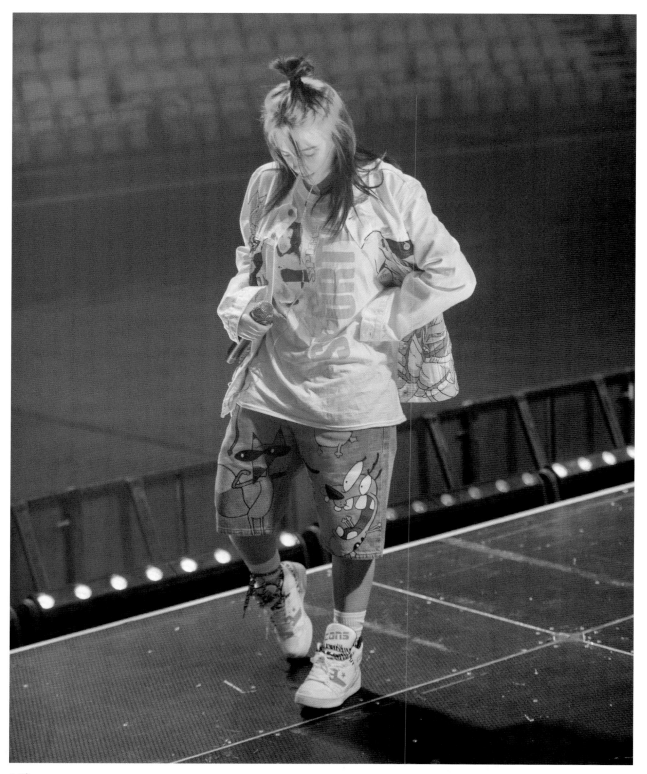

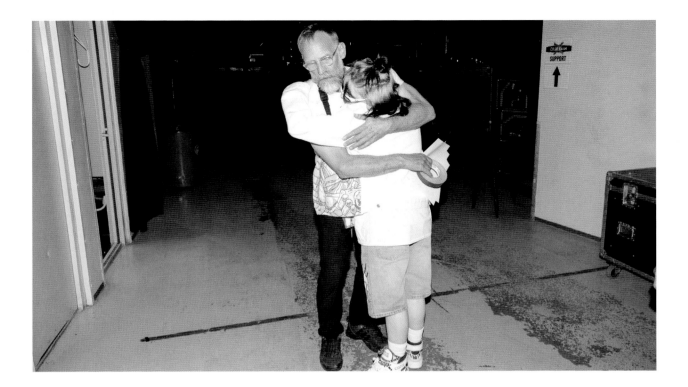

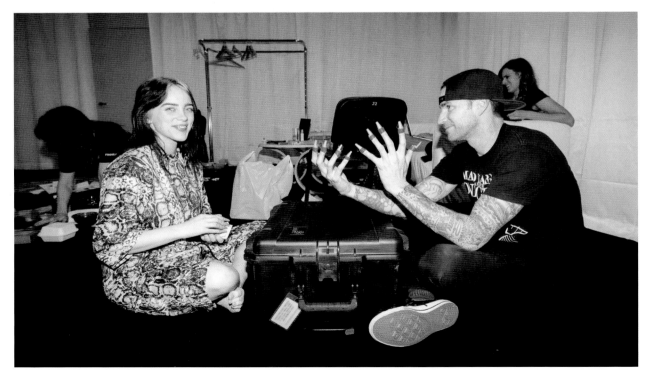

Made Trevor (my guitar tech) put on fake nails so we were even while playing cards.

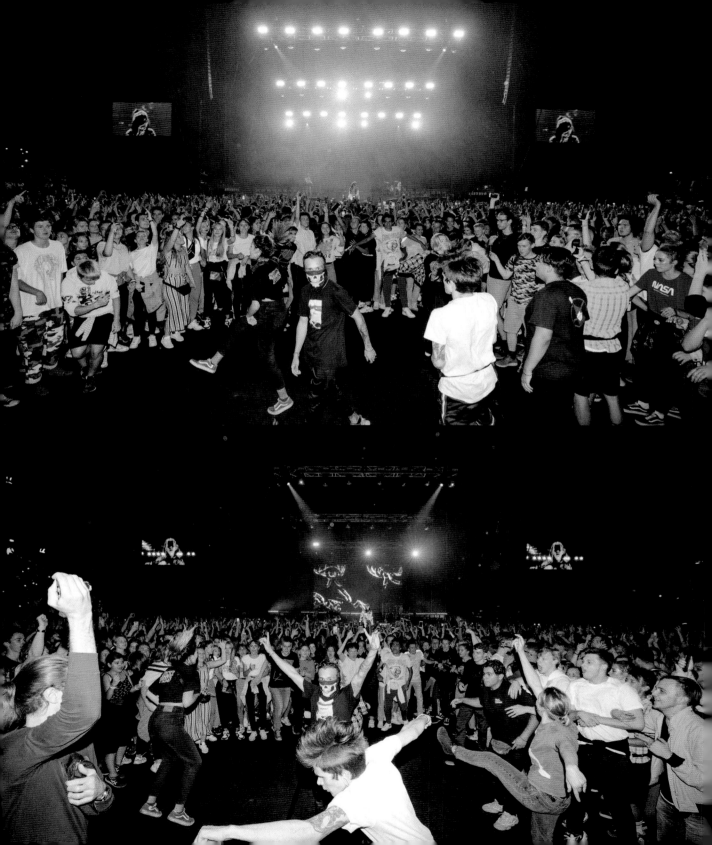

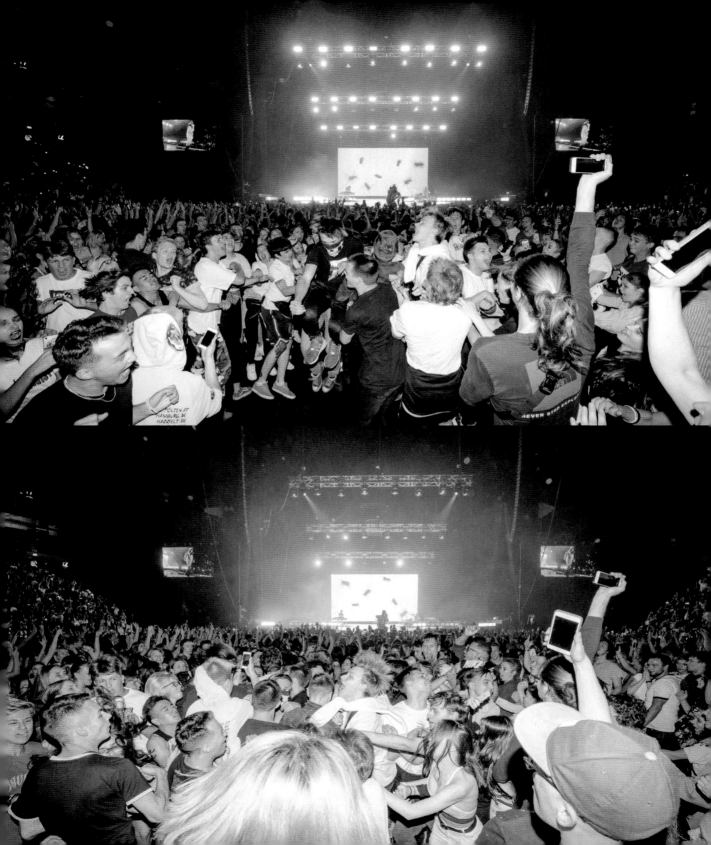

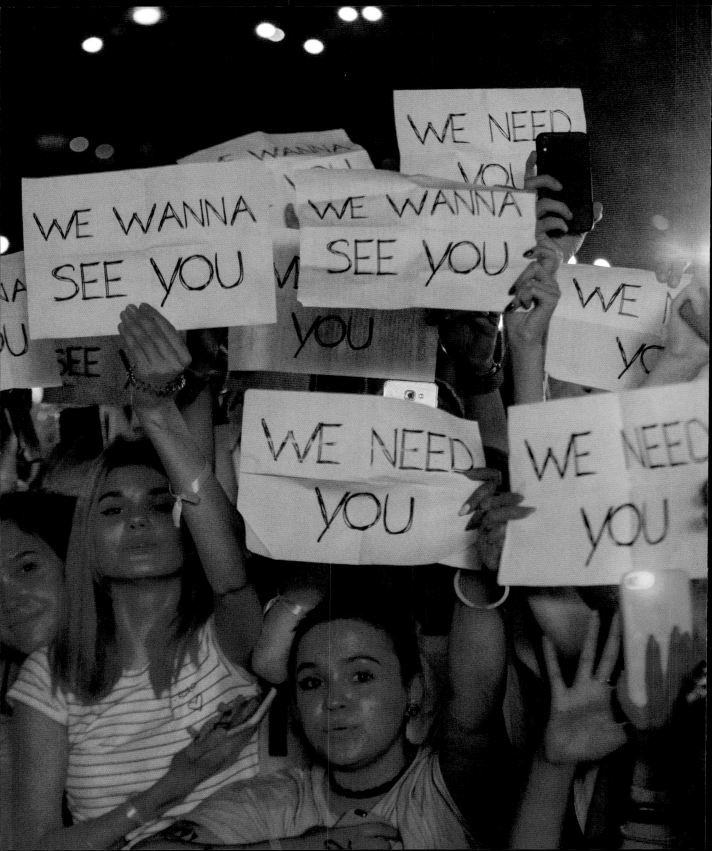

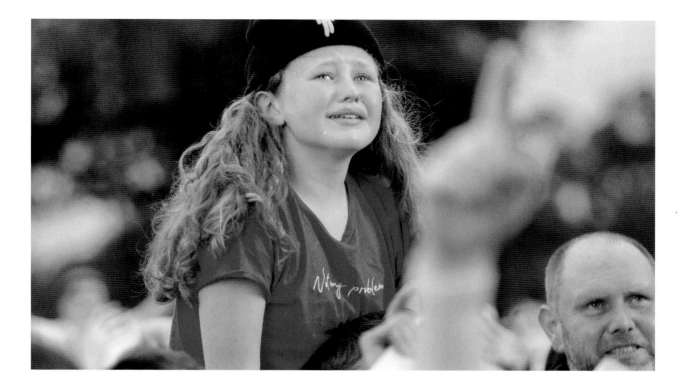

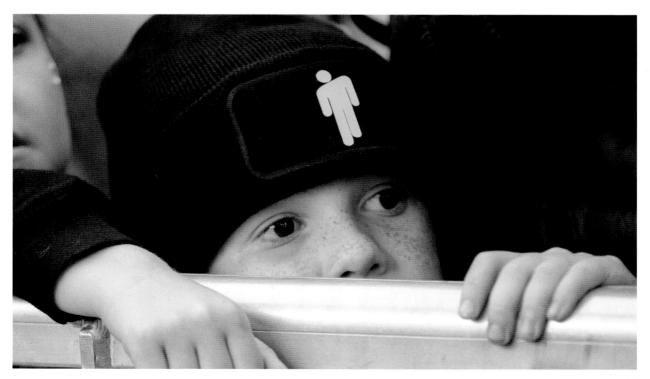

My lovely Laura

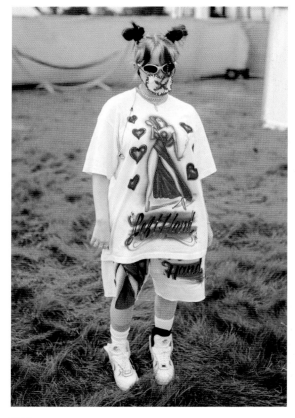

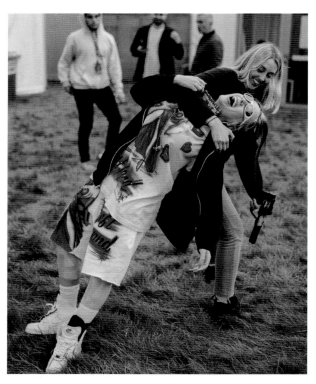

Laura is my day-to-day manager, but we're really good friends, so it doesn't feel like work.

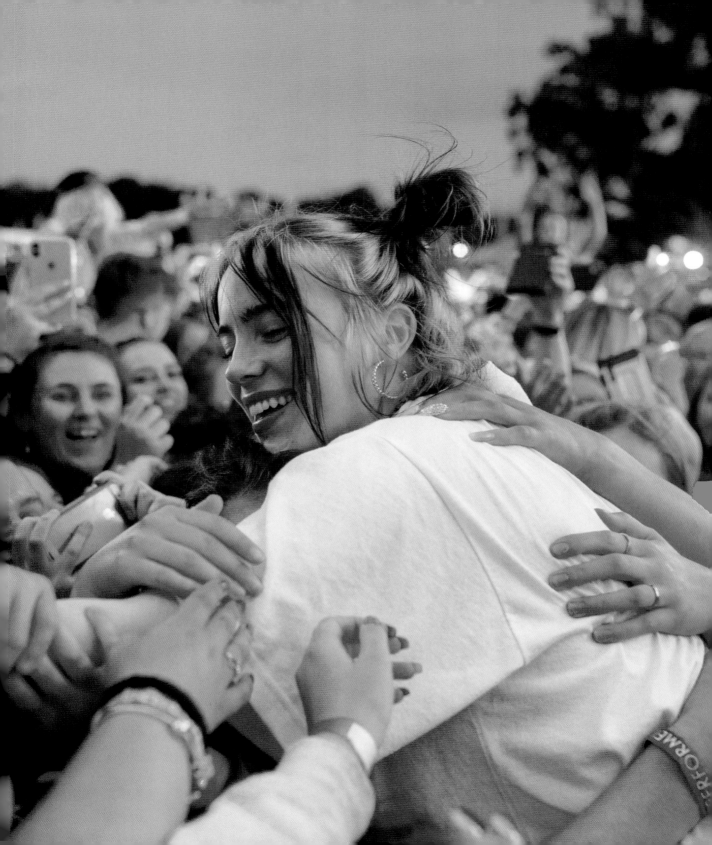

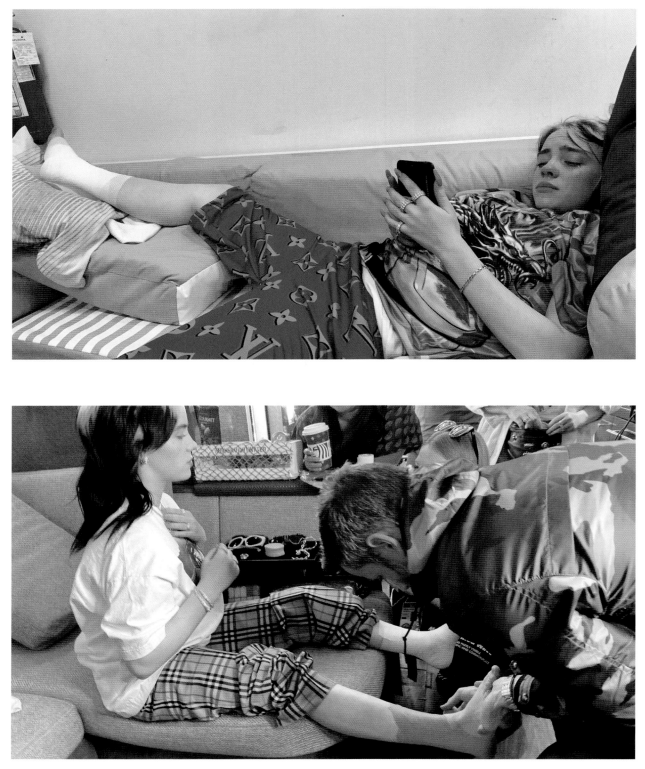

ah haha... once again.

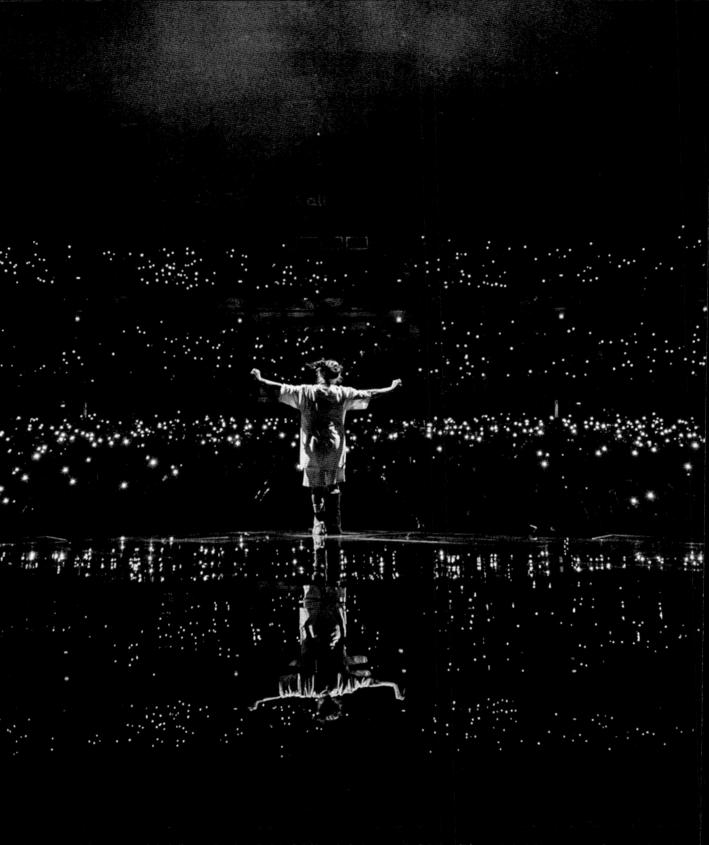

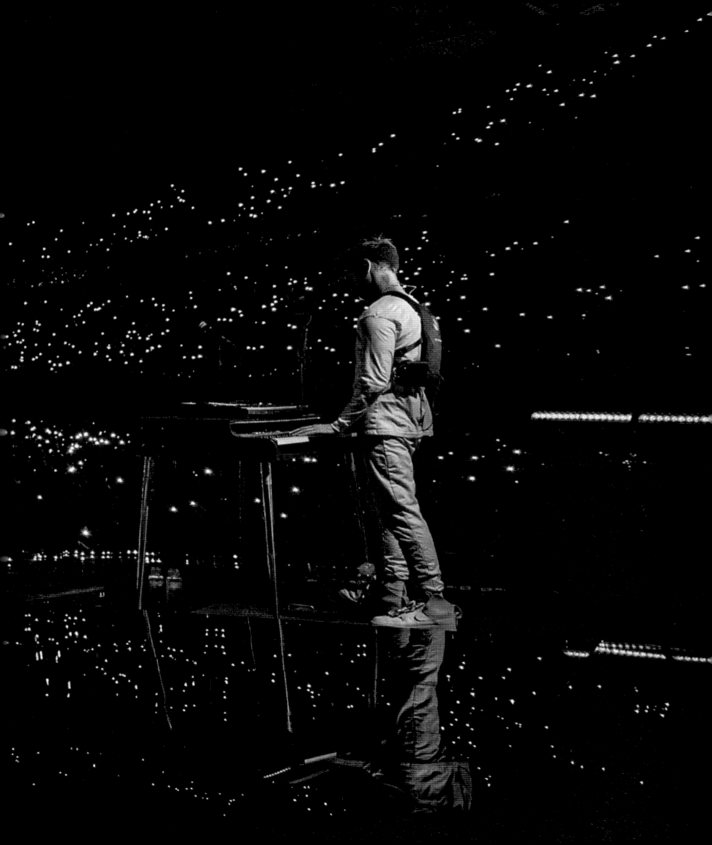

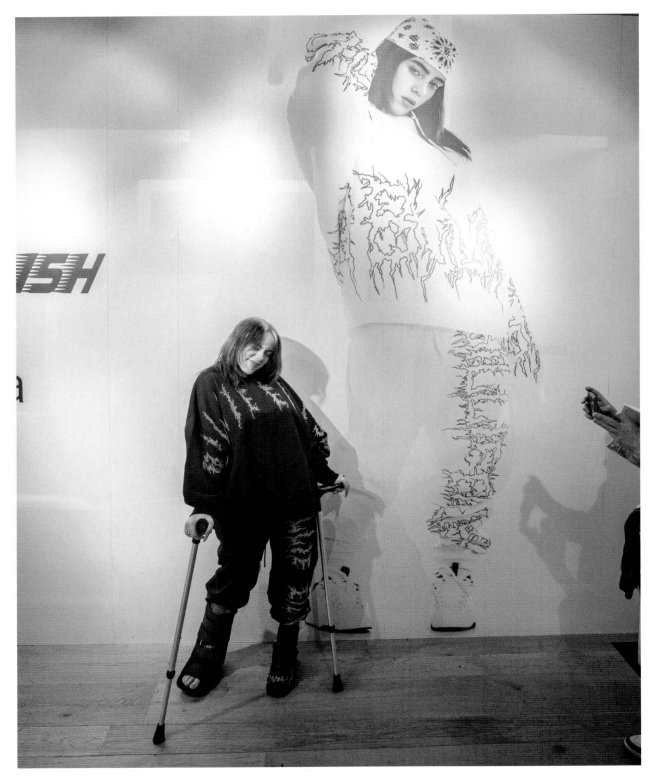

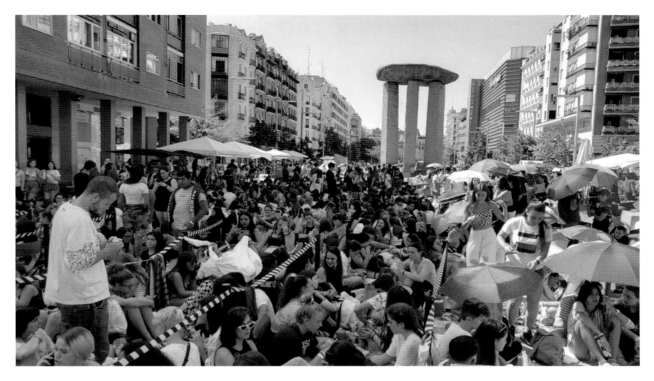

The lines outside the venue before my shows are some of the cutest shit I've ever seen.

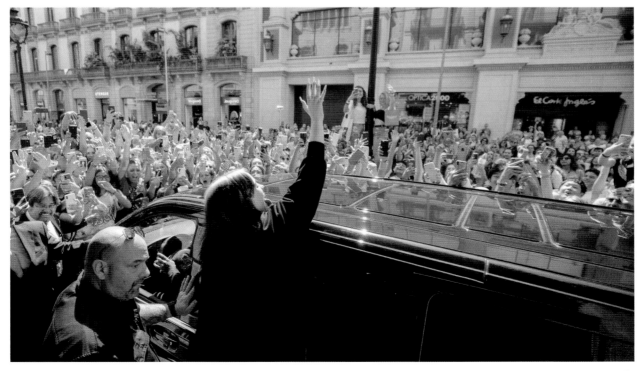

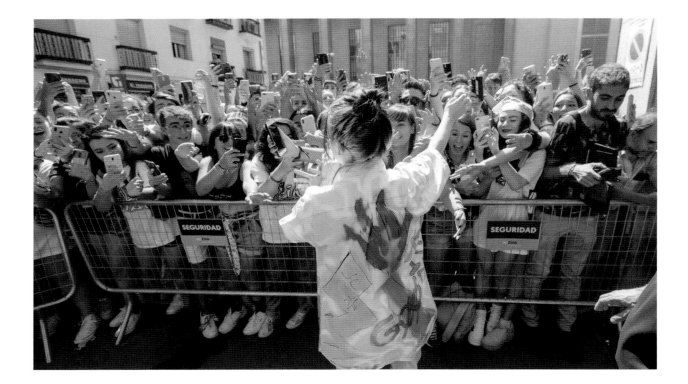

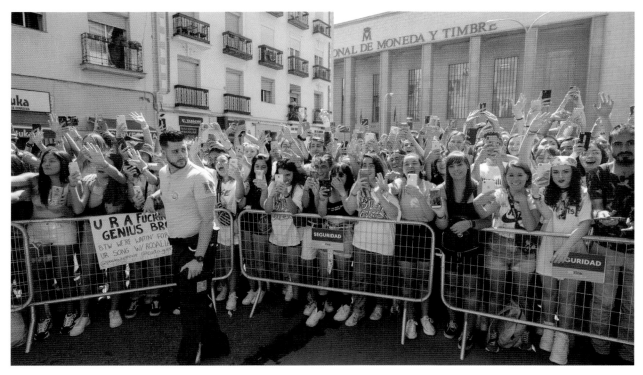

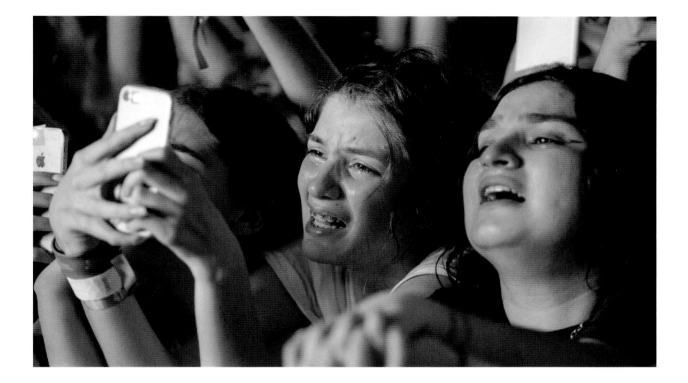

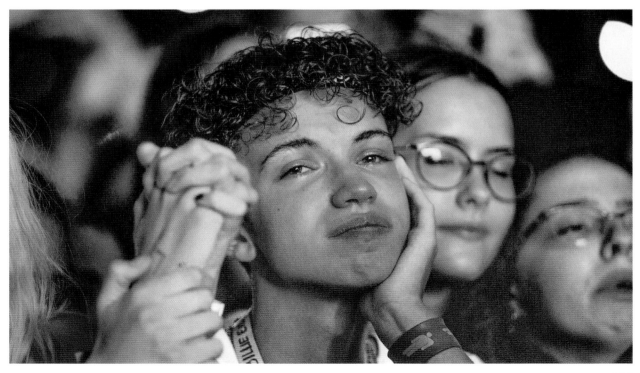

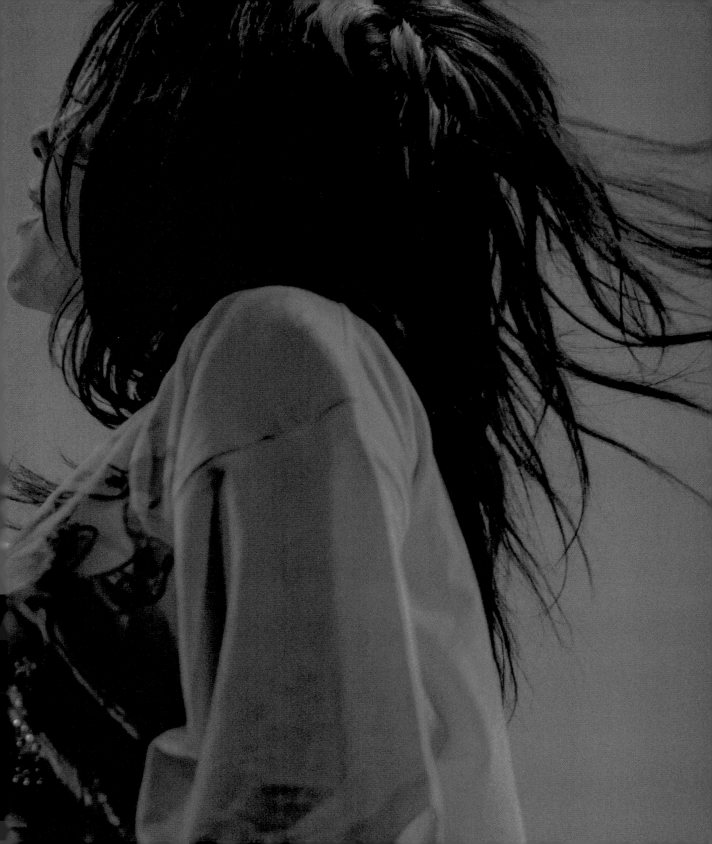

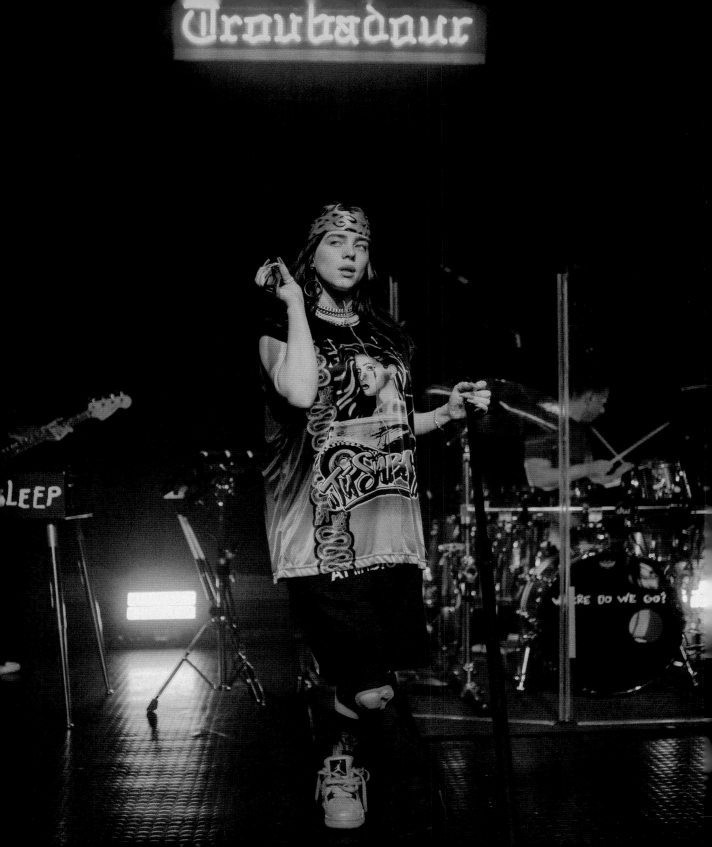

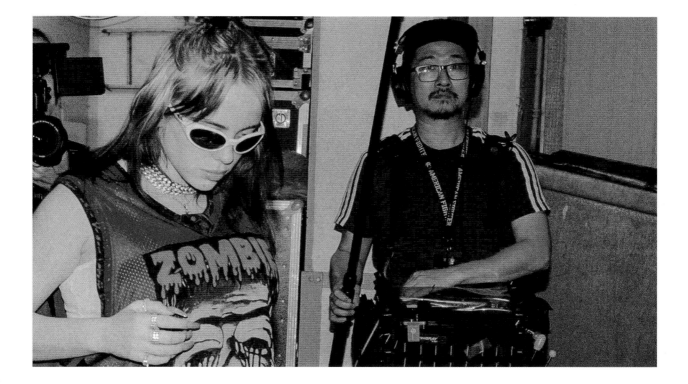

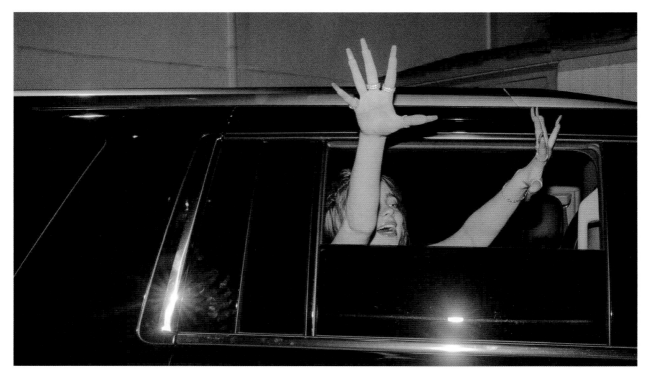

Our Airbnb had a trampoline in the ground and we thought it was the funniest thing ever.

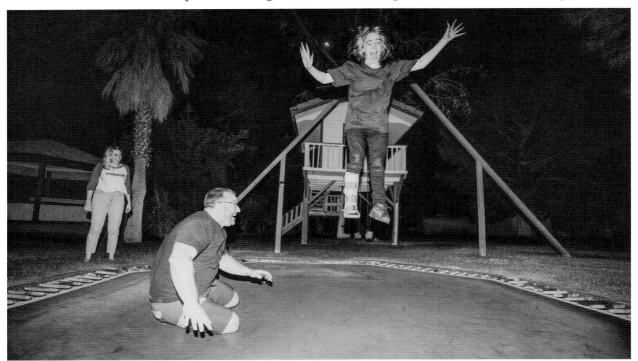

Me laughing so hard I started to pee a little

Me on the ground crossing my legs trying not to pee

Me, defeated.

Season opener for *Saturday Night Live*! Such a special week.

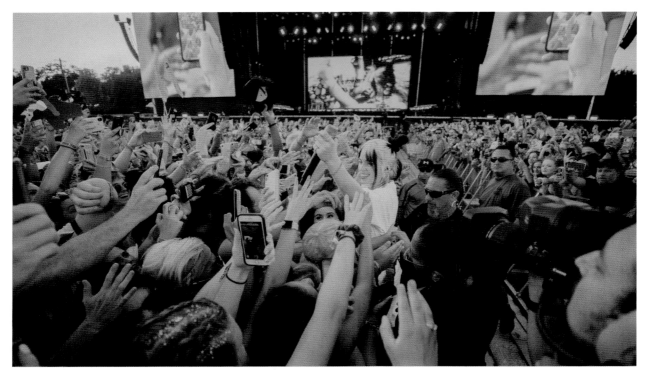

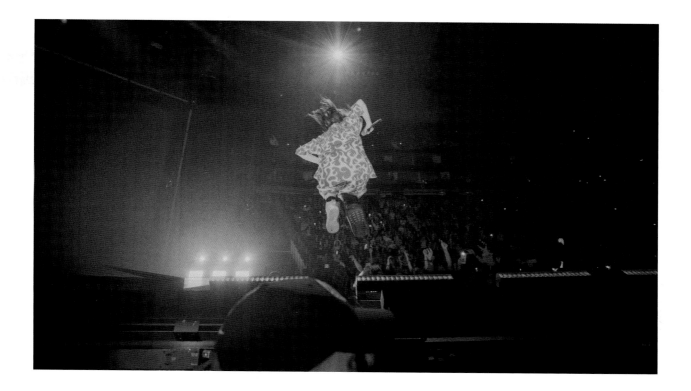

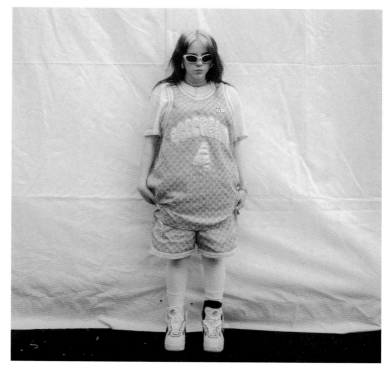

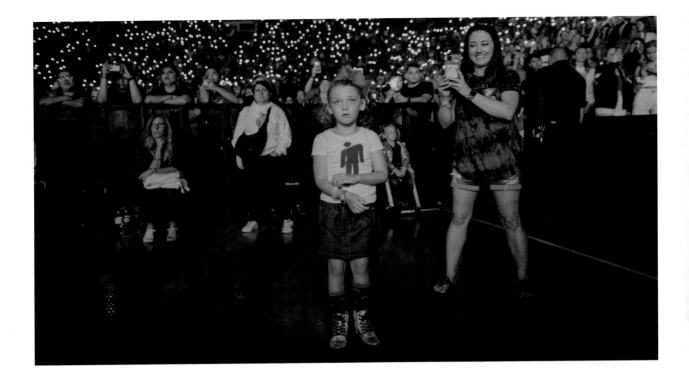

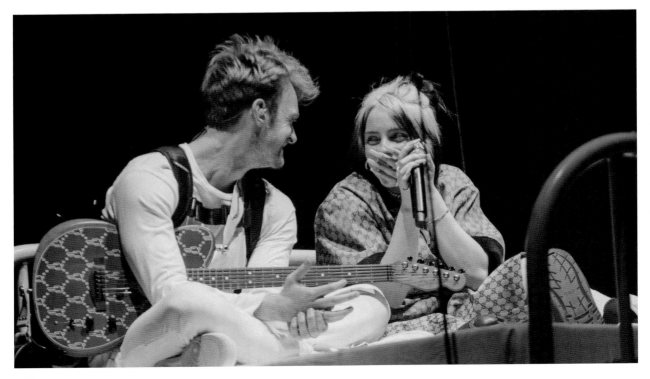

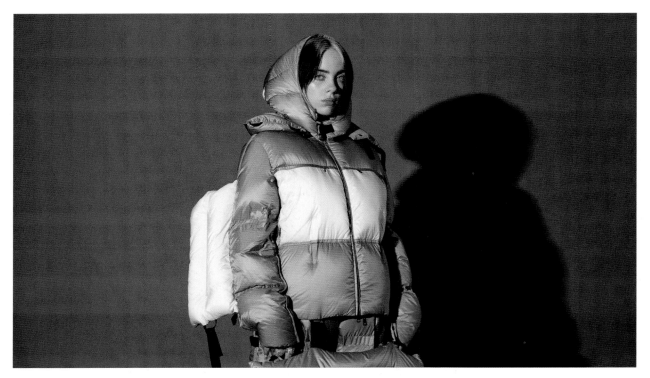

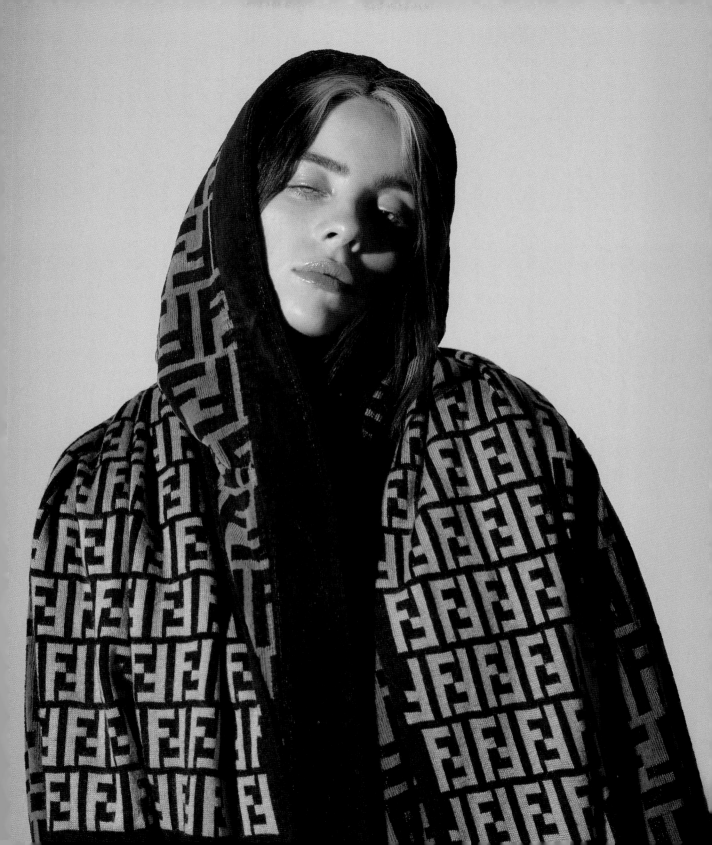

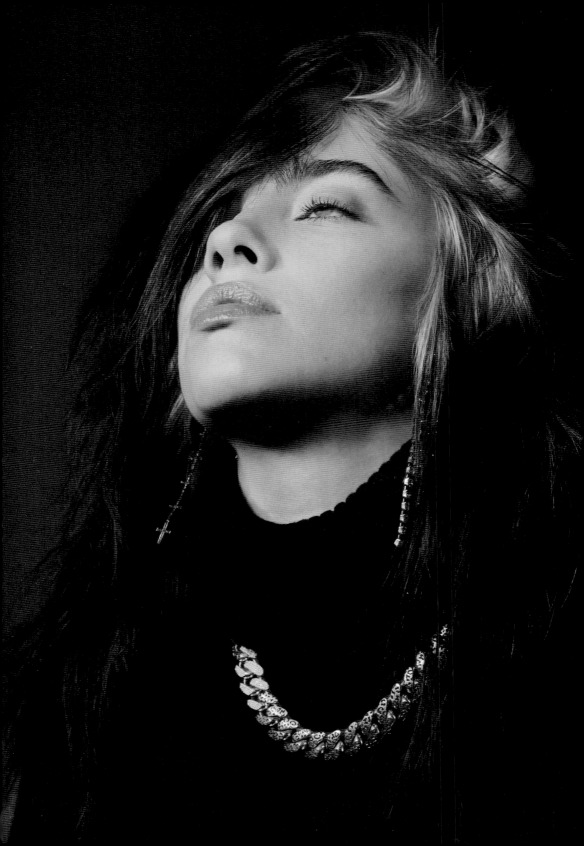

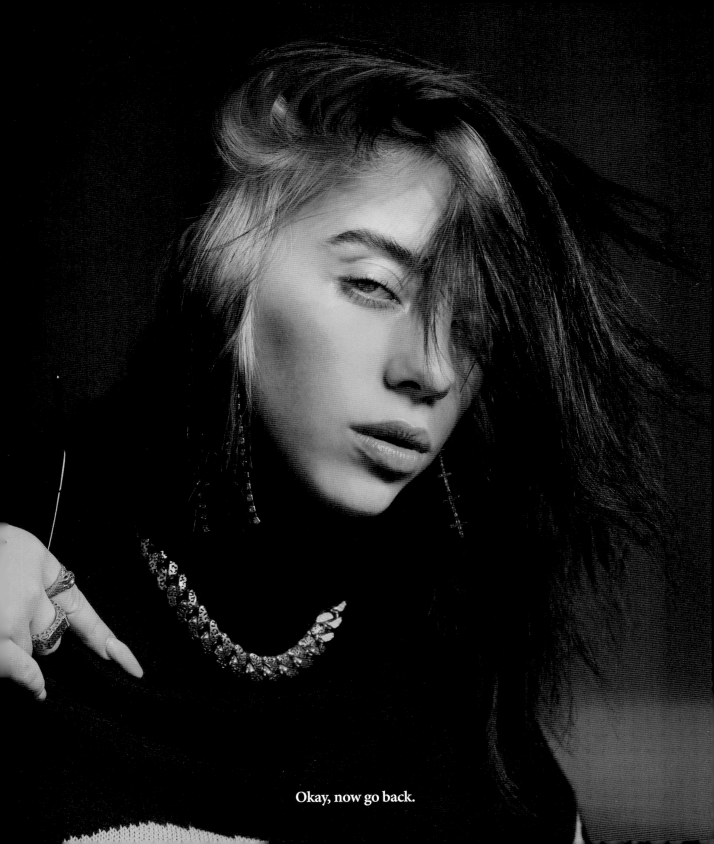

Okay, now go back.

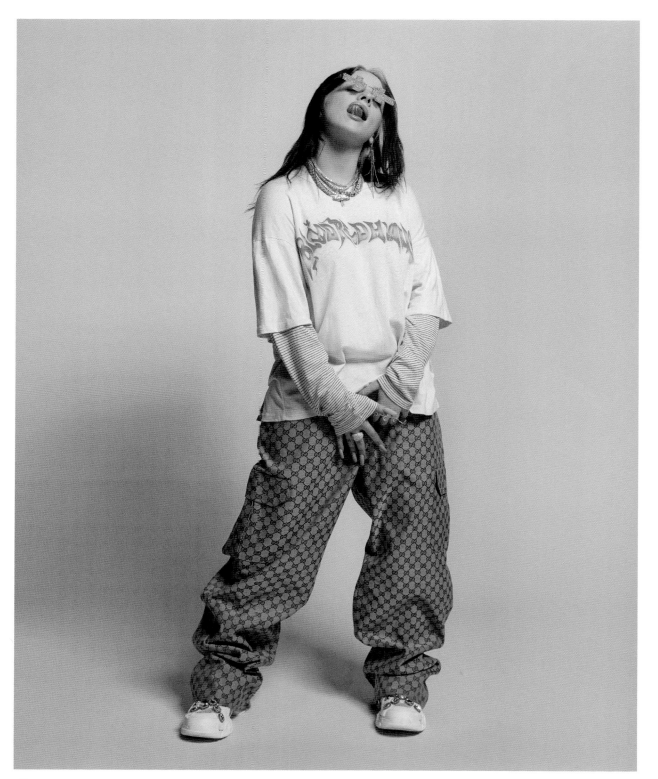

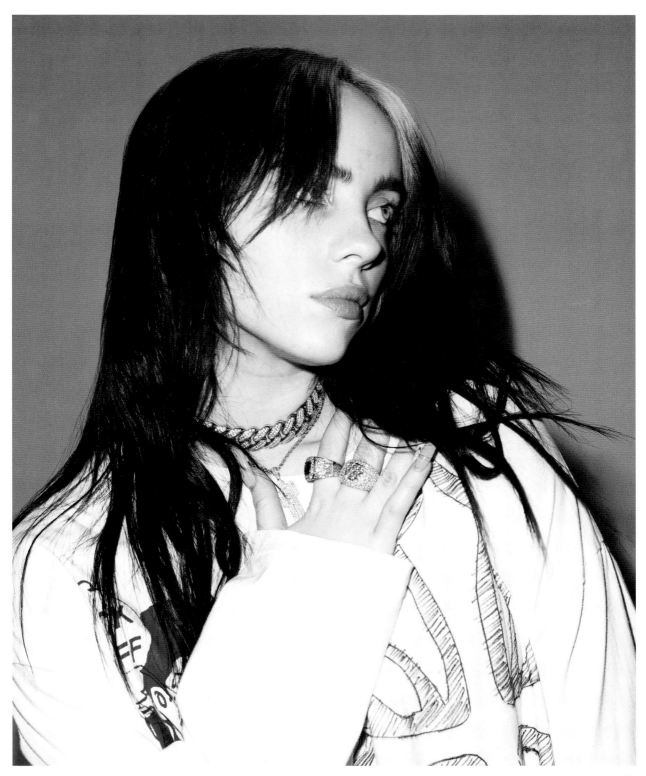

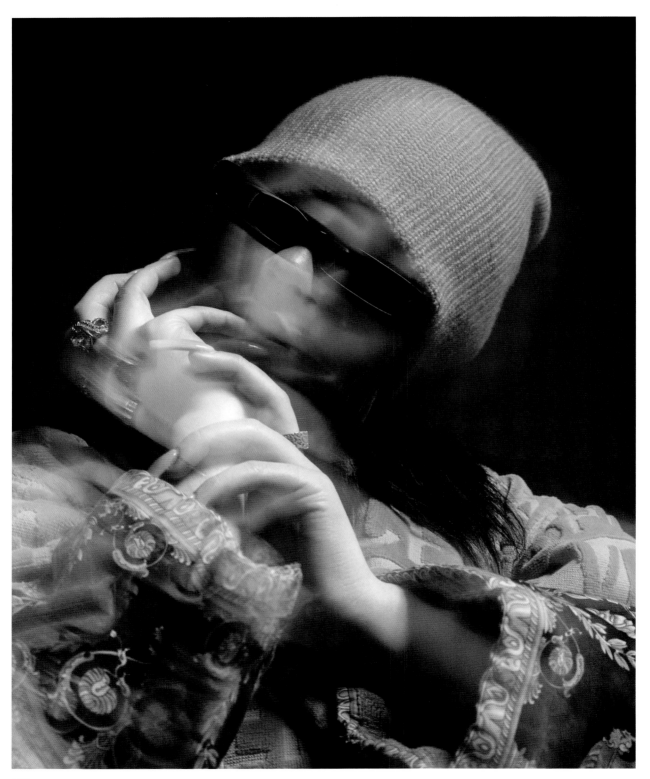

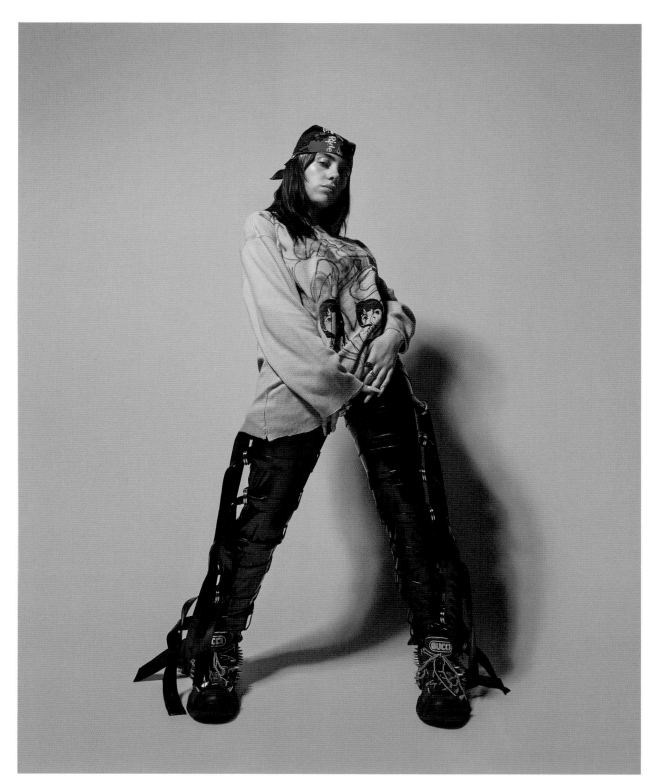

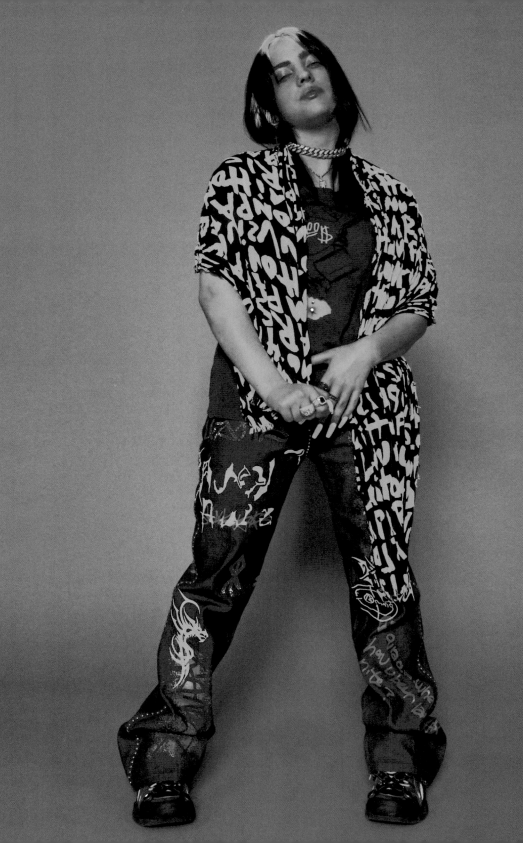

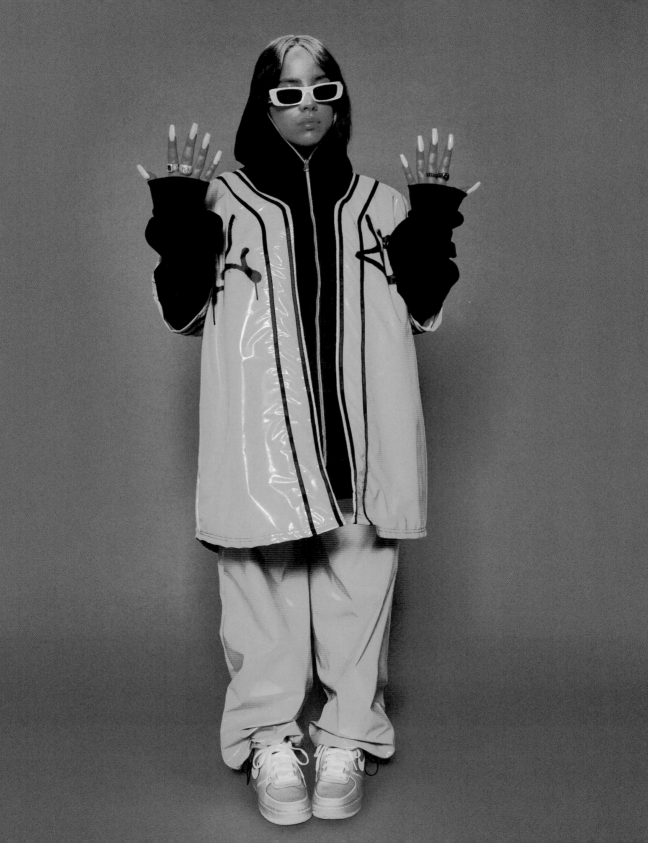

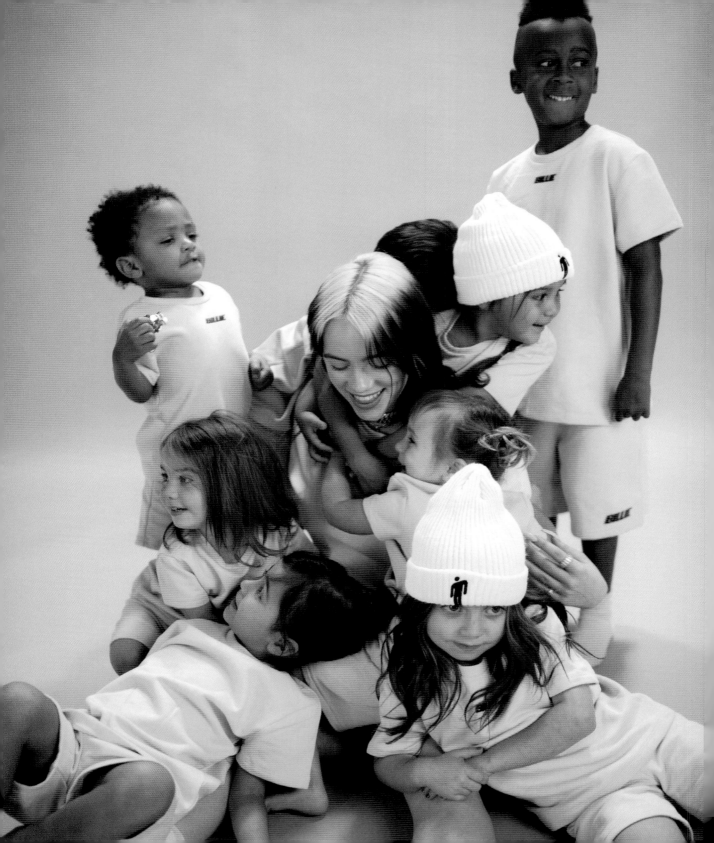

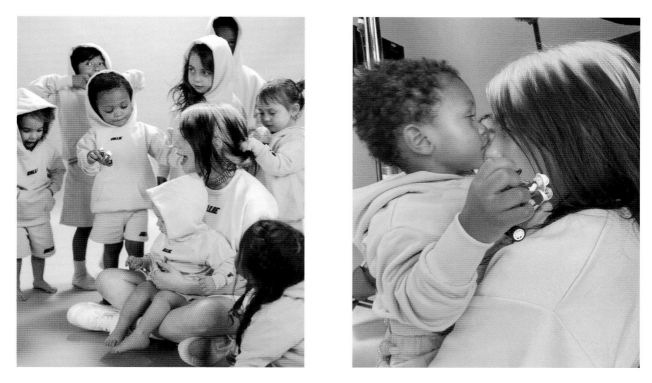

Kids' merch photo shoot! All kids of people I love. These babies are so precious to me.

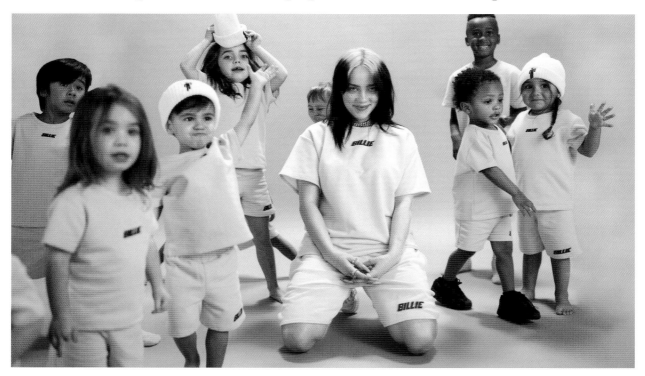

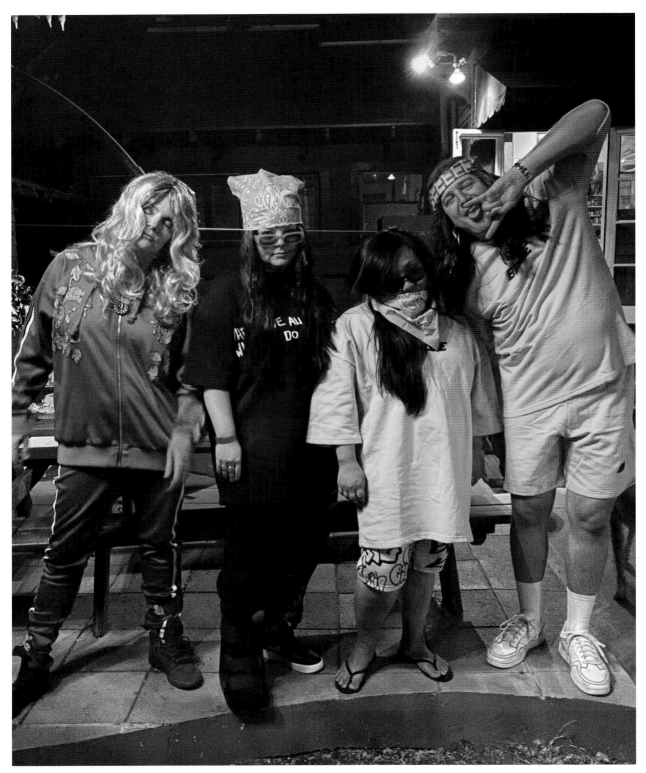

What they were for Halloween

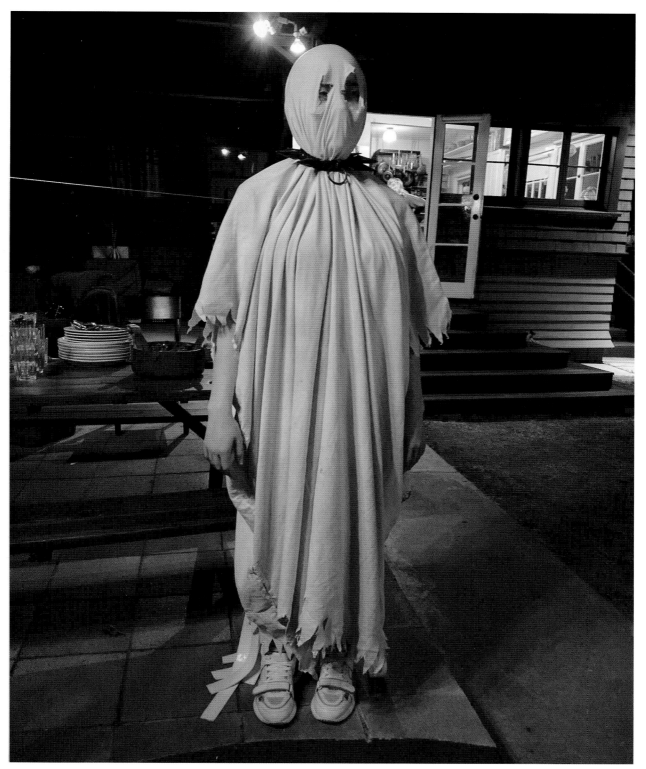

What I was for Halloween

"everything i wanted" video shoot.
This song is about my relationship with my brother, so I forced him to be in the video.
He usually doesn't want anything to do with any shoot, but he stuck with it for me.

This was the beginning of when I started directing all my videos.

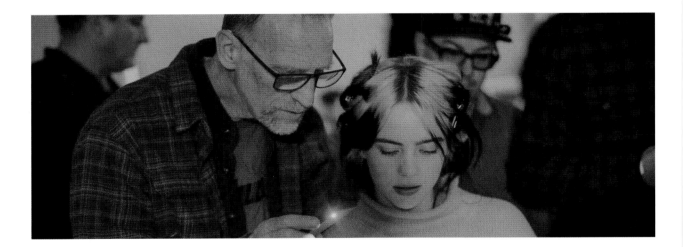

I always wanted to be a director. I'm grateful I have people around me who are easy to work with.

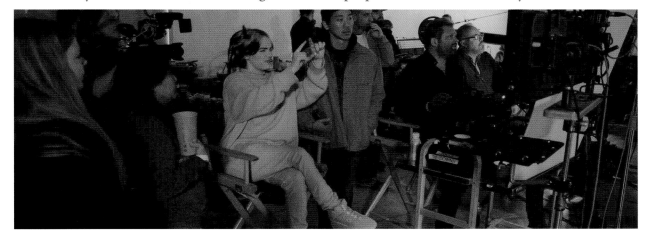

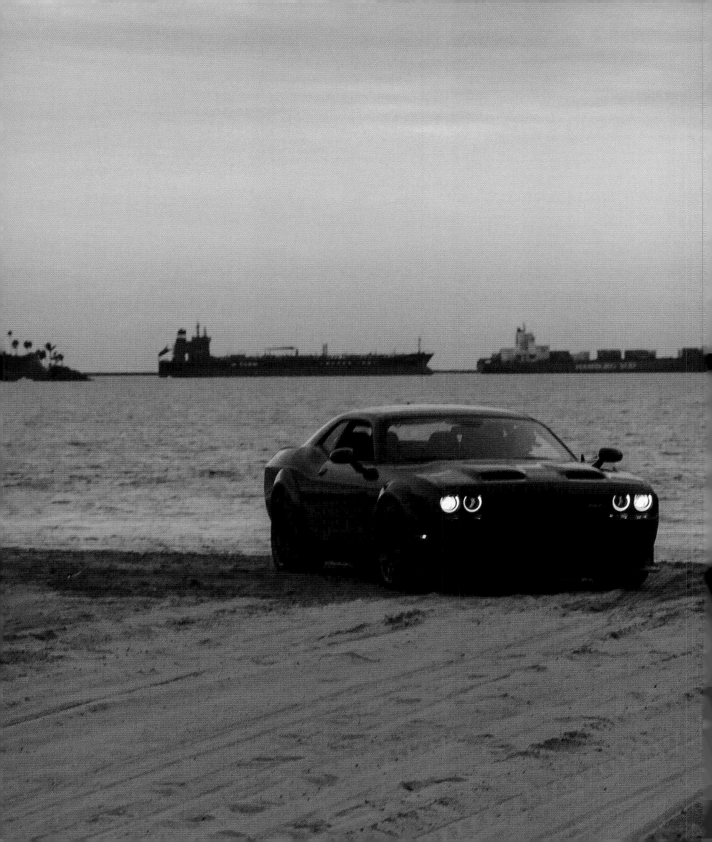

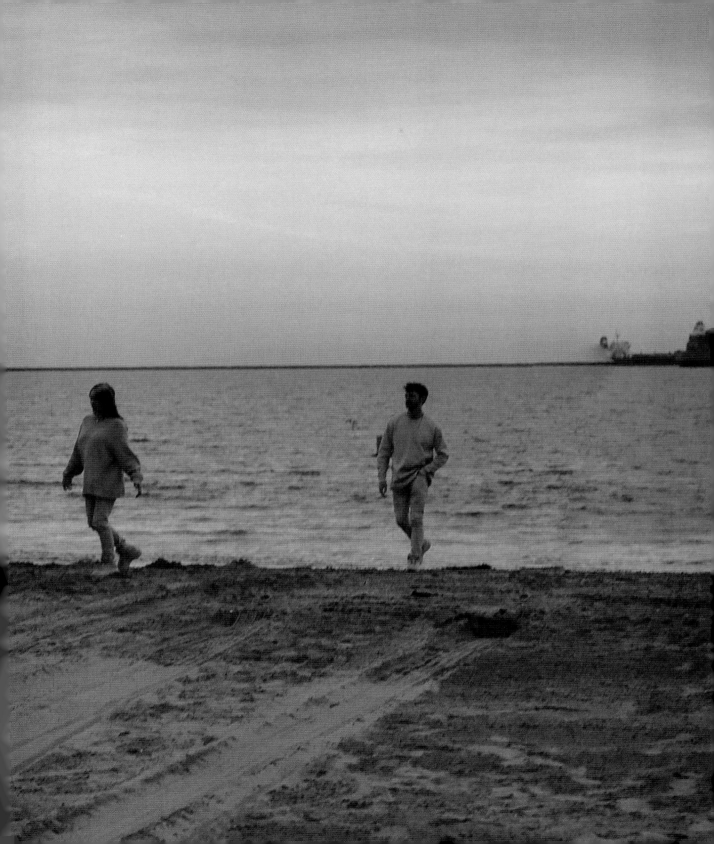

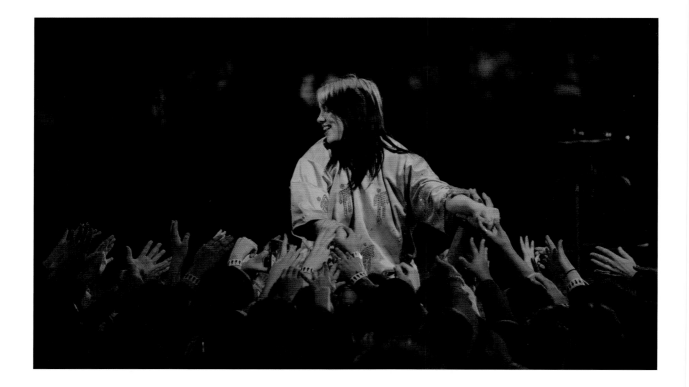

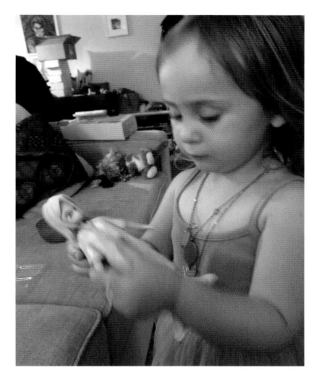

Angel face Adelaide. My manager Danny's daughter.

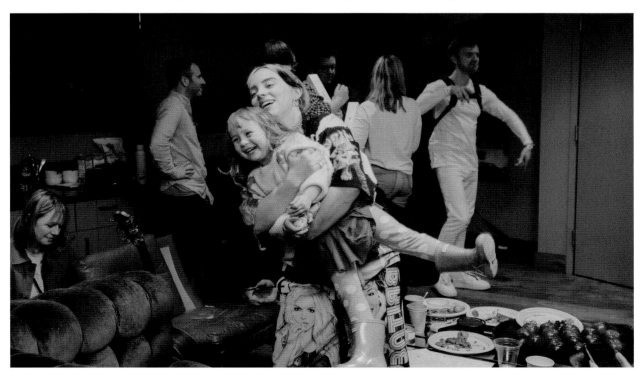

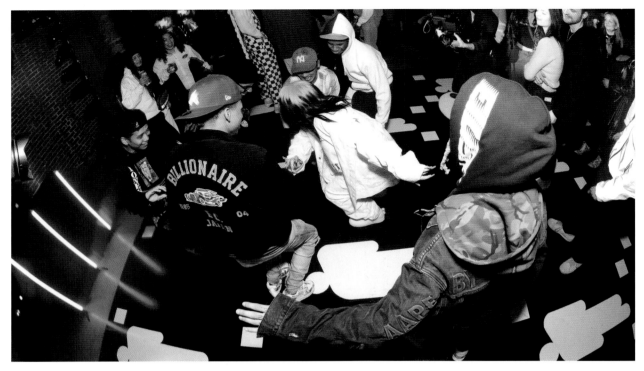

One of the best nights of my life. This party was exactly what I wanted.

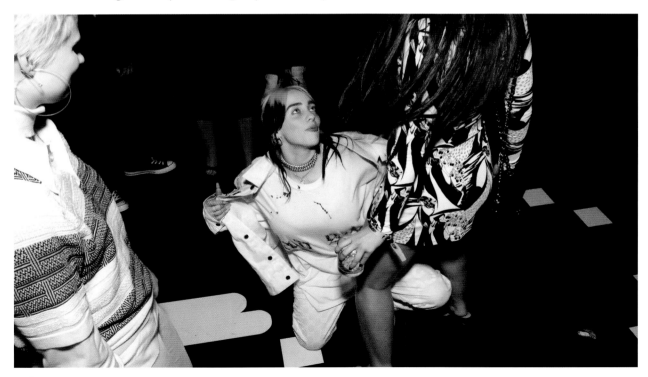

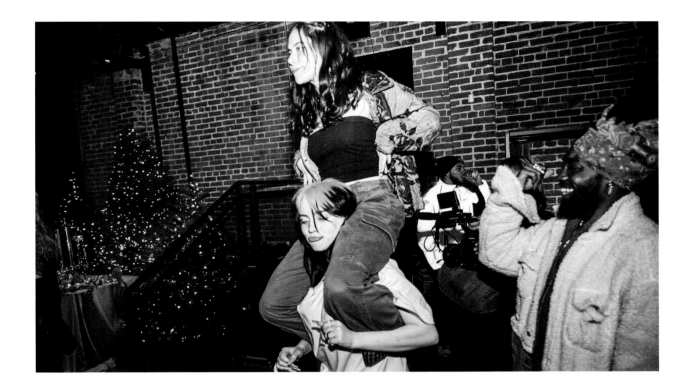

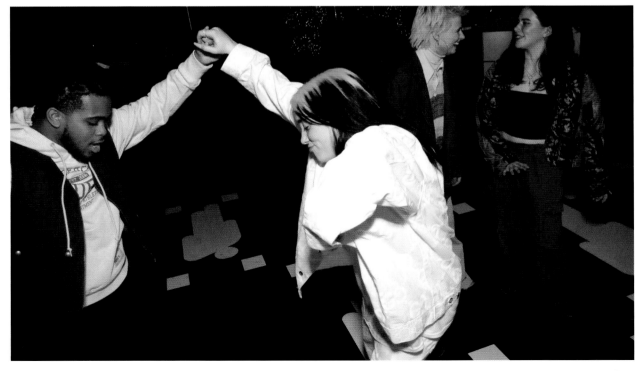

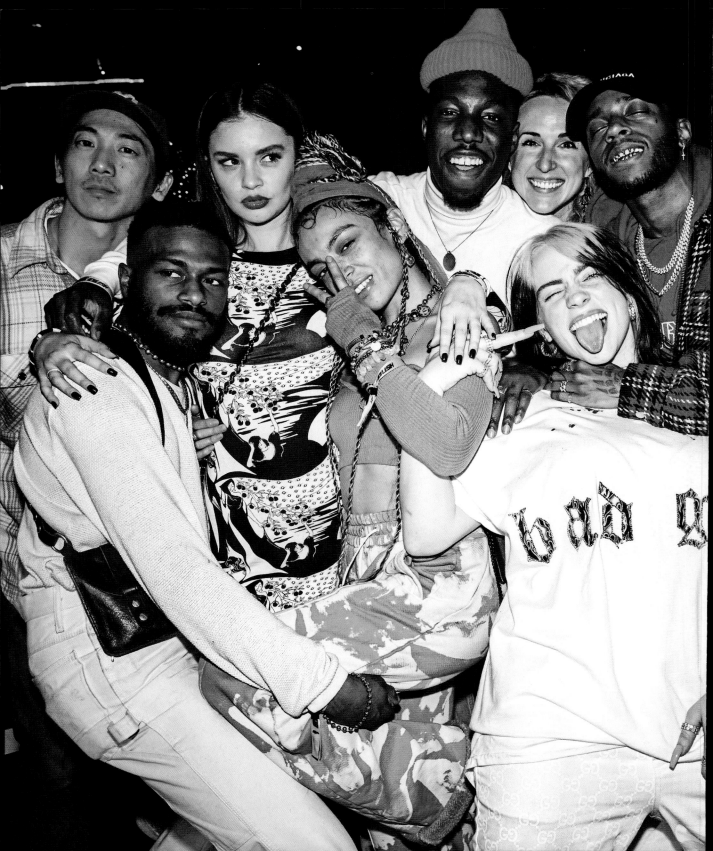

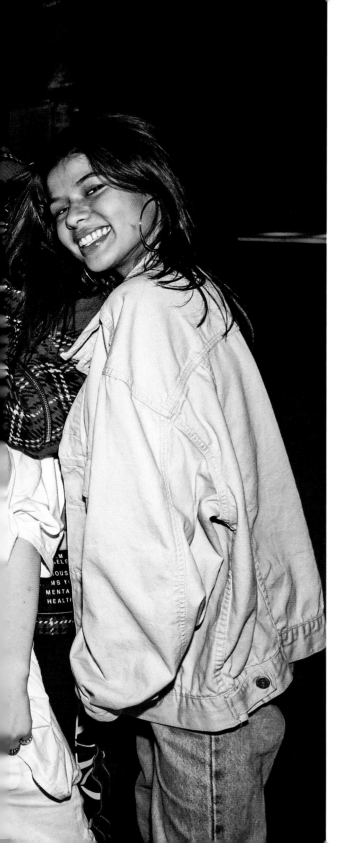

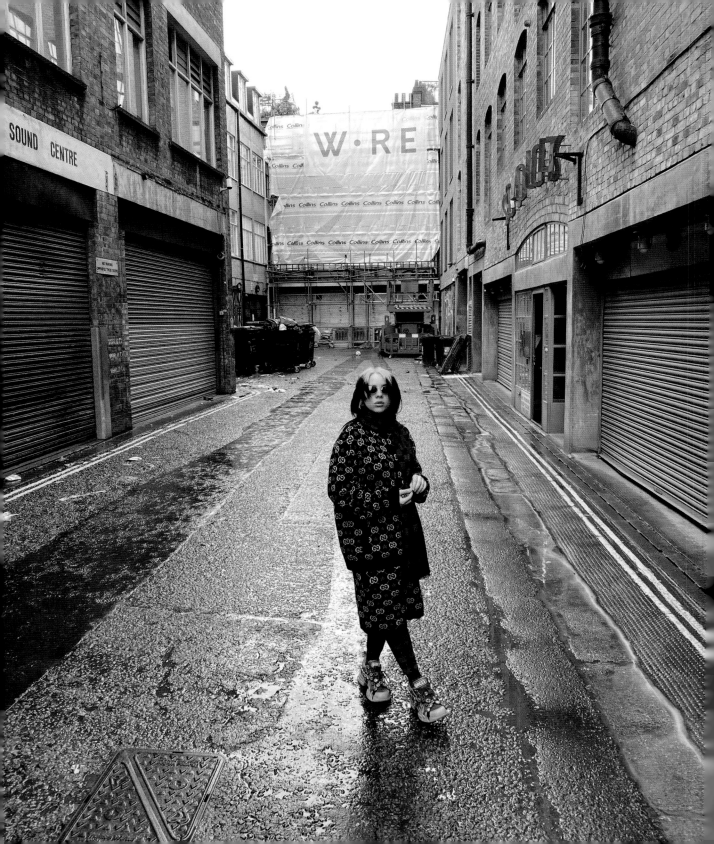

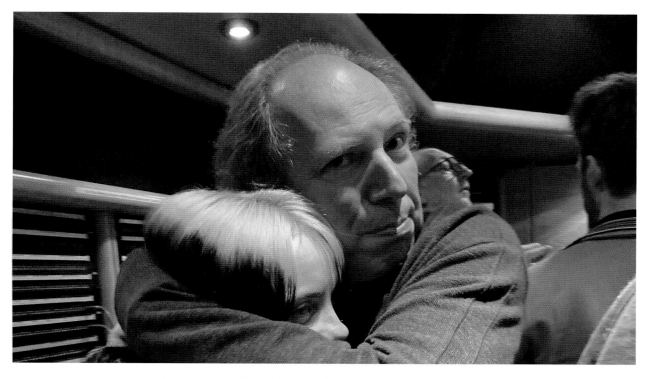

Trip to London to watch Bond for the first time and work with Hans Zimmer

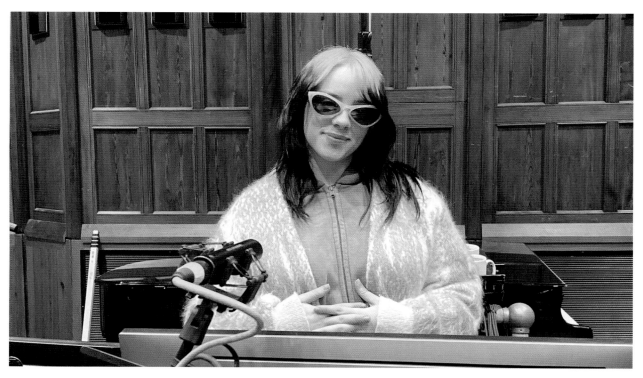

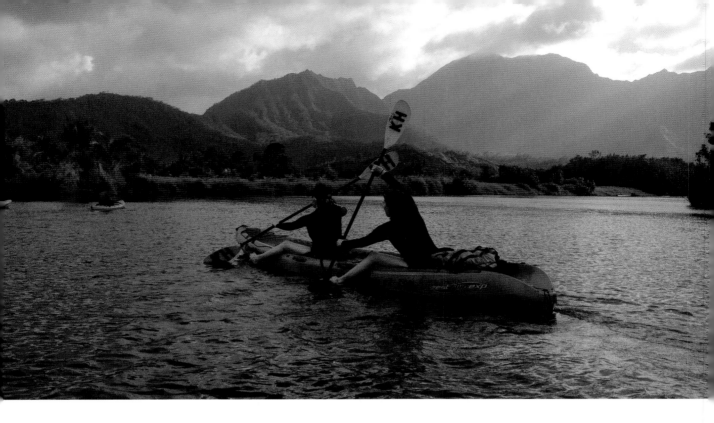

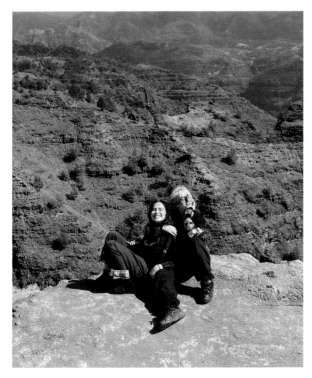

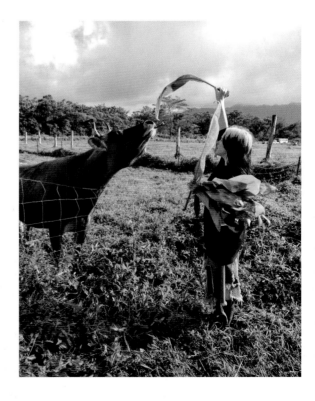

Went on vacation to Hawaii with Drew. I still think of it as a dream.

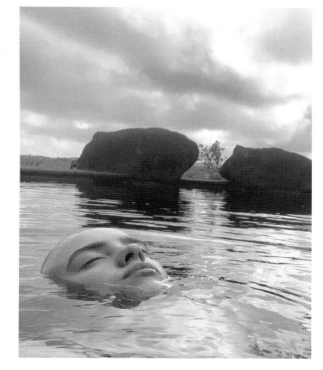

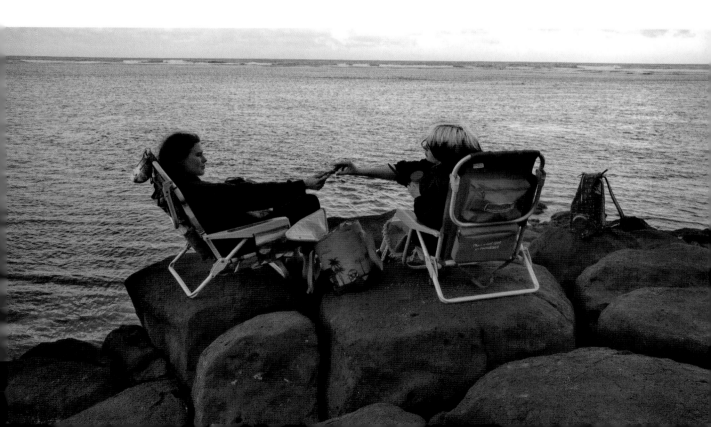

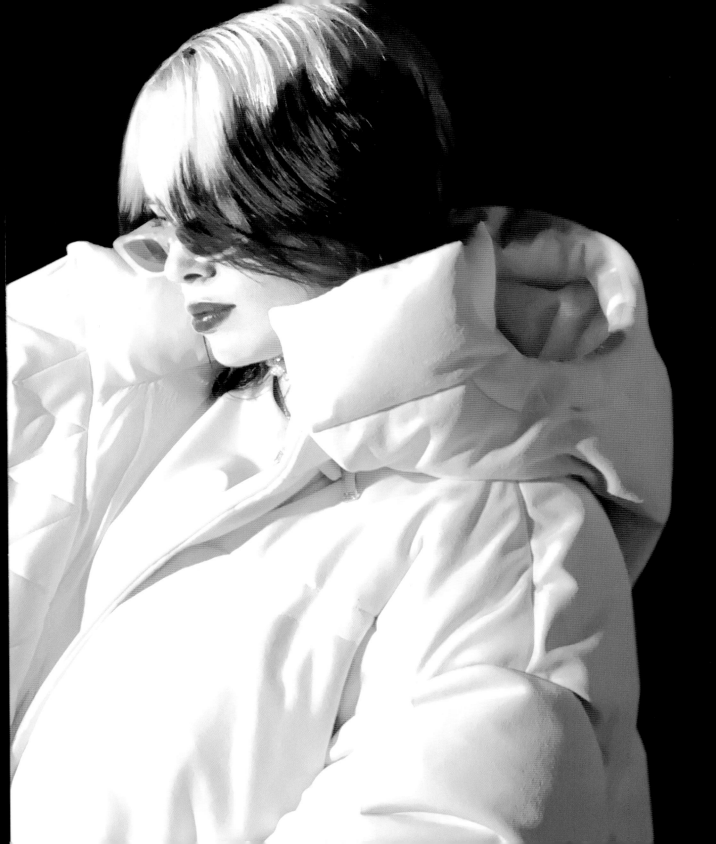

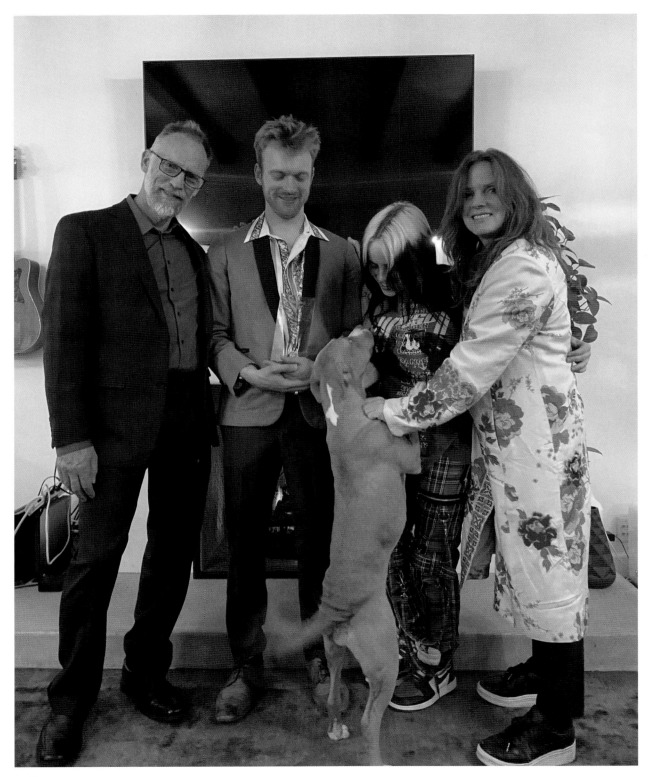

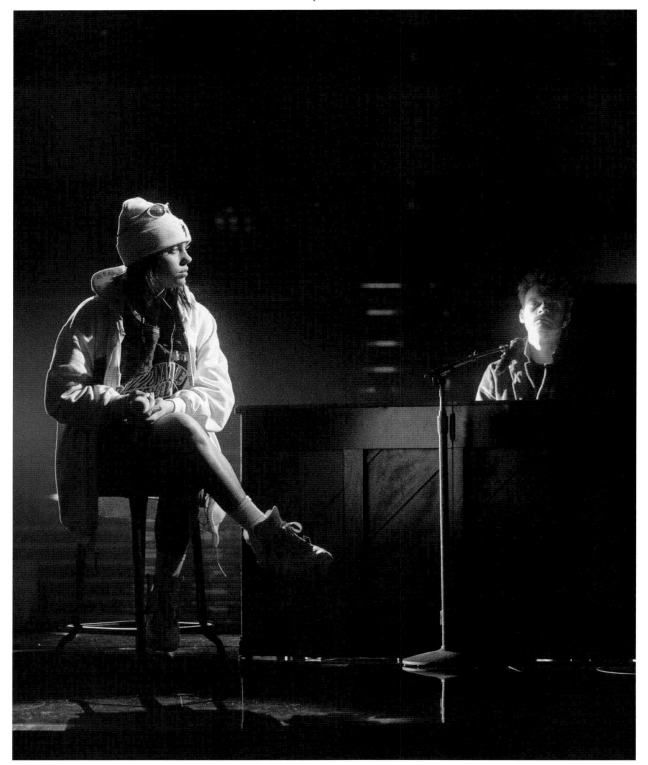

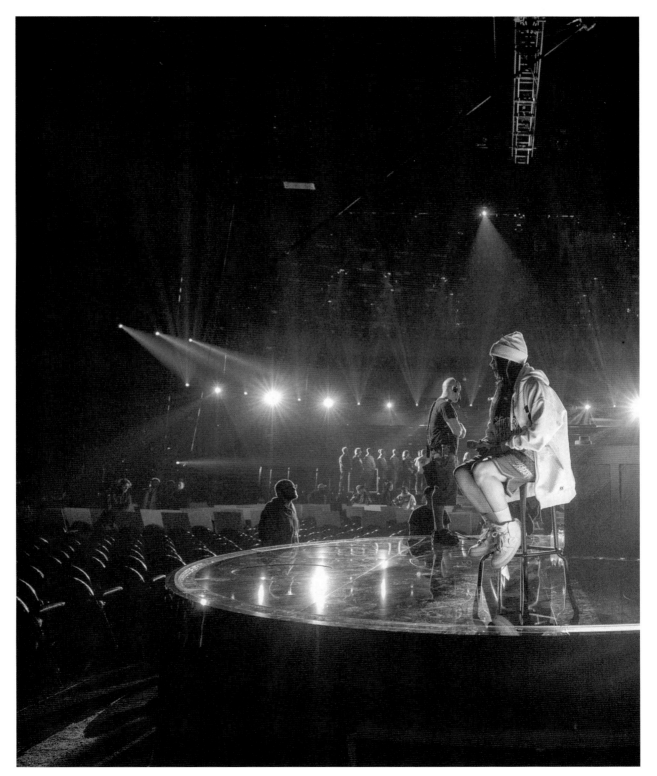

Grammy day!

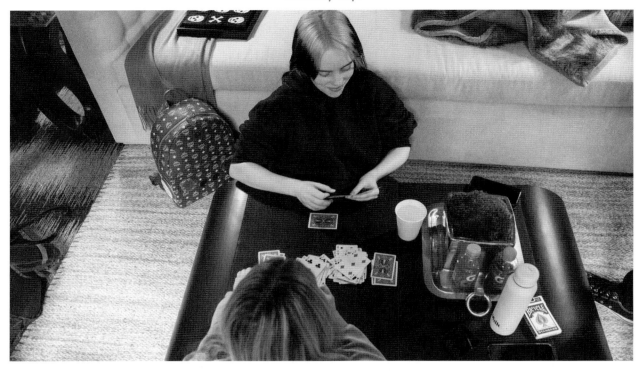

I was pretending to be on vocal rest all day so of course we played cards instead of talking, as always

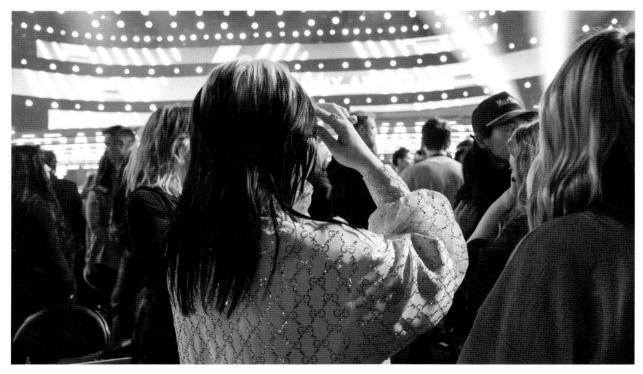

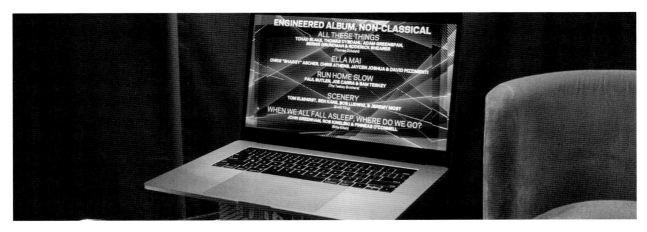

Here's us winning our first Grammy of the night while in the green room!!!!

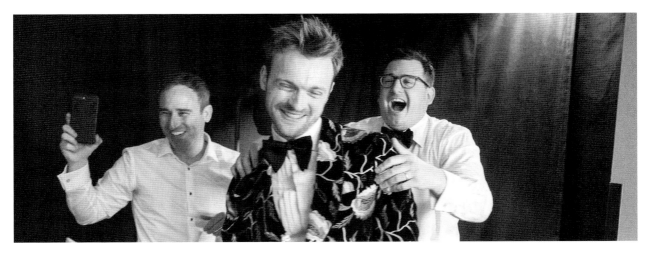

One of the many surreal moments of that day

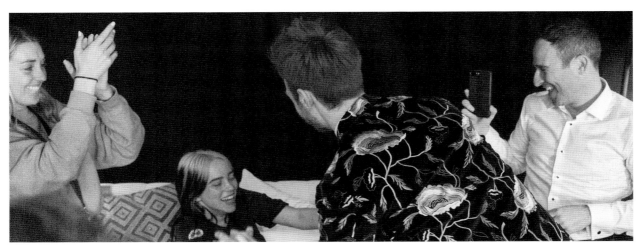

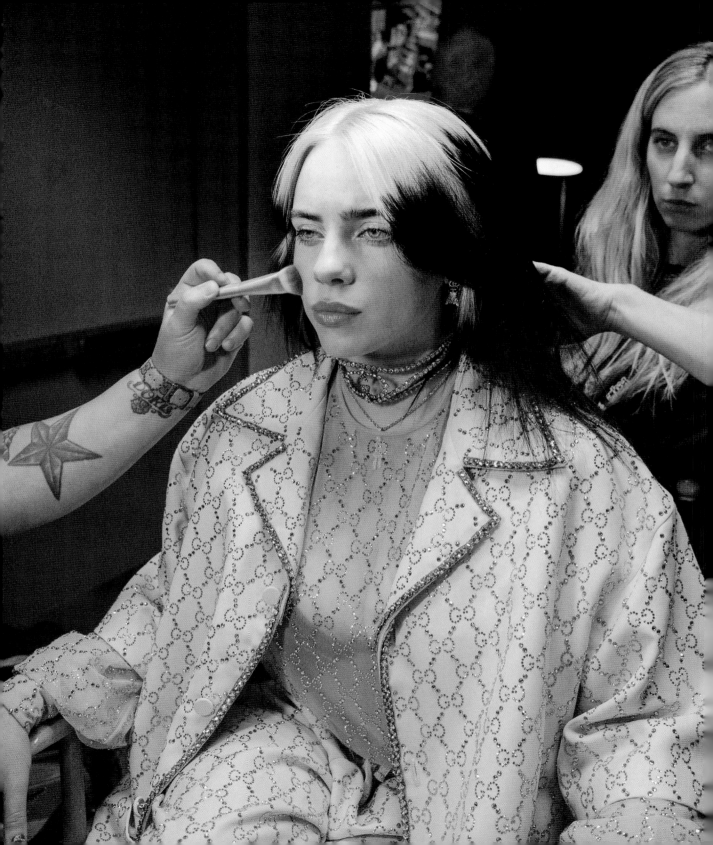

After the show all of us were crying. All of us.

Grammy after-party. Best night.

OSCARS

It was insane to be in the same room as all of those incredibly iconic and inspiring people. I was more nervous for that performance than I've ever been, and to this day I feel like it was the worst I've ever done LMAO. Still such an honor.

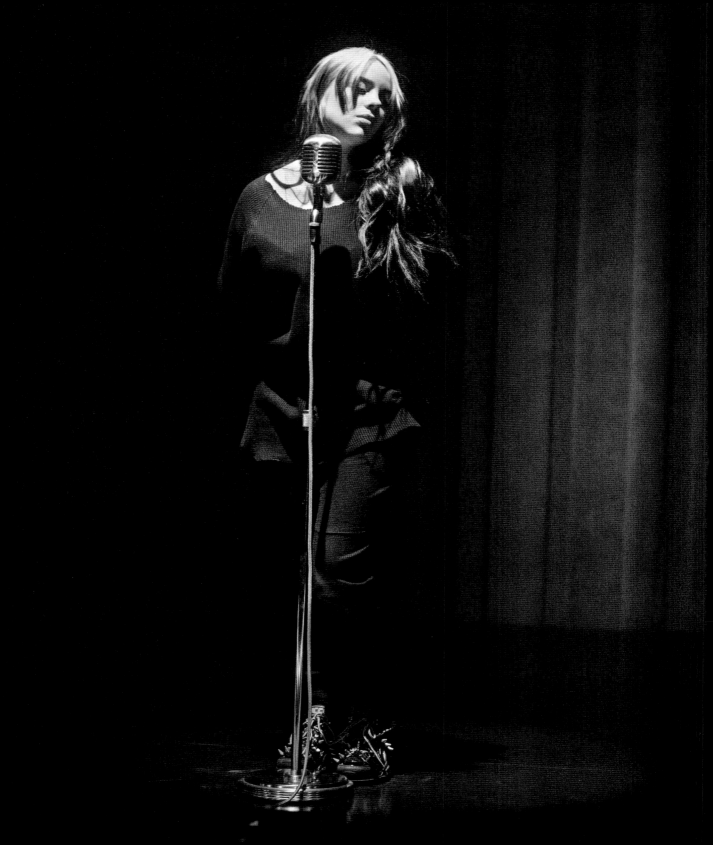

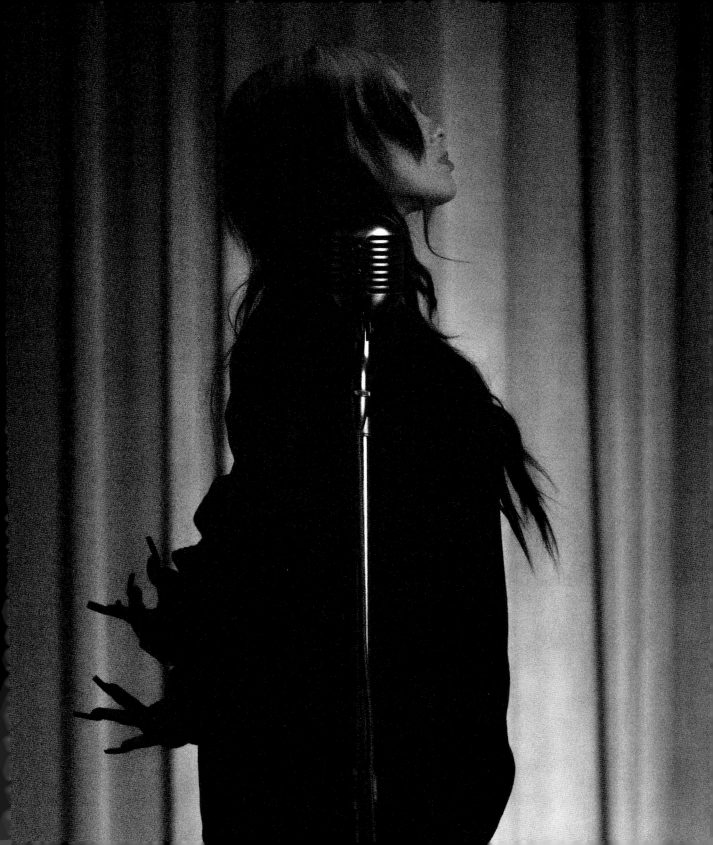

Rehearsals for my world tour that never happened

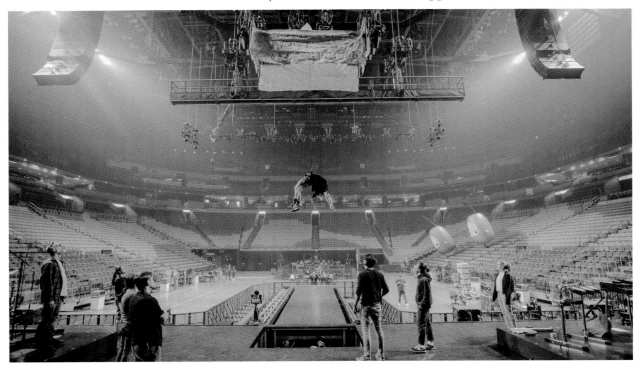

We did three shows and then had to go home because of COVID.

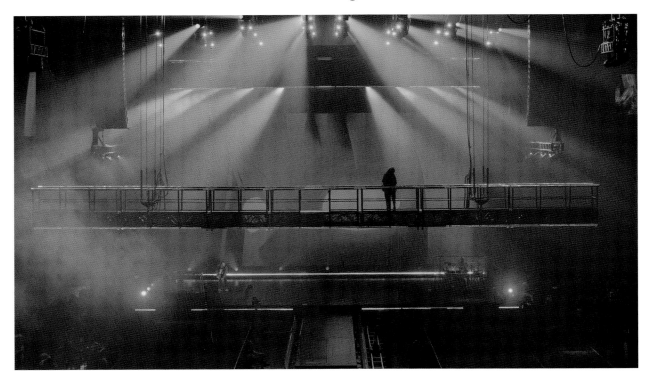

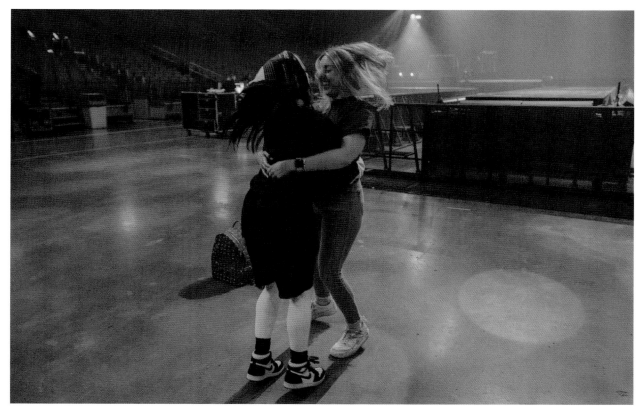

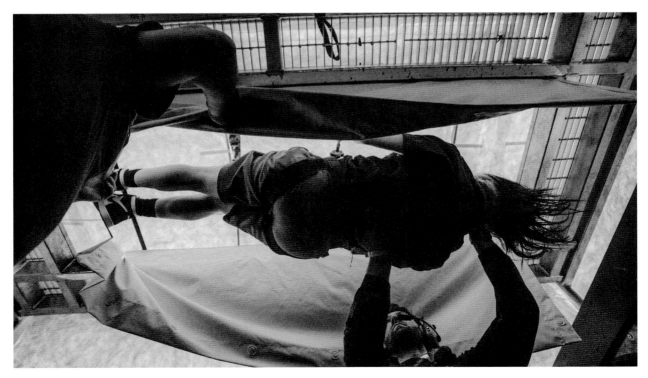

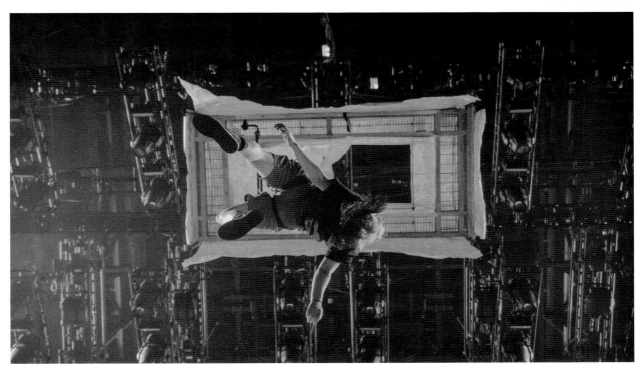

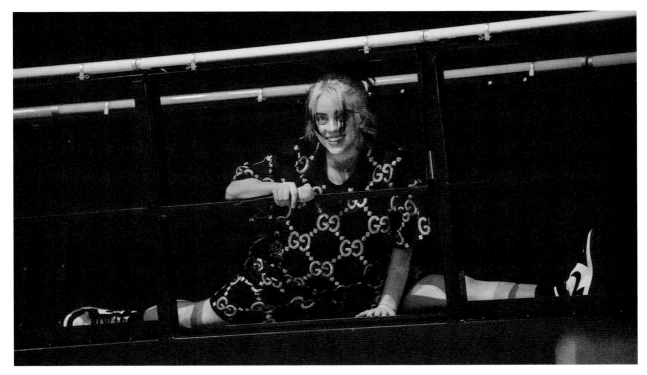

All me and Matty do is laugh.

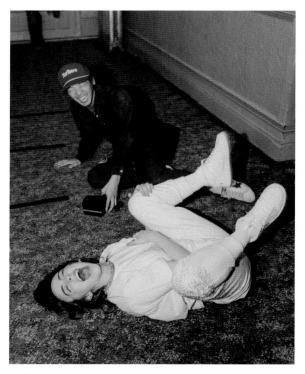
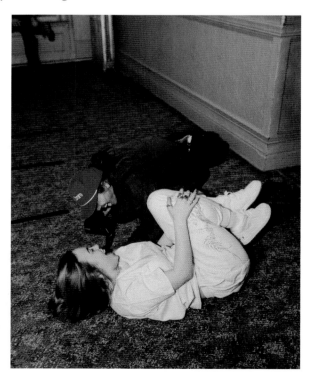

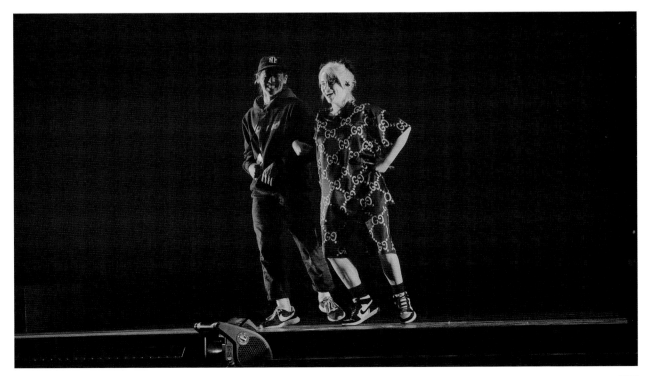

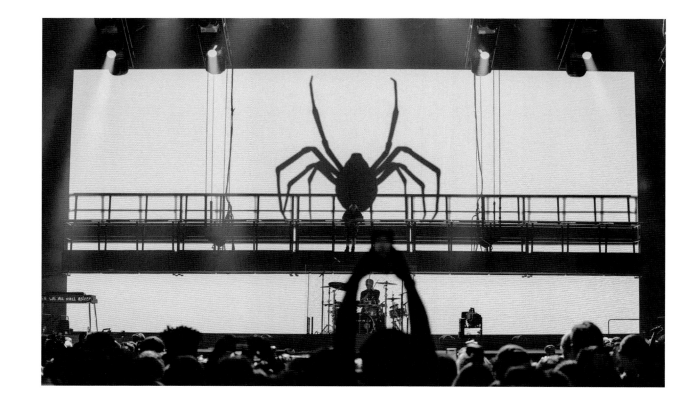

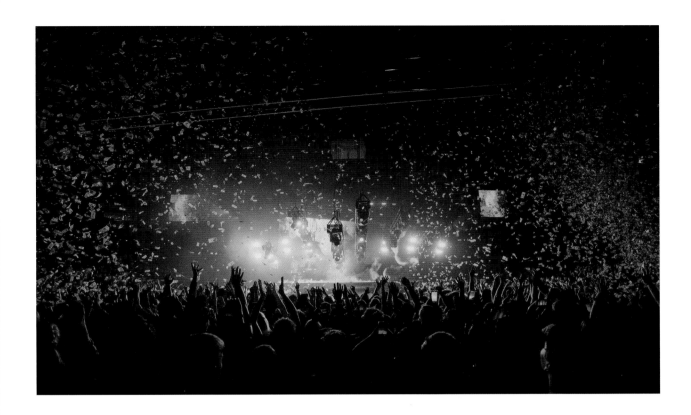

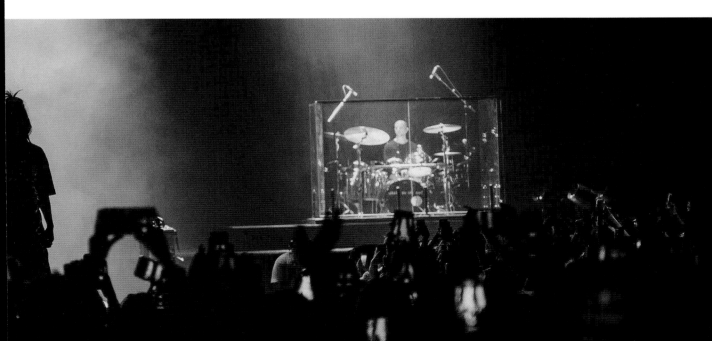

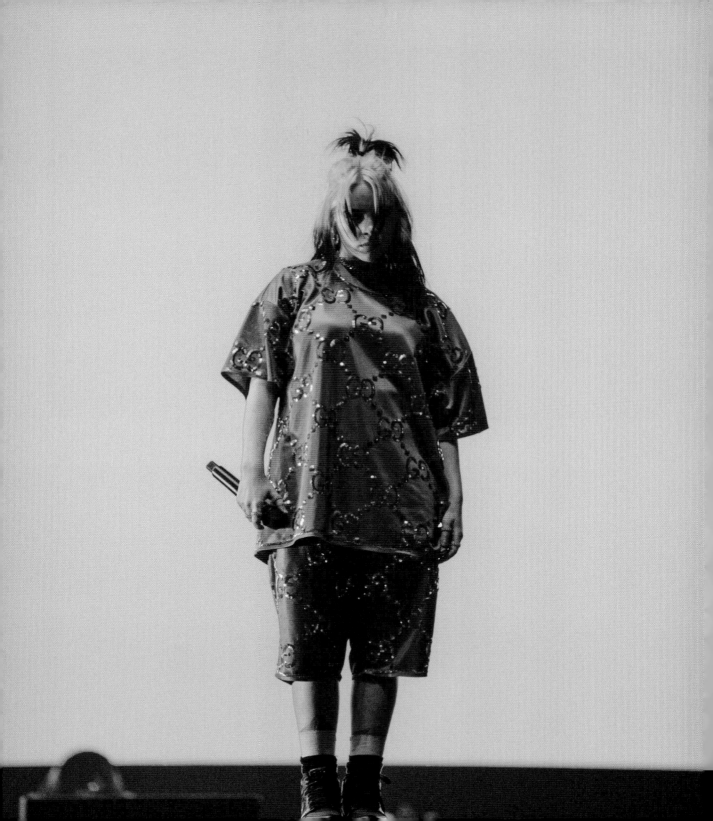

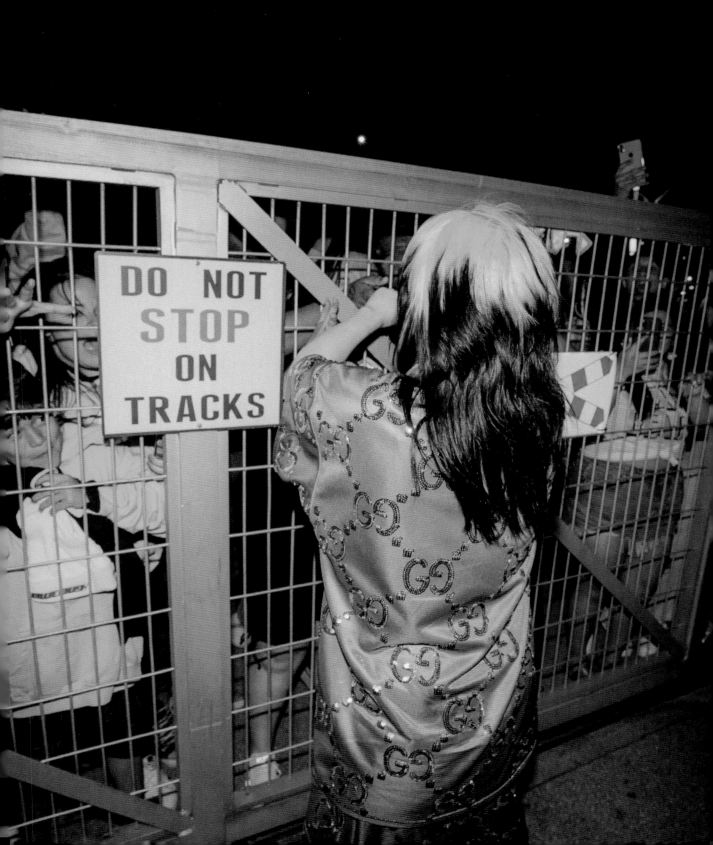

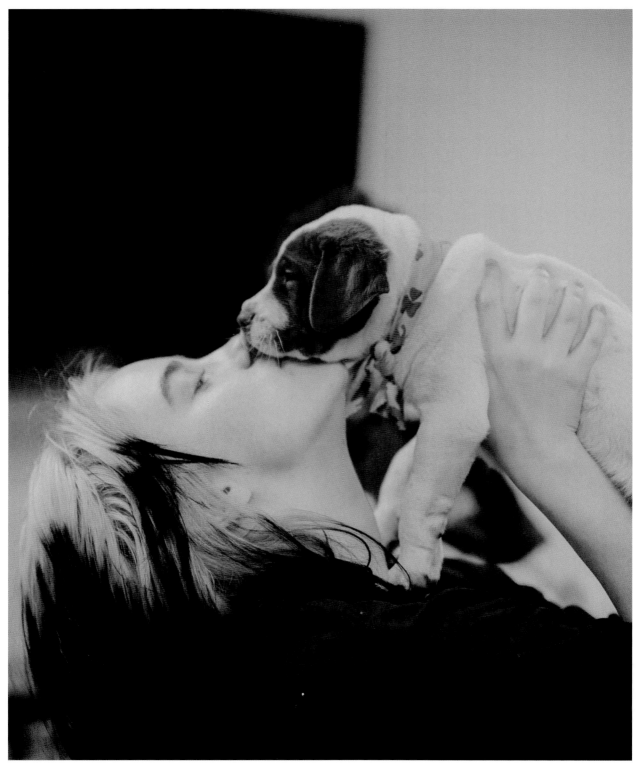

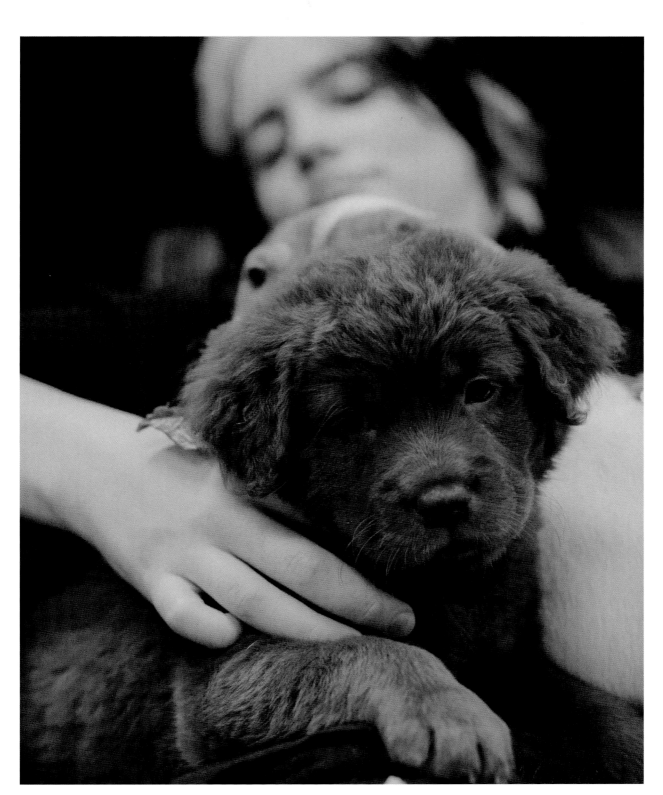

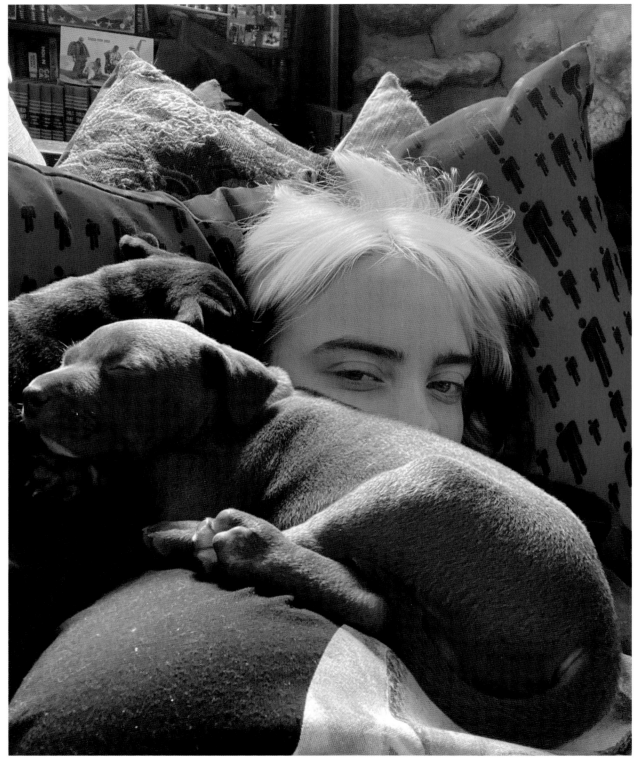

I adopted a little stinky puppy named shark

See you soon

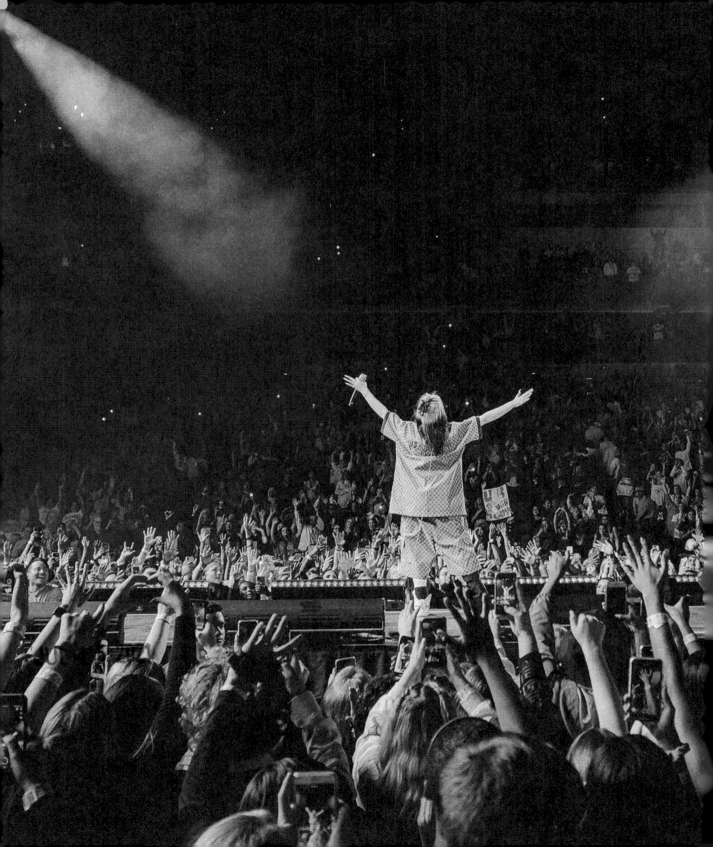